# EDINBURGH

## A NEW PERSPECTIVE

First published in 2006
by

Mercat Press Ltd.
10 Coates Crescent, Edinburgh EH3 7AL
www.mercatpress.com

ISBN 10: 1 84183 093 3
ISBN 13: 978 1 84183 093 3

Cover Design: Mark Blackadder
Printed in China, through World Print

# EDINBURGH

## A NEW PERSPECTIVE

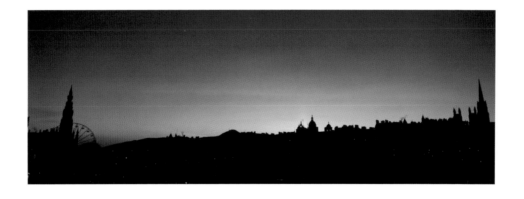

## JASON BAXTER

Mercat Press
www.mercatpress.com

This book is dedicated to my wife Fi. Thank you for all your love, support and patience in helping me to pursue my lifelong dream. You mean the world to me.

# INTRODUCTION

From a very young age I can remember being impressed by Edinburgh—the imposing arcitecture, its vibrancy and atmosphere. I moved to Edinburgh from Glasgow about four years ago, not as a photographer but as a student following a new career path. I appreciated the city's beauty and couldn't help but notice that the many postcards in tourist shops didn't reflect my vision. I began to think of a way I could use photography to portray this dynamic Edinburgh.

Why the panoramic format? For many years I have admired the work of Scottish photographer Colin Prior, inspired by his landscape panoramas. I realised that the panoramic format could also be successfully applied to cityscapes and architecture, and so the idea was born. After eight months of early starts to get the perfect lighting conditions, I began to build a decent portfolio, and as there didn't appear to be a book portraying Edinburgh in this way, I decided to do one myself. I sought out a publisher and the idea became reality. A deal was made and my first book was born; a dream come true.

I've included more details about each photograph featured in the book on pages 108-113.

# TECHNICAL NOTE

For this project I purchased a Fuji GX-617 fine art panoramic camera with a wide angle 90mm lens. It is increasingly popular for its outstanding quality and results. I was an immediate convert. For the initial images I used Fuji Velvia 50 ASA film, renowned for its immensely sharp grain and superb saturated colours, which make an ideal combination. This film was replaced by Fuji with the Velvia 100 ASA. I still prefer the original, but you can't stop progress. However the new Velvia has more tonal range and can therefore capture more detail in the shadows.

Shooting at the magical hours of sunrise and sunset has produced stunning results which excite me. For every shoot I take my trusty light meter and my Canon digital camera. This is where technology comes into its own. Using a combination of traditional light meter, experience and digital camera gives me the opportunity to ensure that the shot is captured in the way I intended.

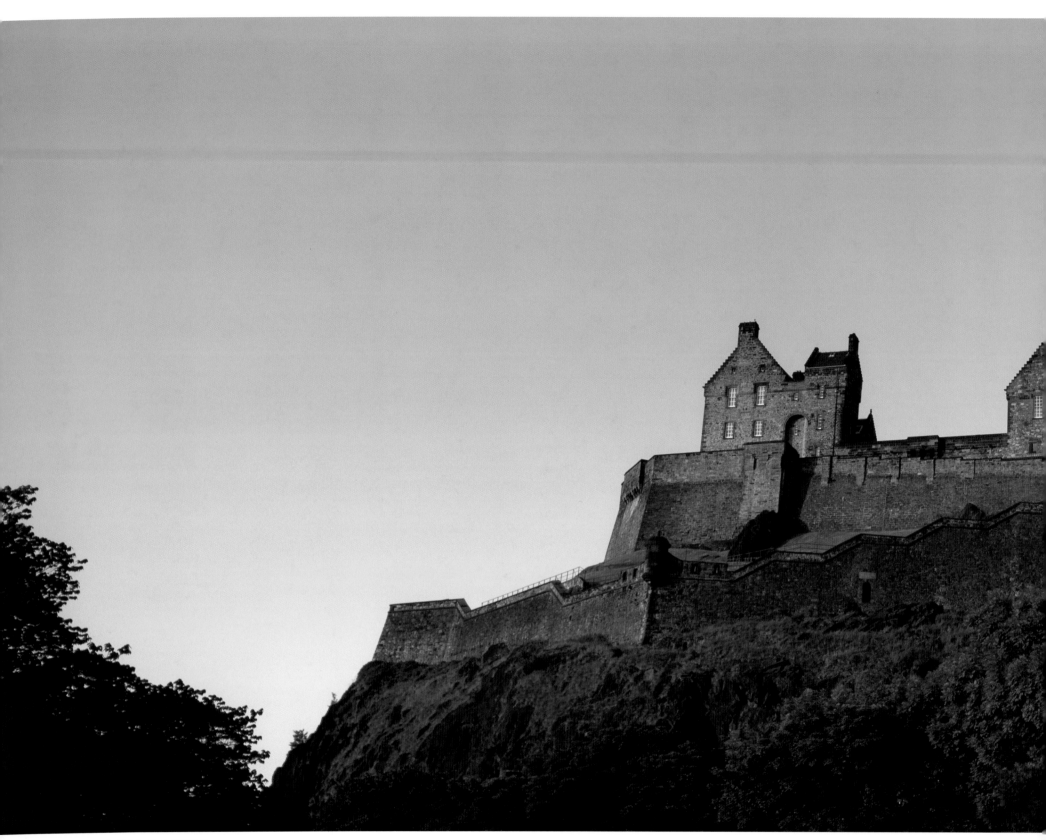

EDINBURGH CASTLE

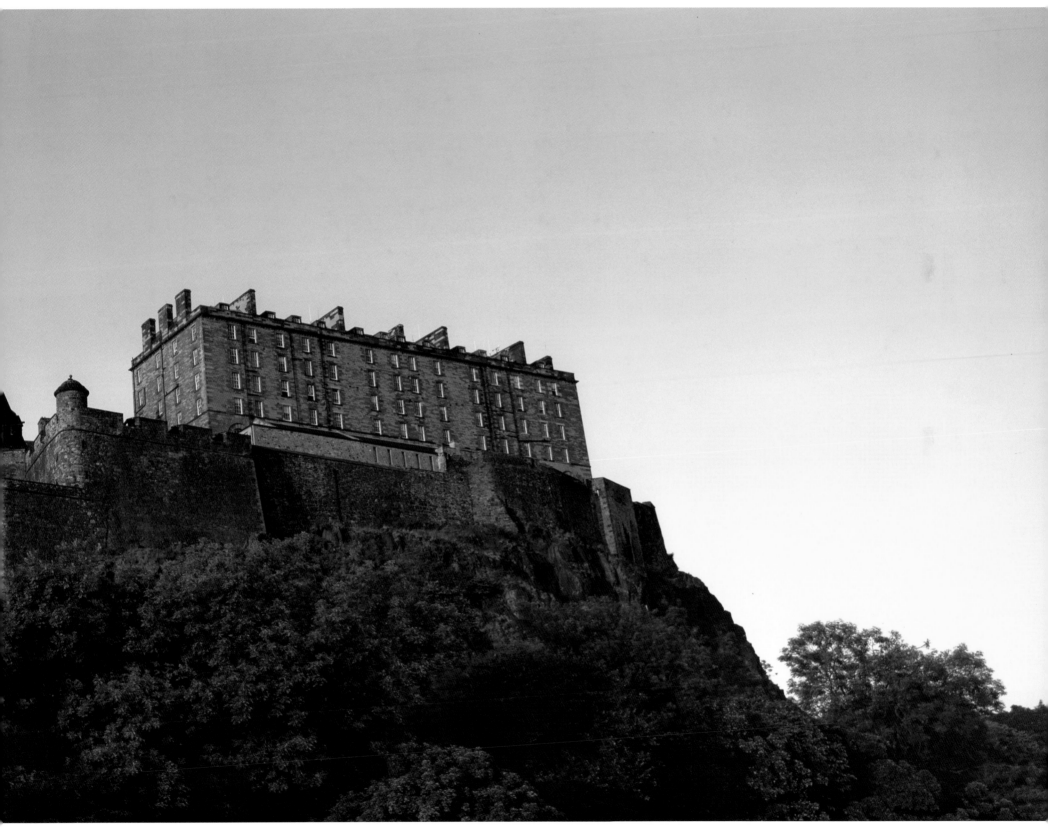

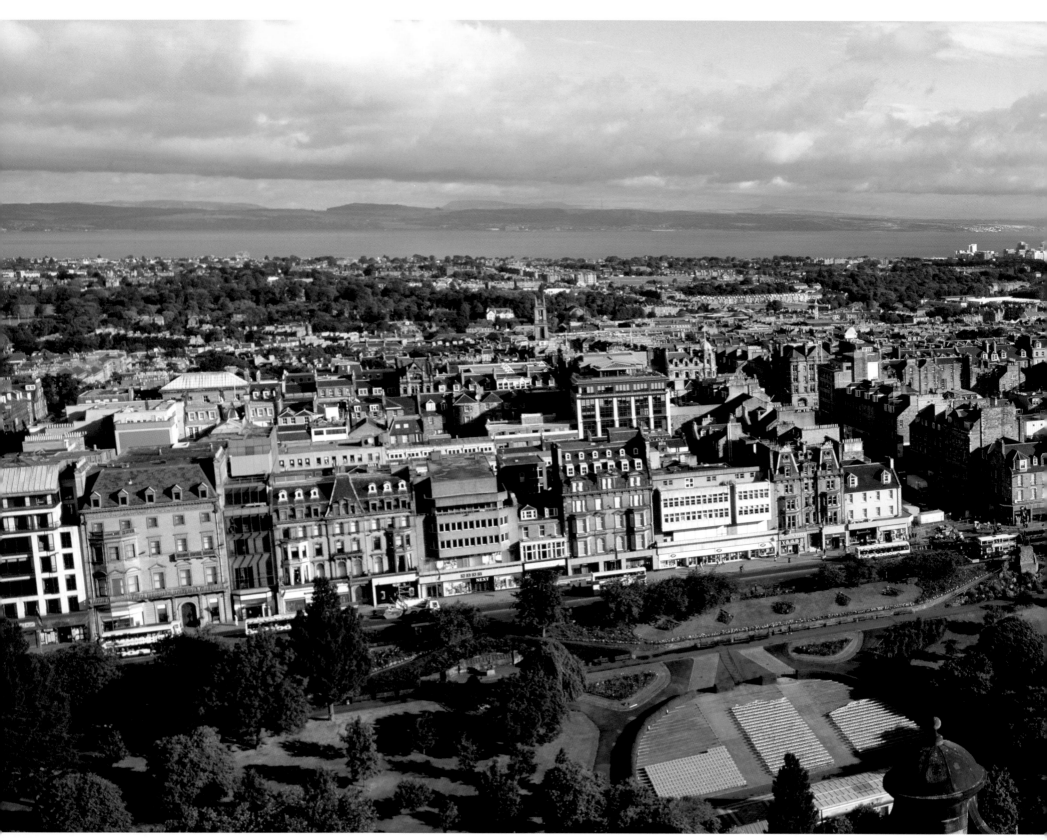

PRINCES STREET GARDENS LOOKING EAST TO FIFE

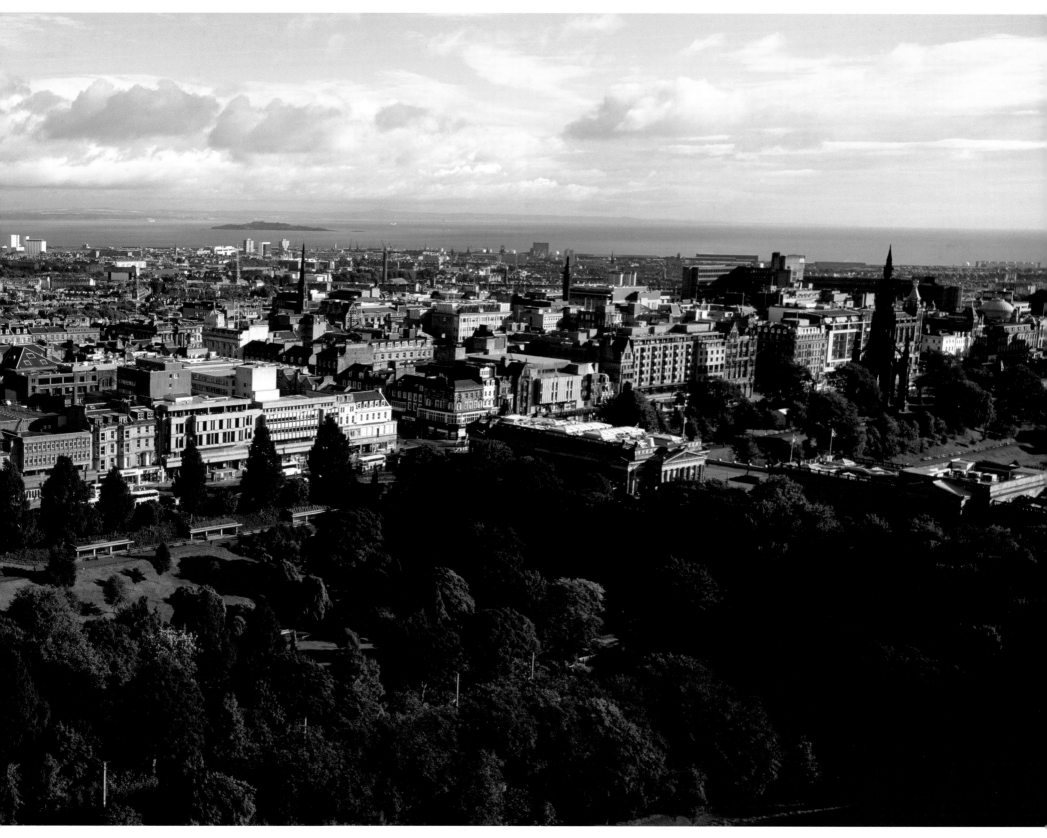

FORTH RAIL BRIDGE

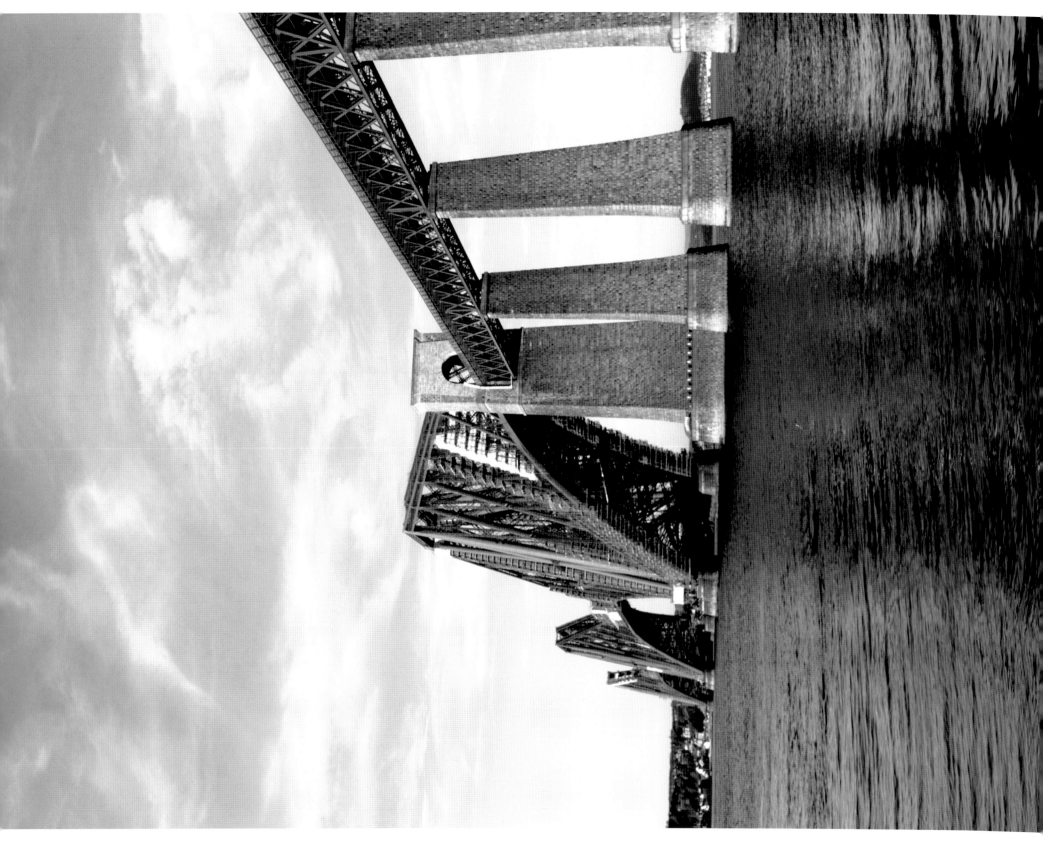

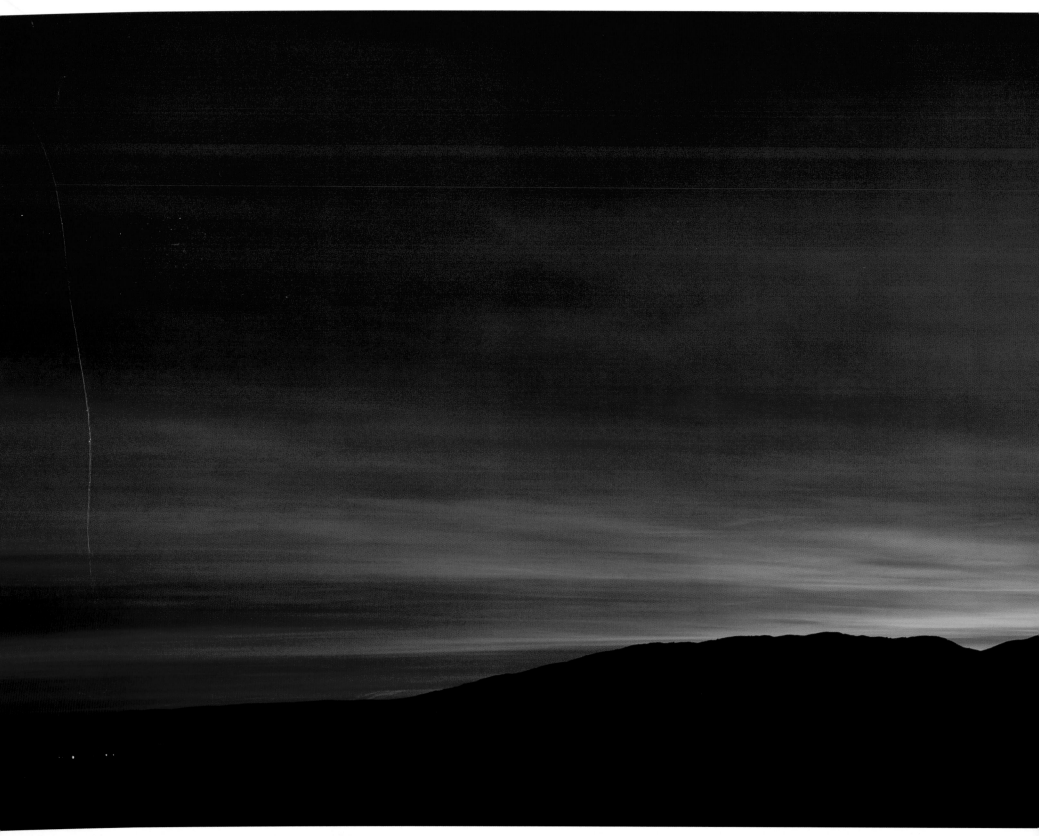

ARTHUR'S SEAT AND SALISBURY CRAGS

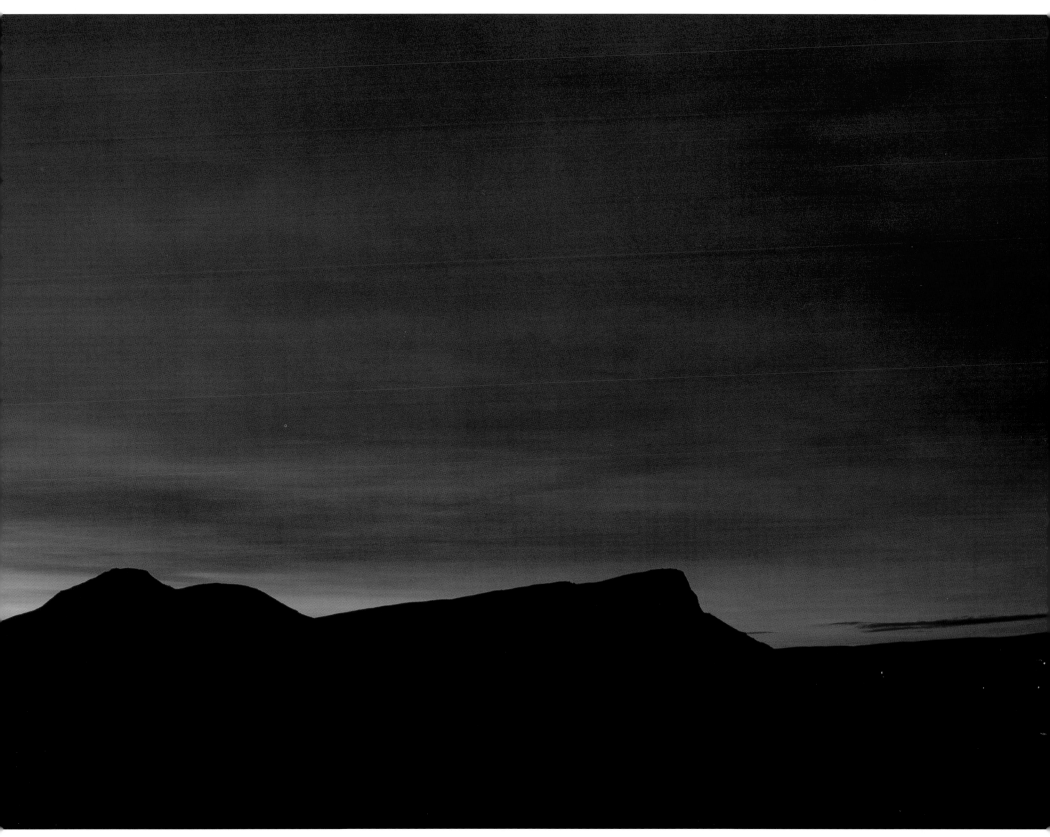

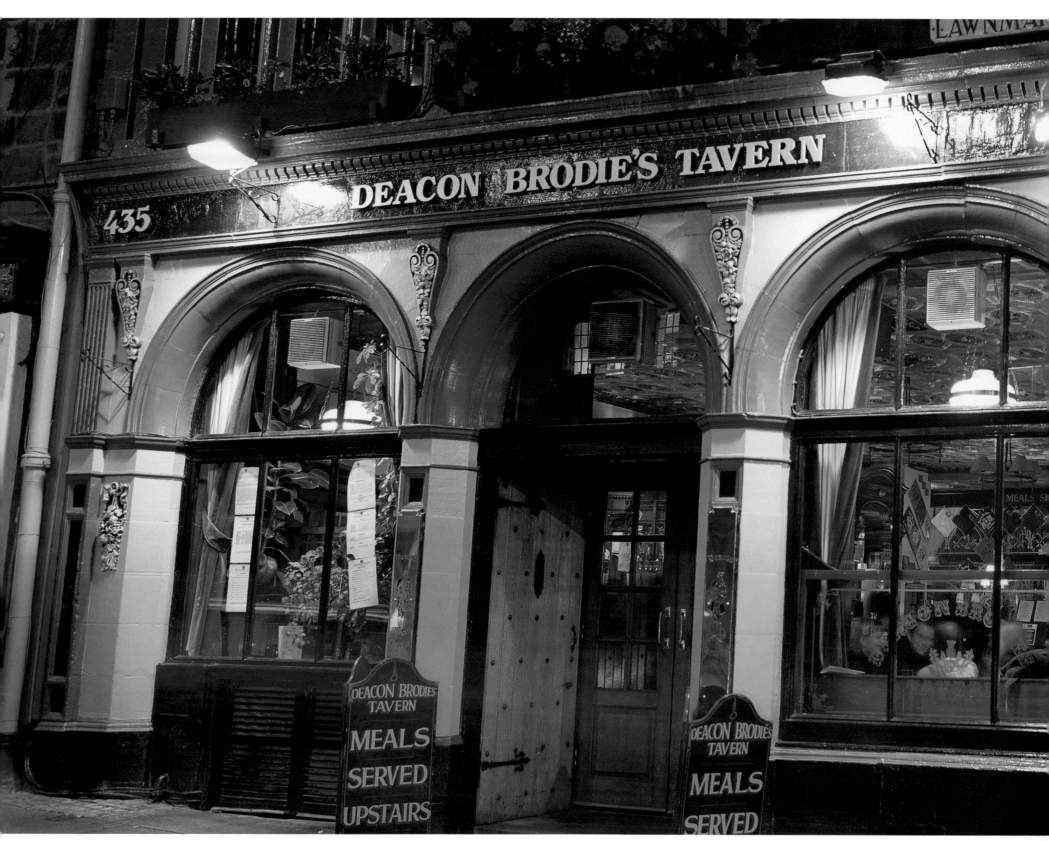

DEACON BRODIE'S TAVERN, ROYAL MILE

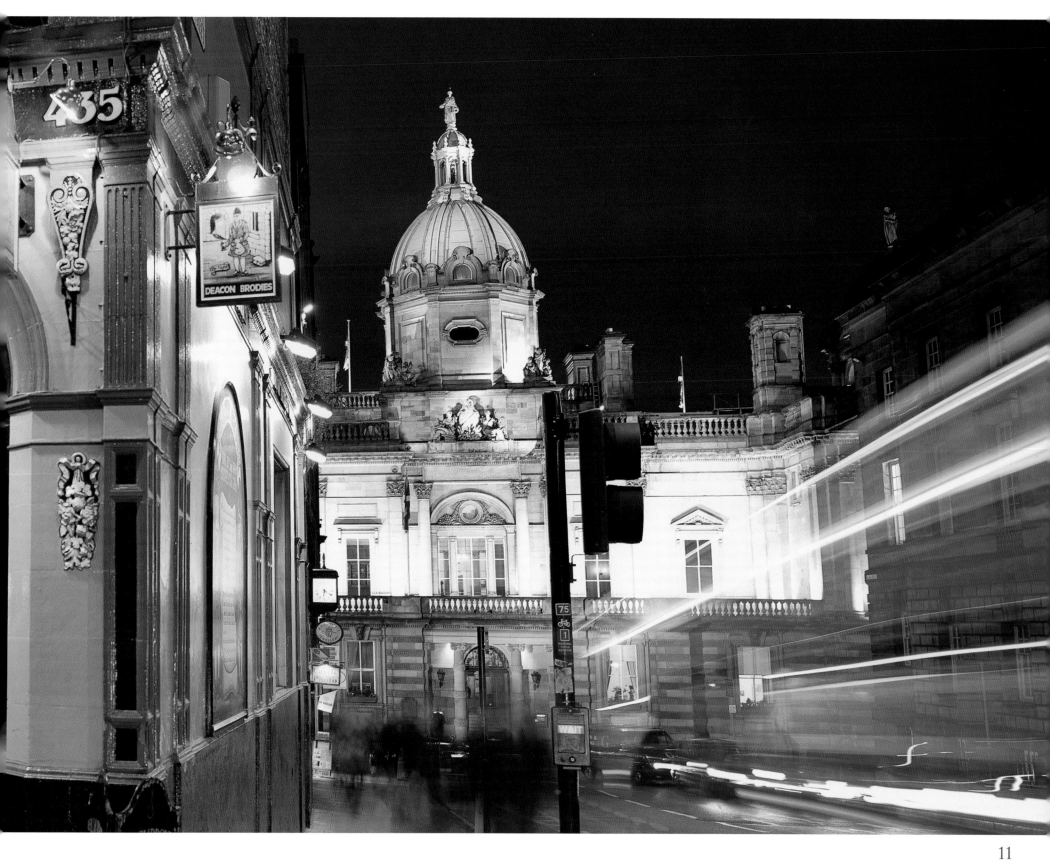

OCEAN POINT 1, LEITH

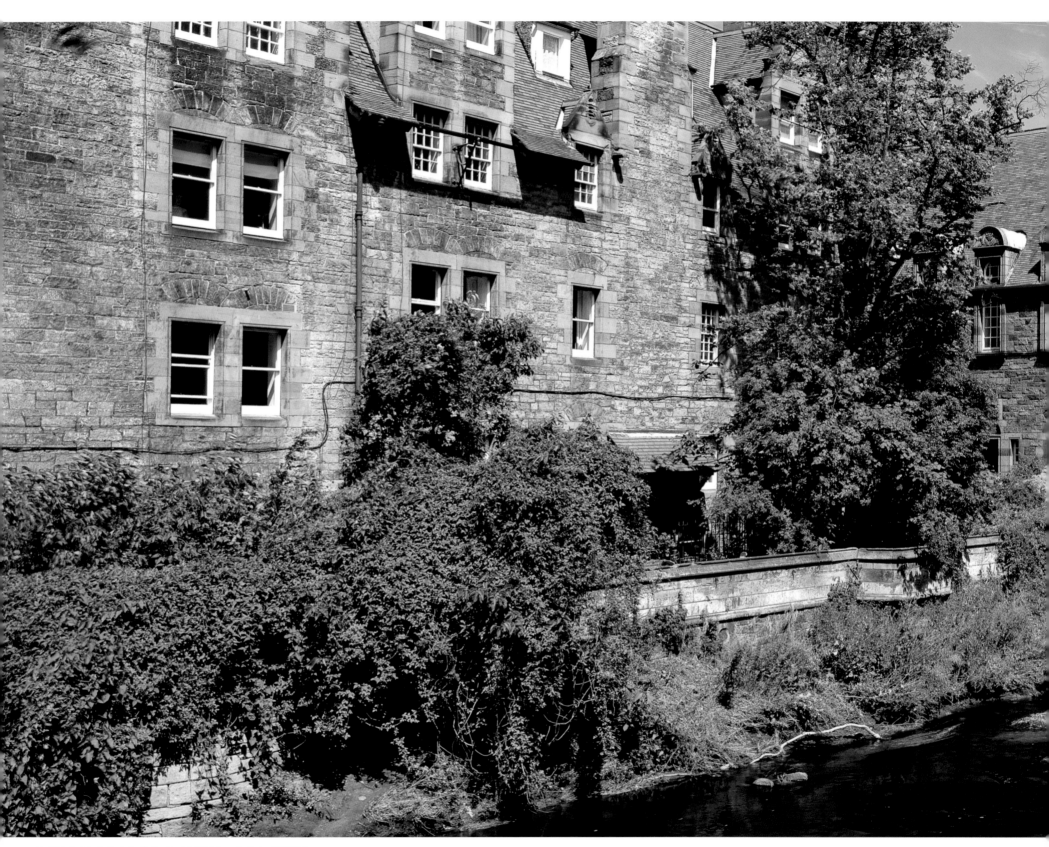

DEAN VILLAGE, WATER OF LEITH

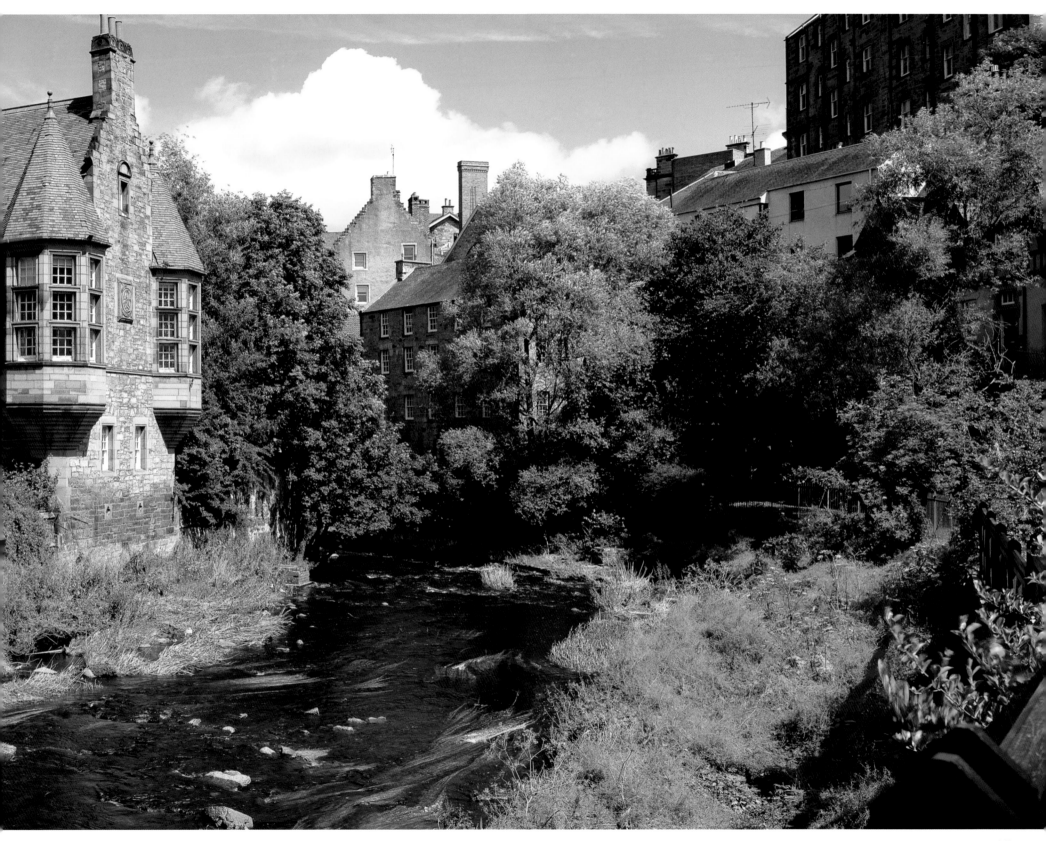

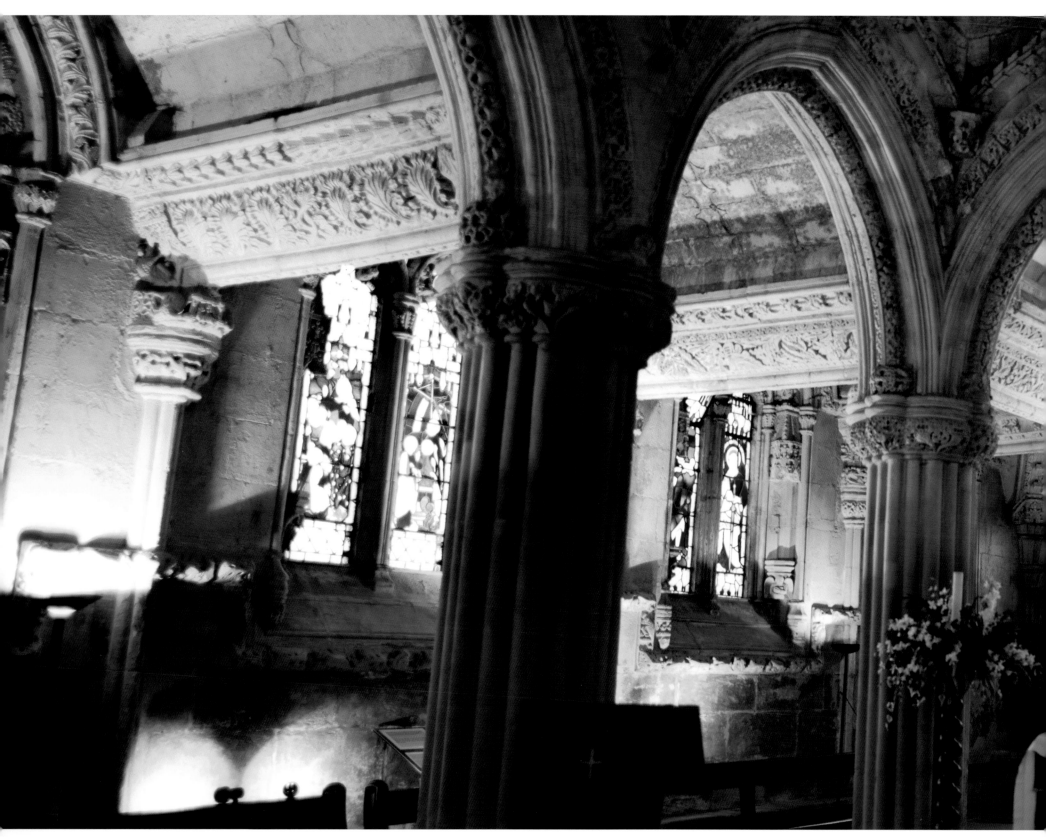

ROSSLYN CHAPEL

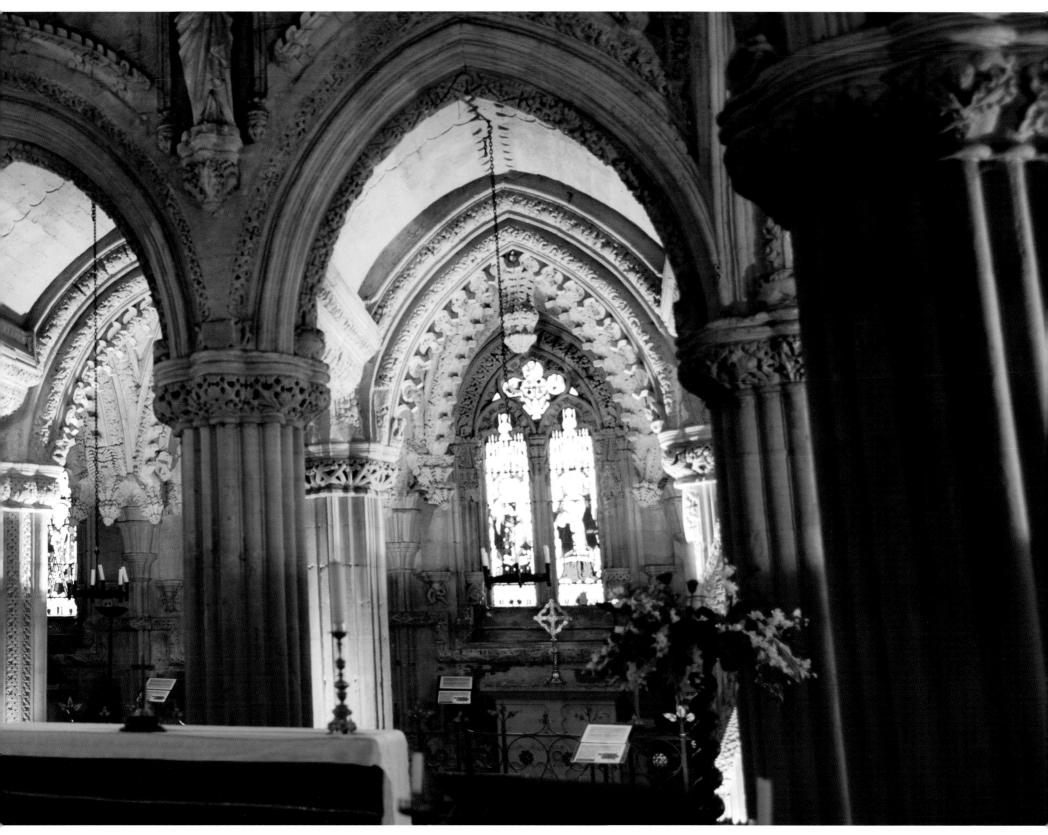

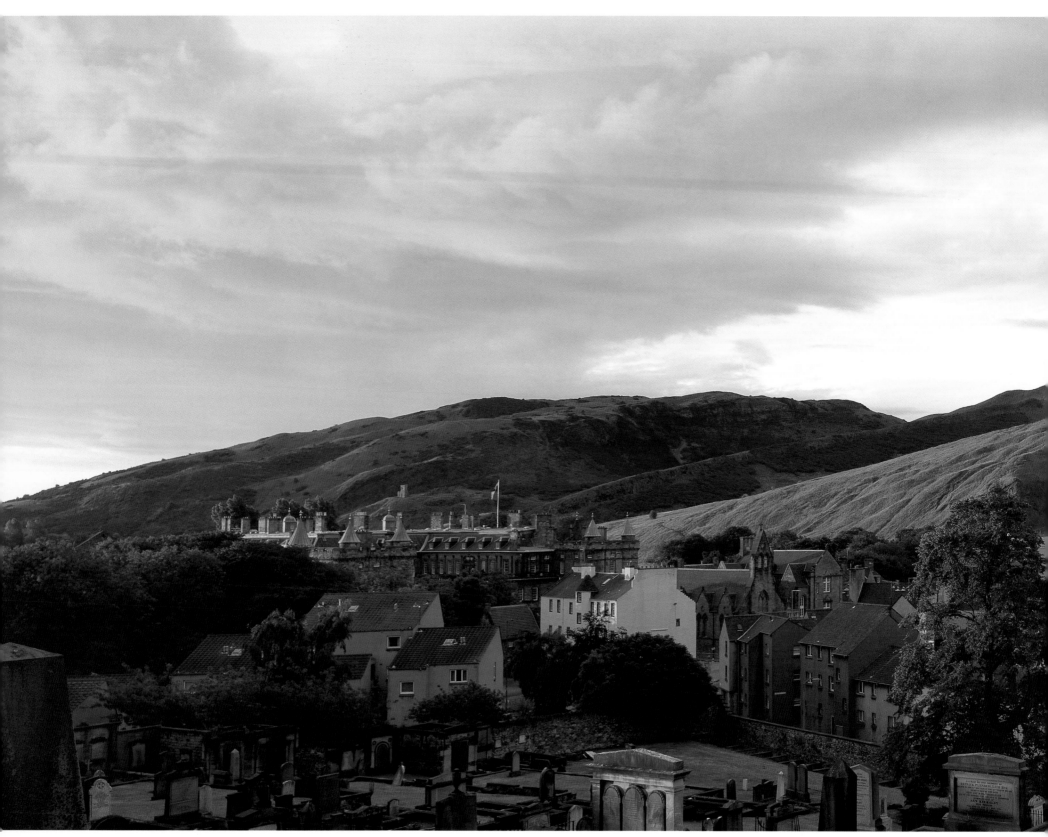

SCOTTISH PARLIAMENT, PALACE OF HOLYROOD

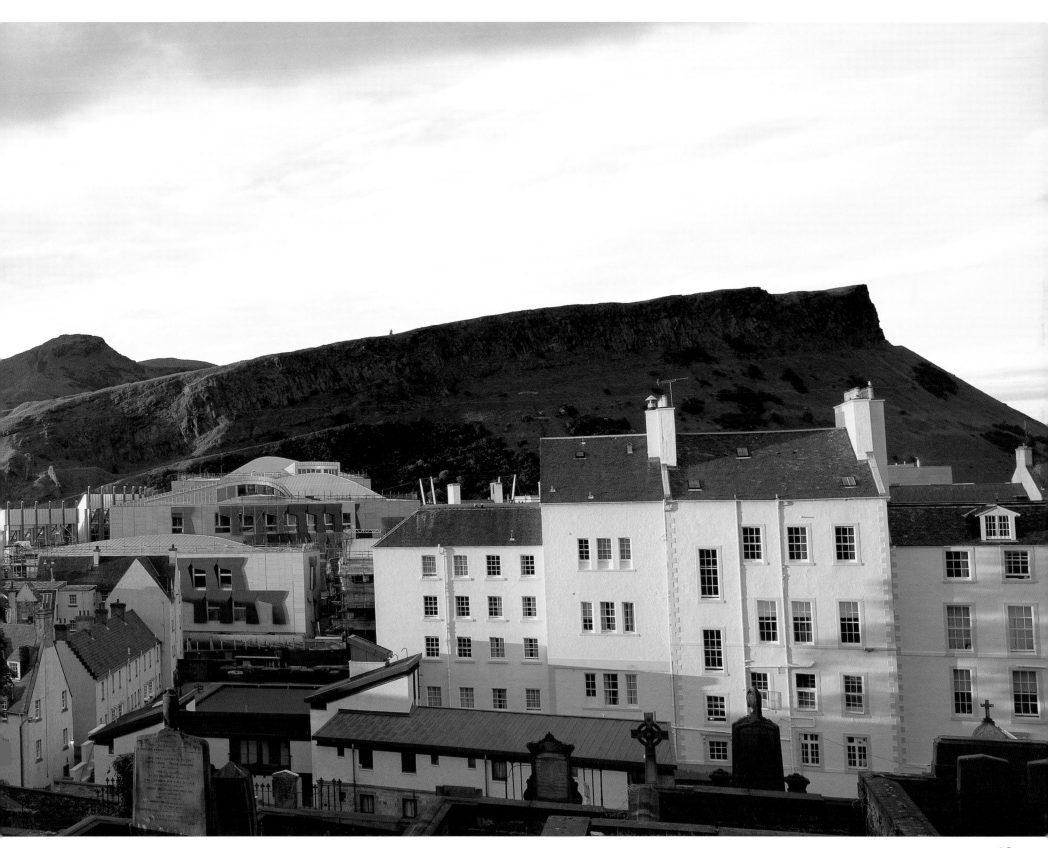

THE ROYAL YACHT *BRITANNIA*

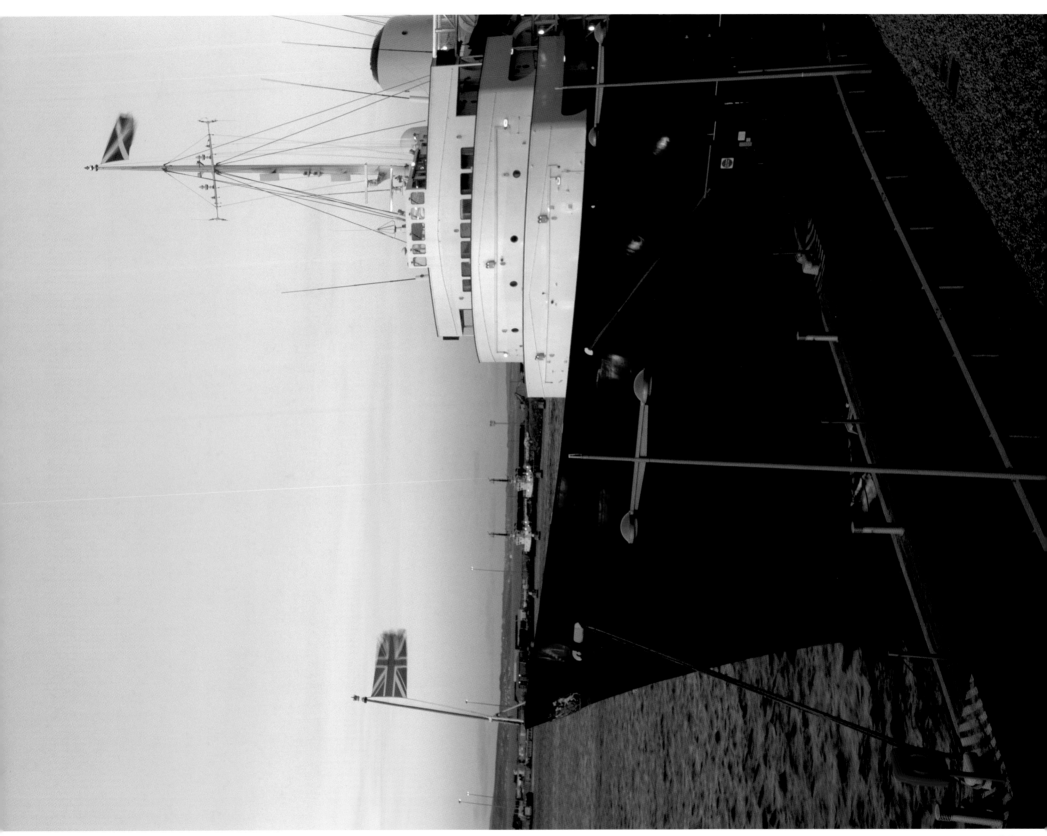

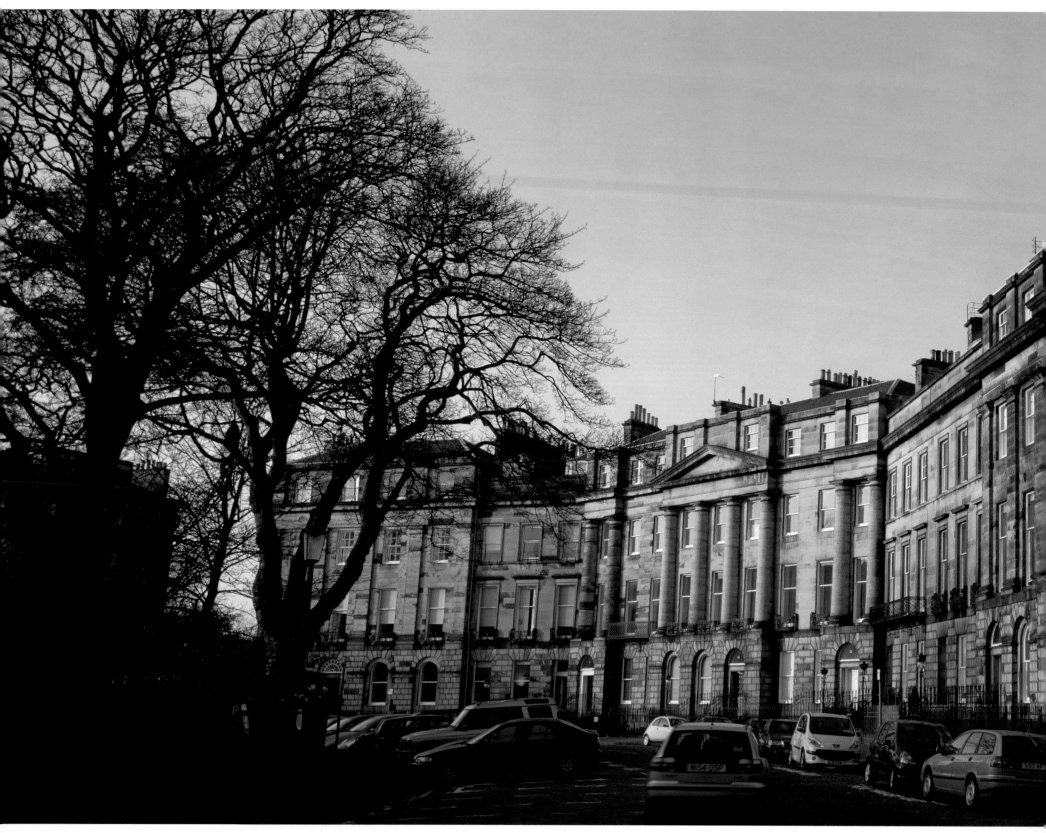

MORAY PLACE, NEW TOWN

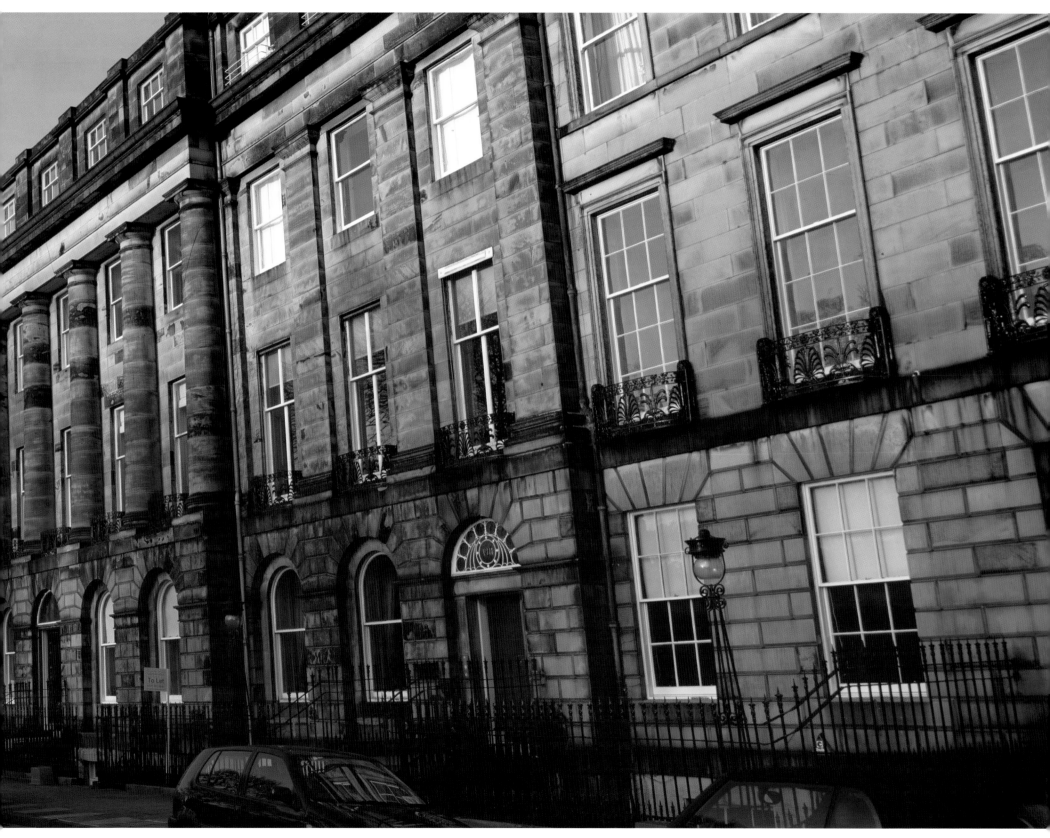

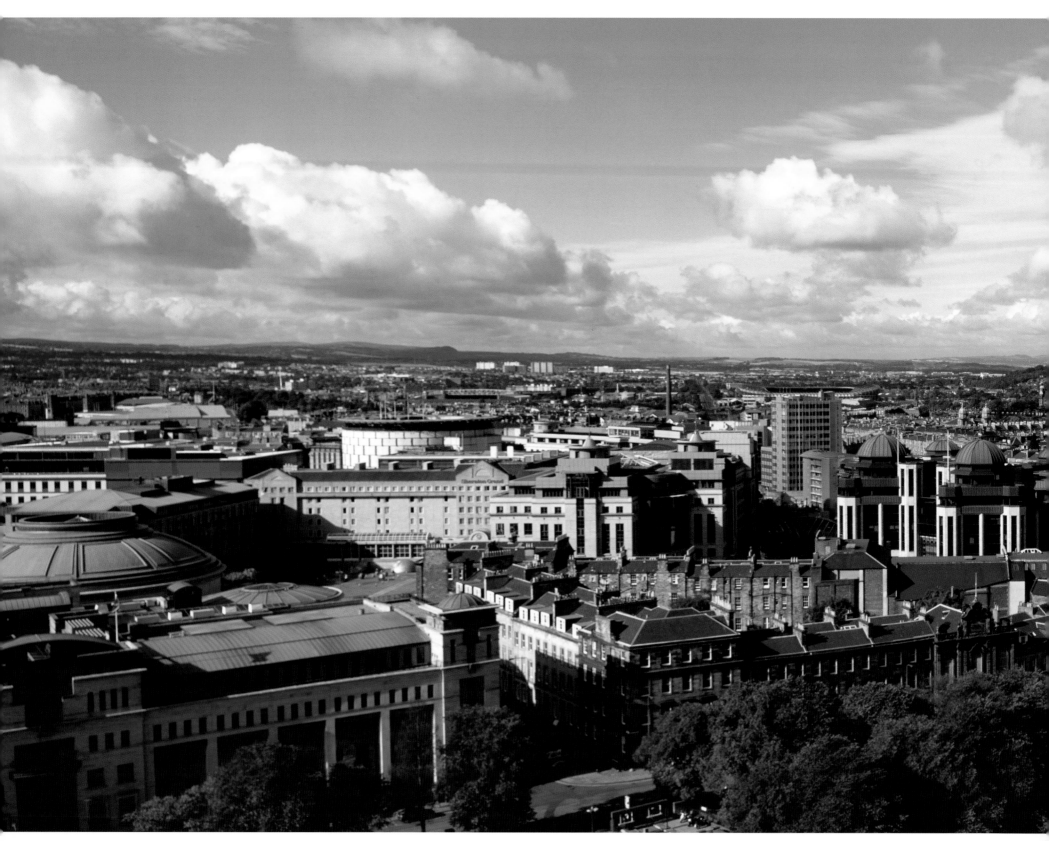

OVERLOOKING FINANCIAL DISTRICT

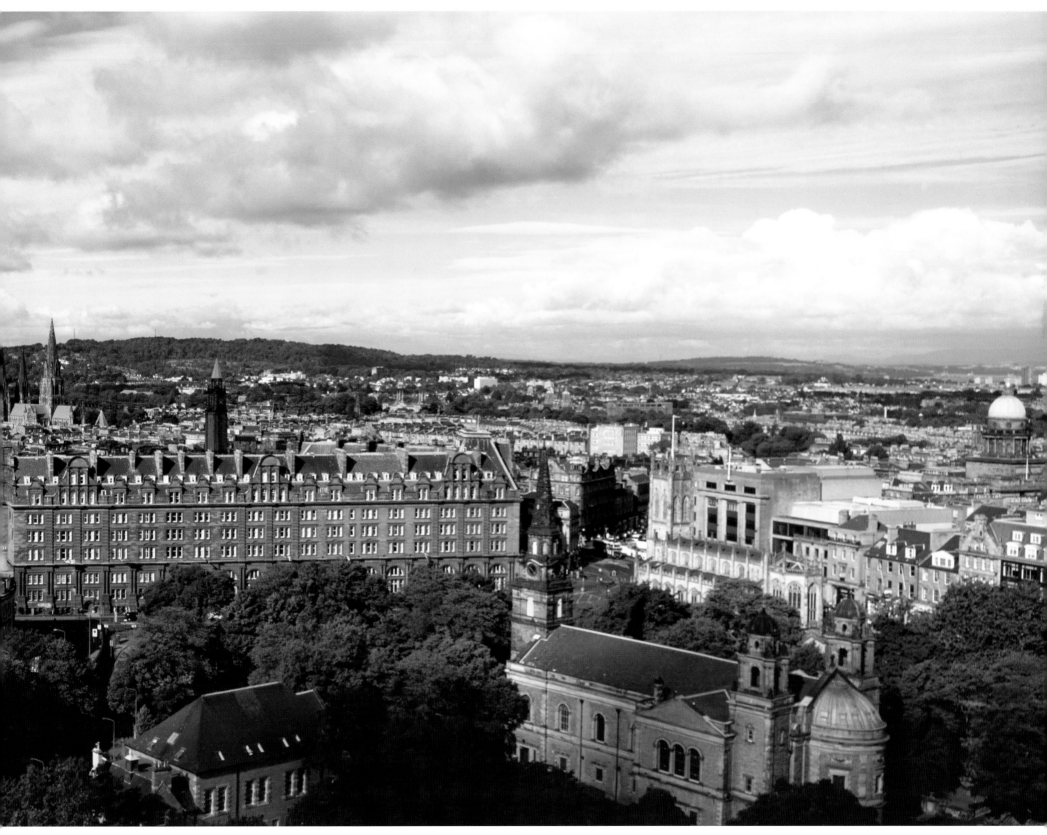

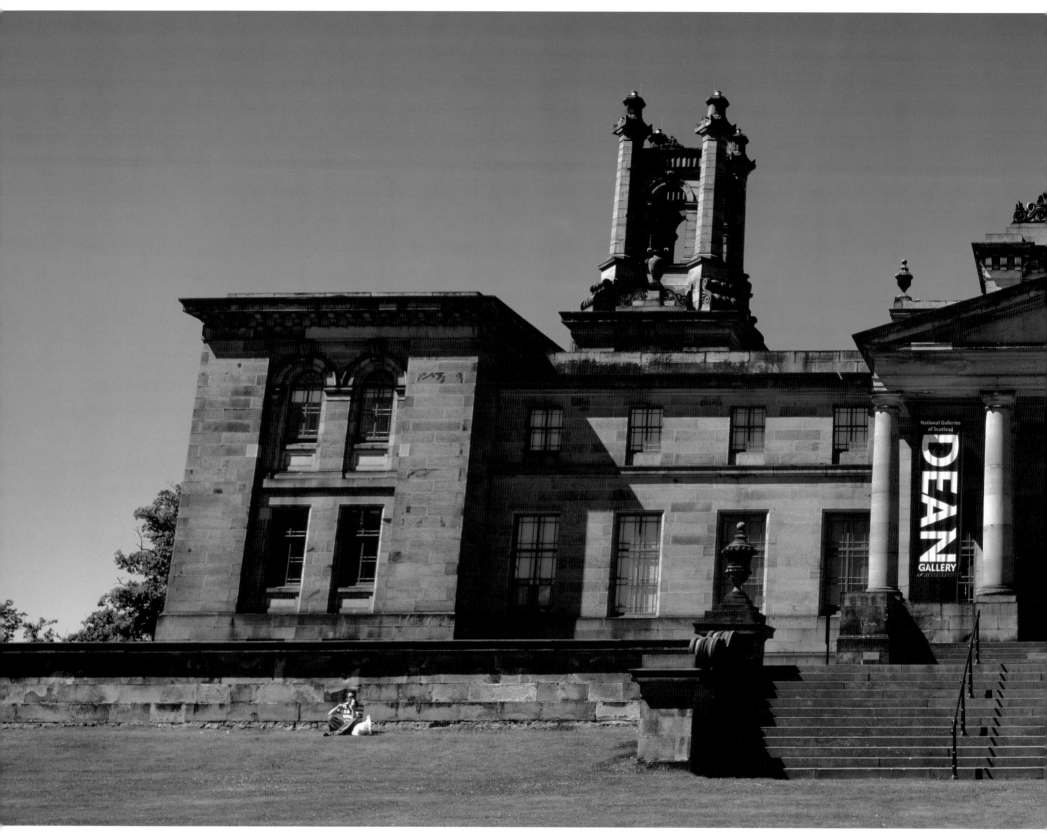

DEAN GALLERY

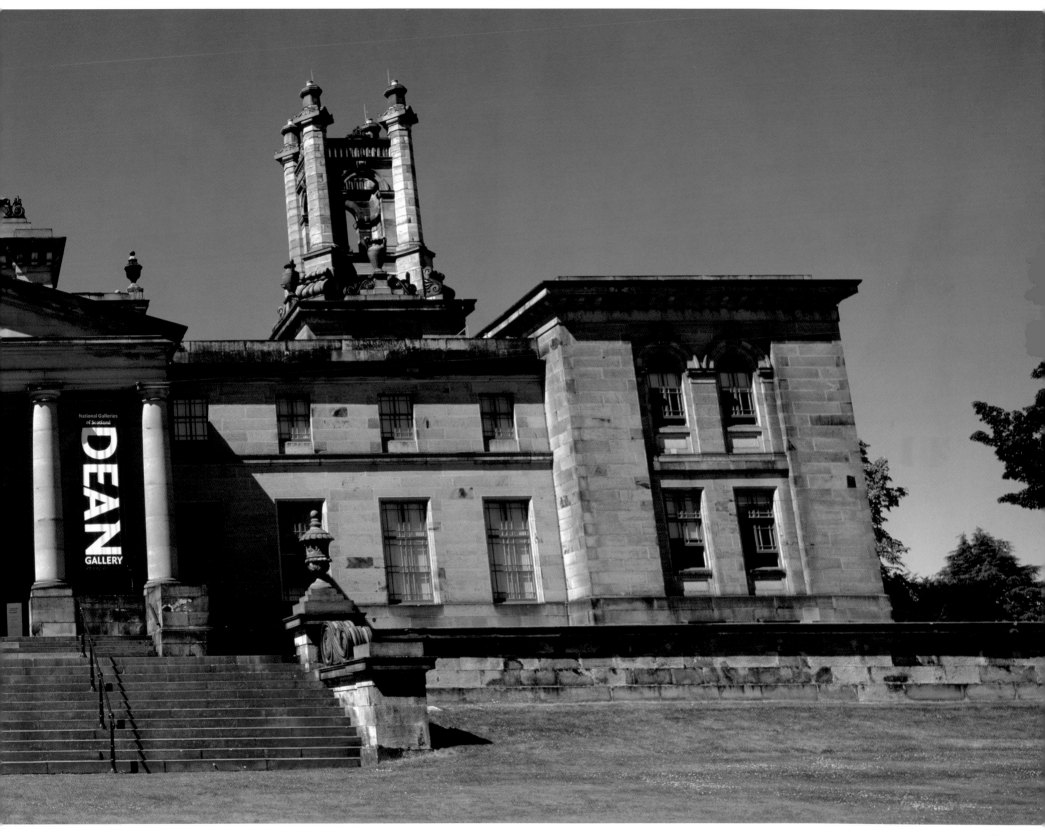

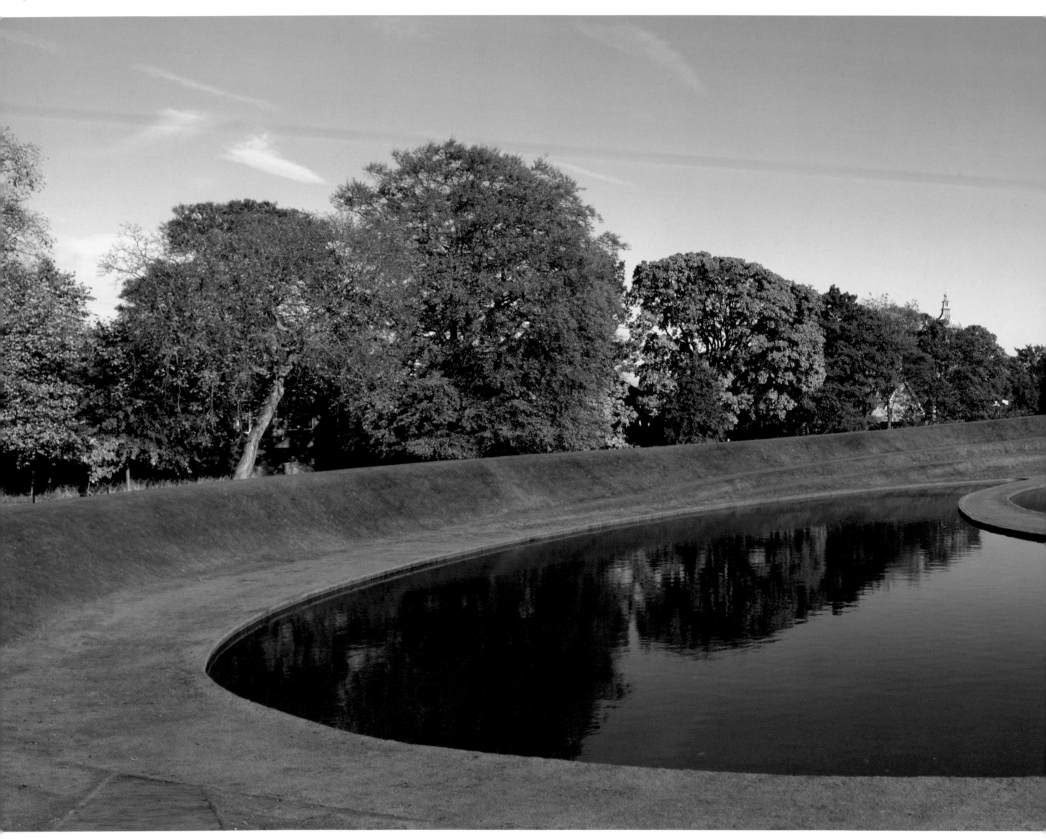

LANDFORM, SCOTTISH NATIONAL GALLERY OF MODERN ART

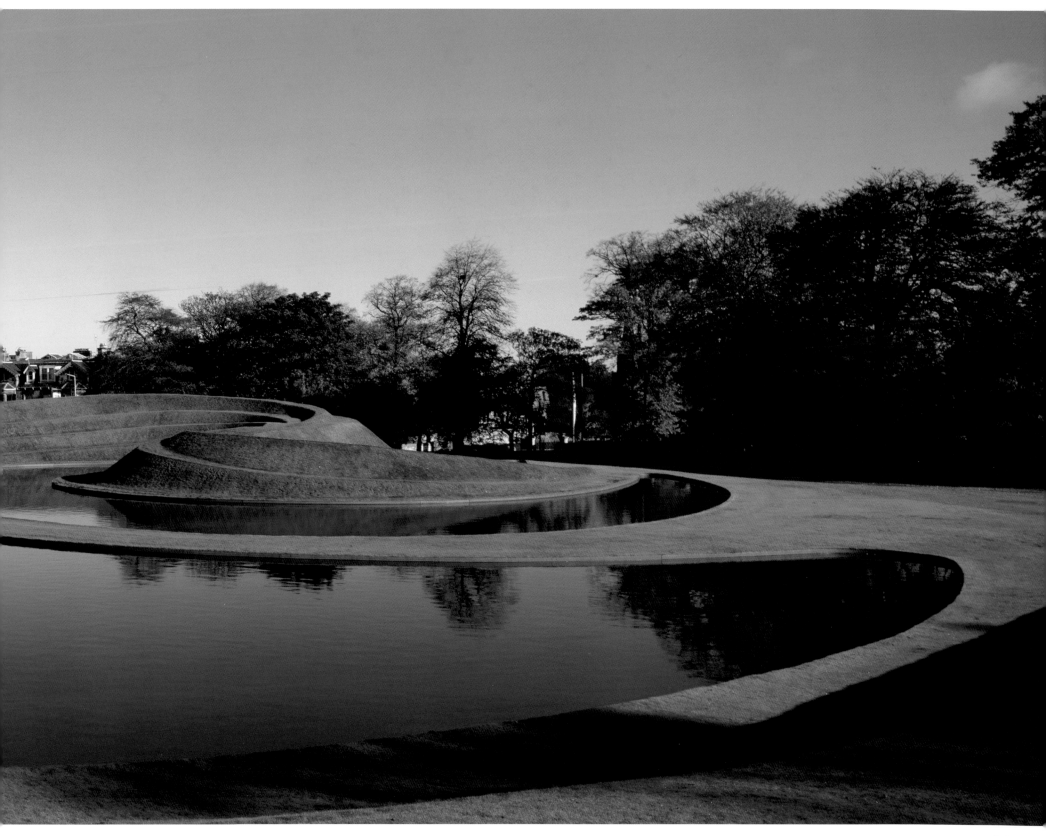

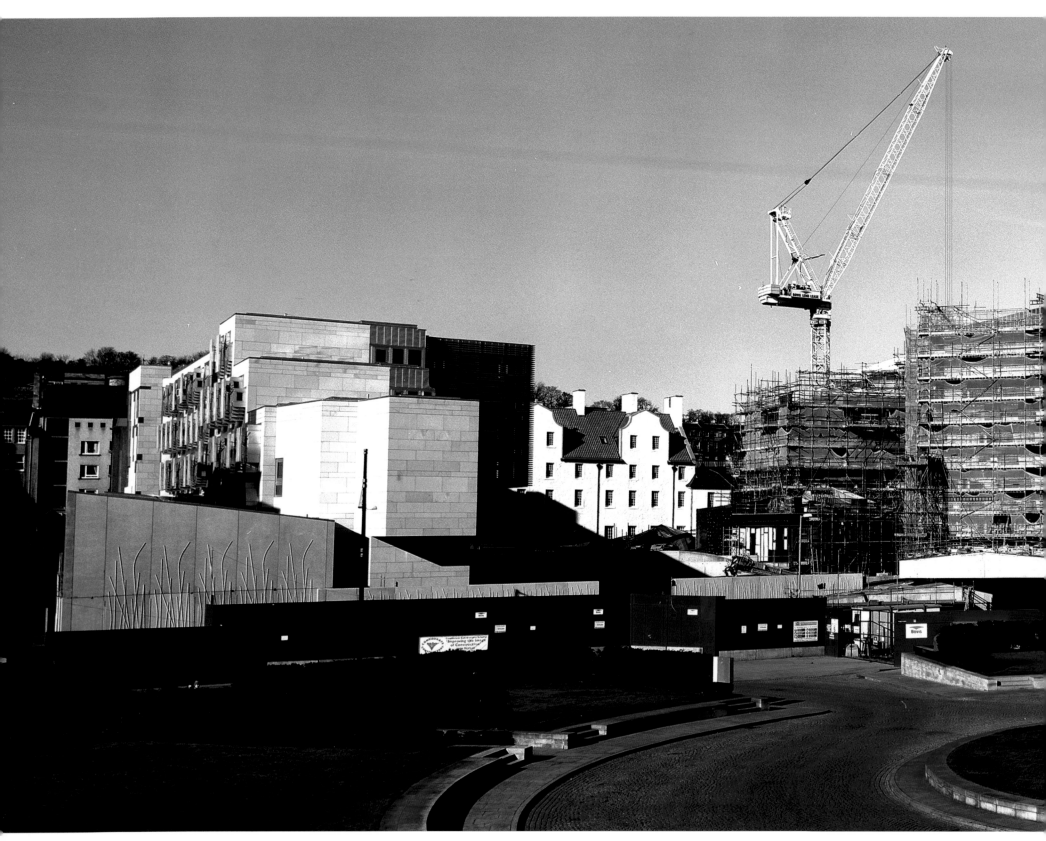

UNDER CONSTRUCTION, SCOTTISH PARLIAMENT

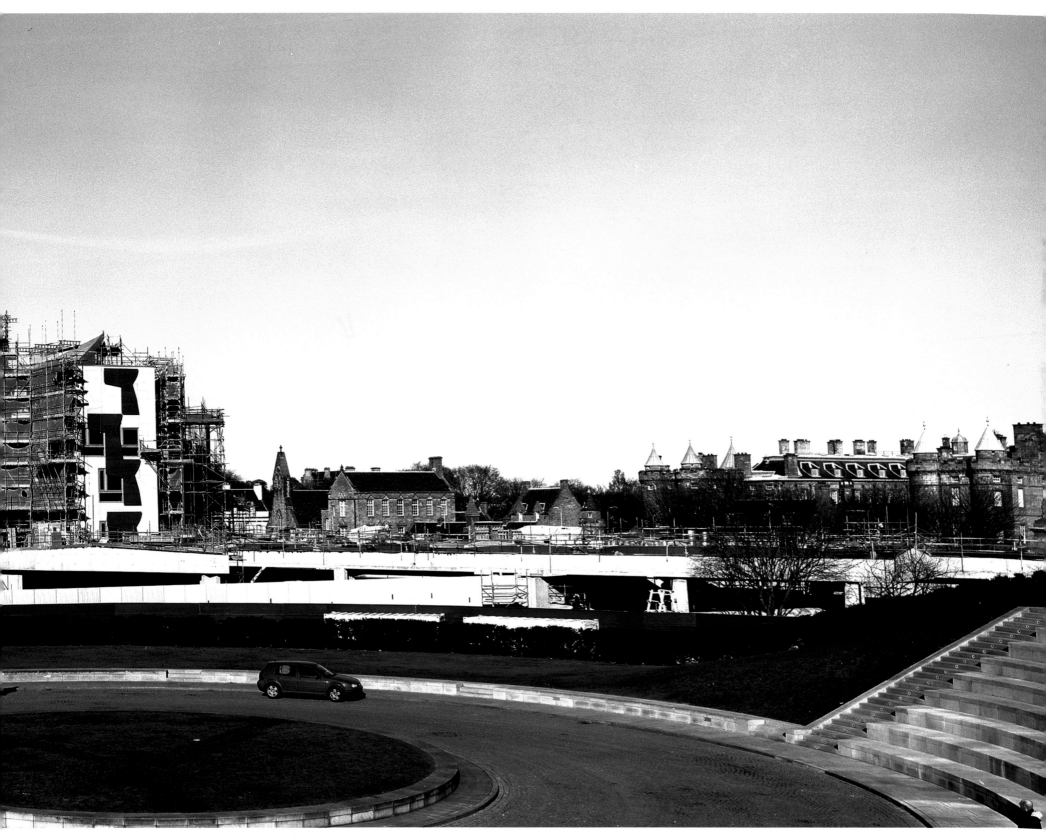

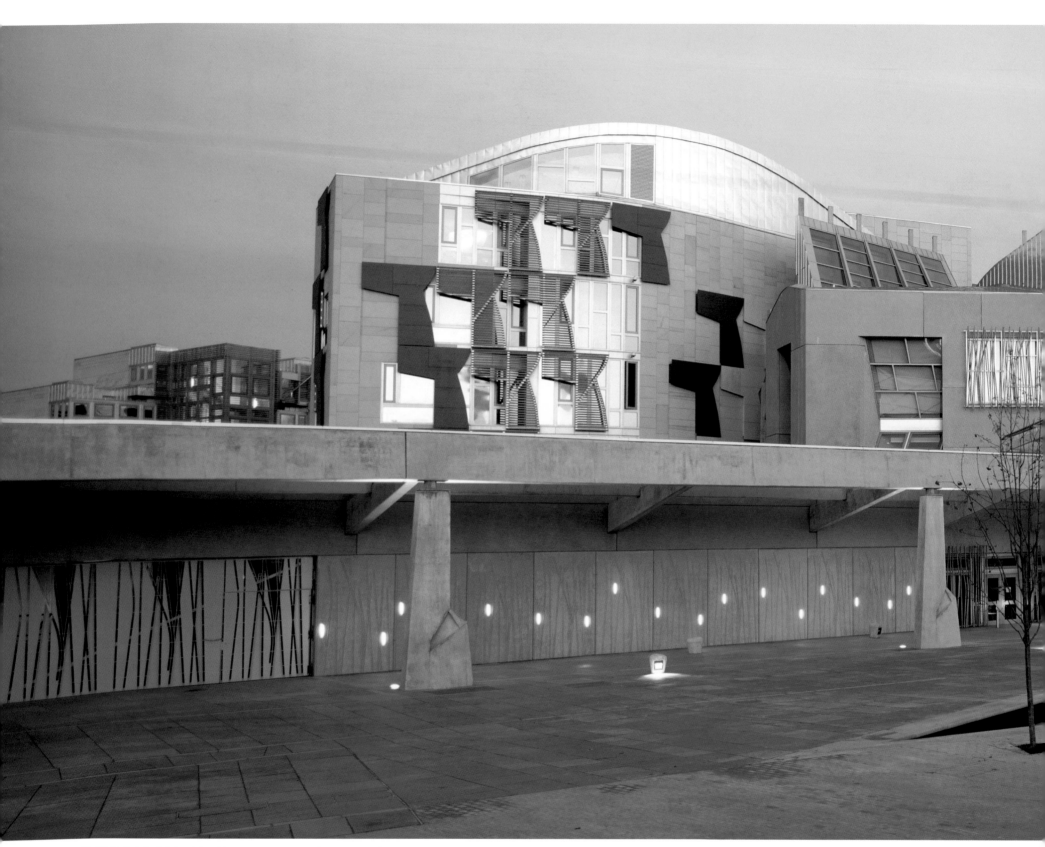

SCOTTISH PARLIAMENT, EARLY MORNING

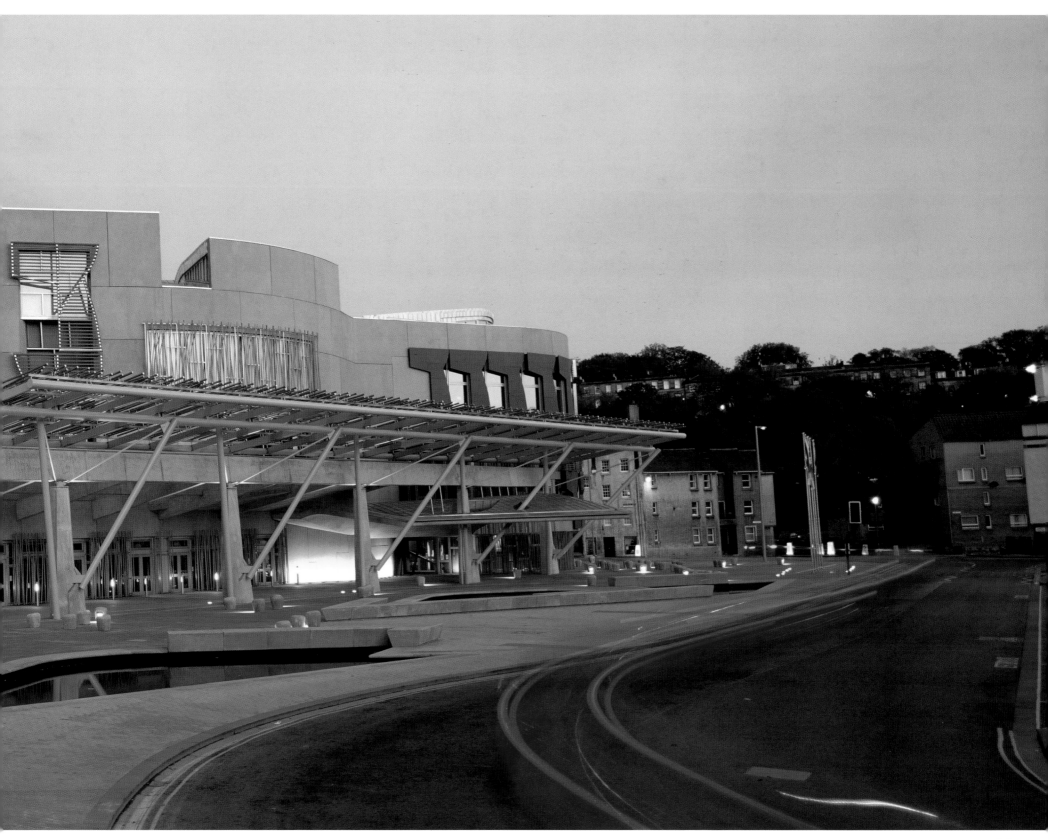

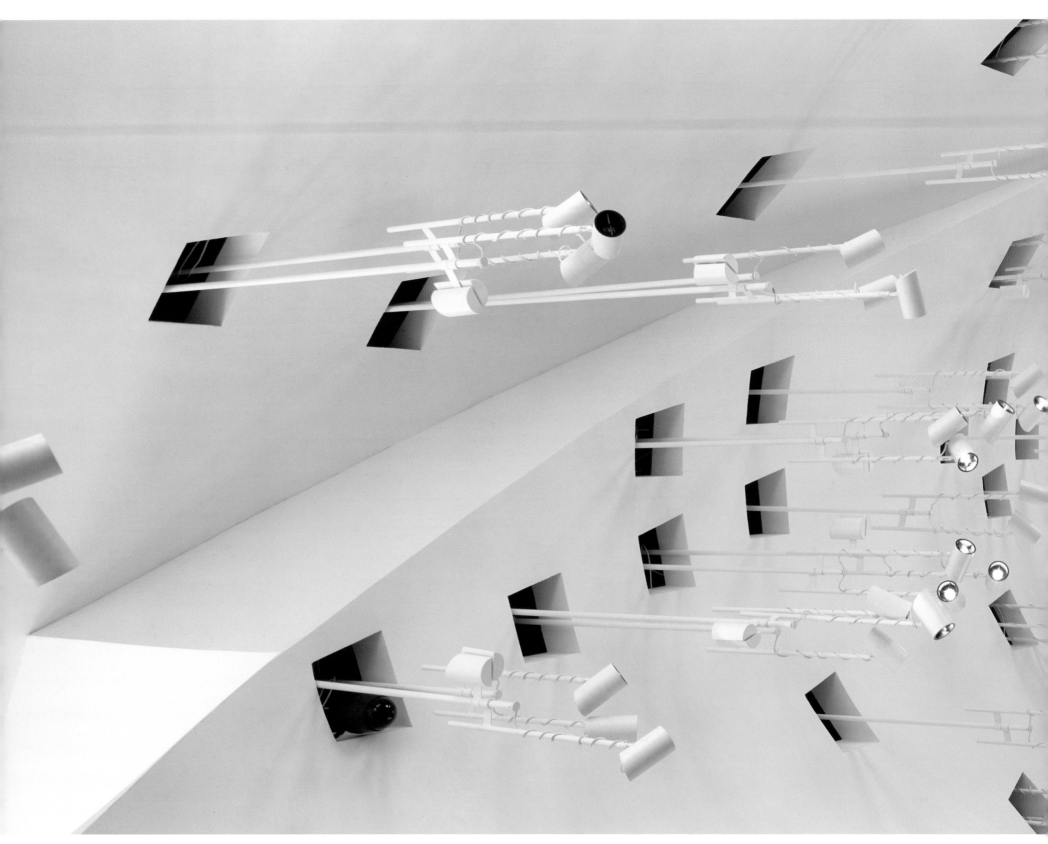

LARGE COMMITTEE ROOM, SCOTTISH PARLIAMENT

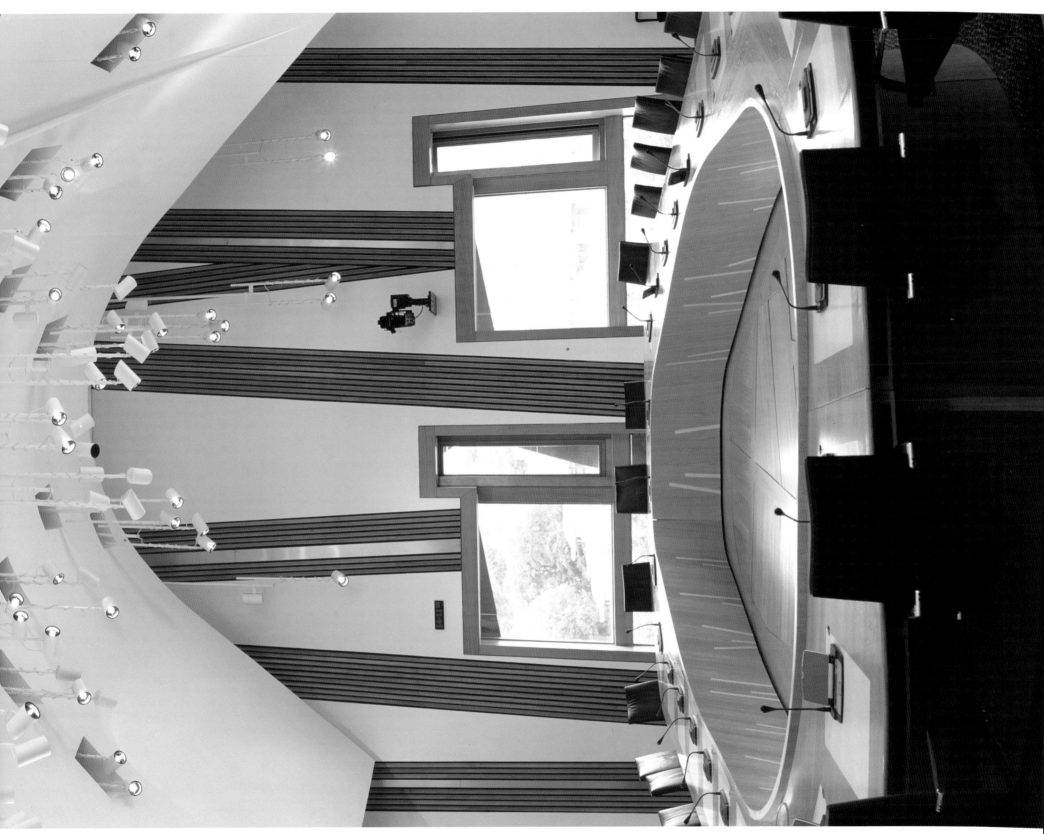

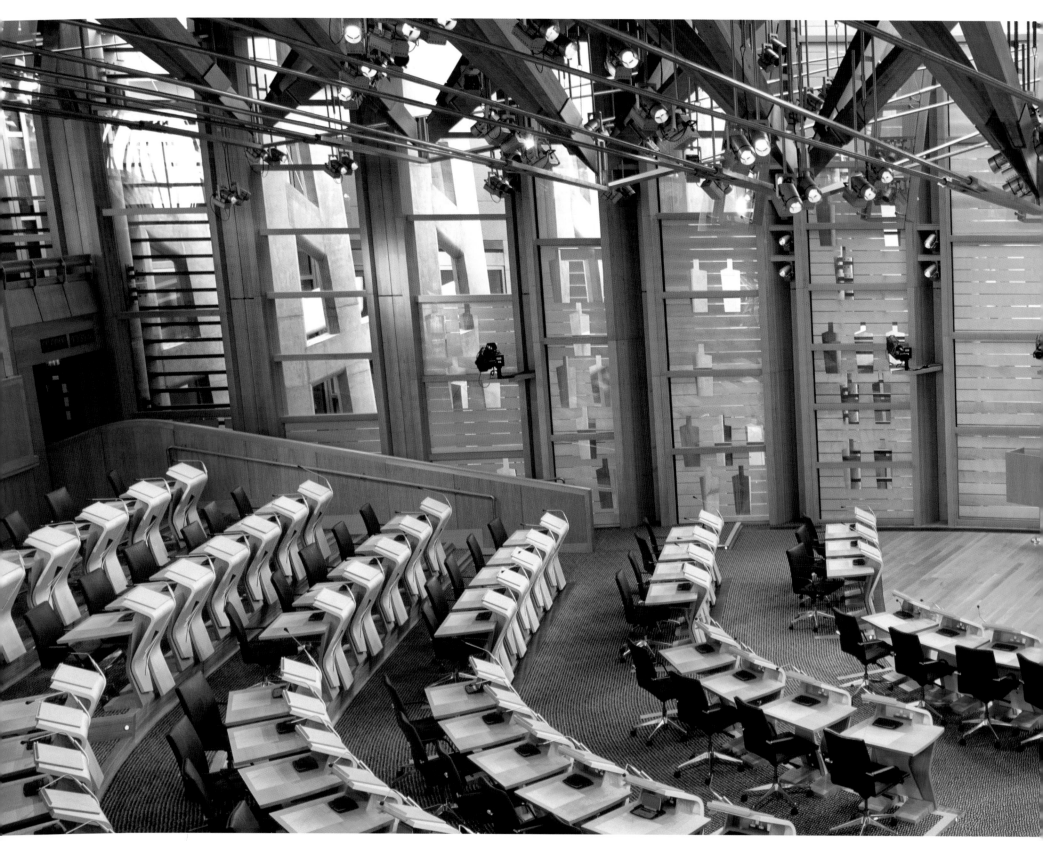

DEBATING CHAMBER, SCOTTISH PARLIAMENT

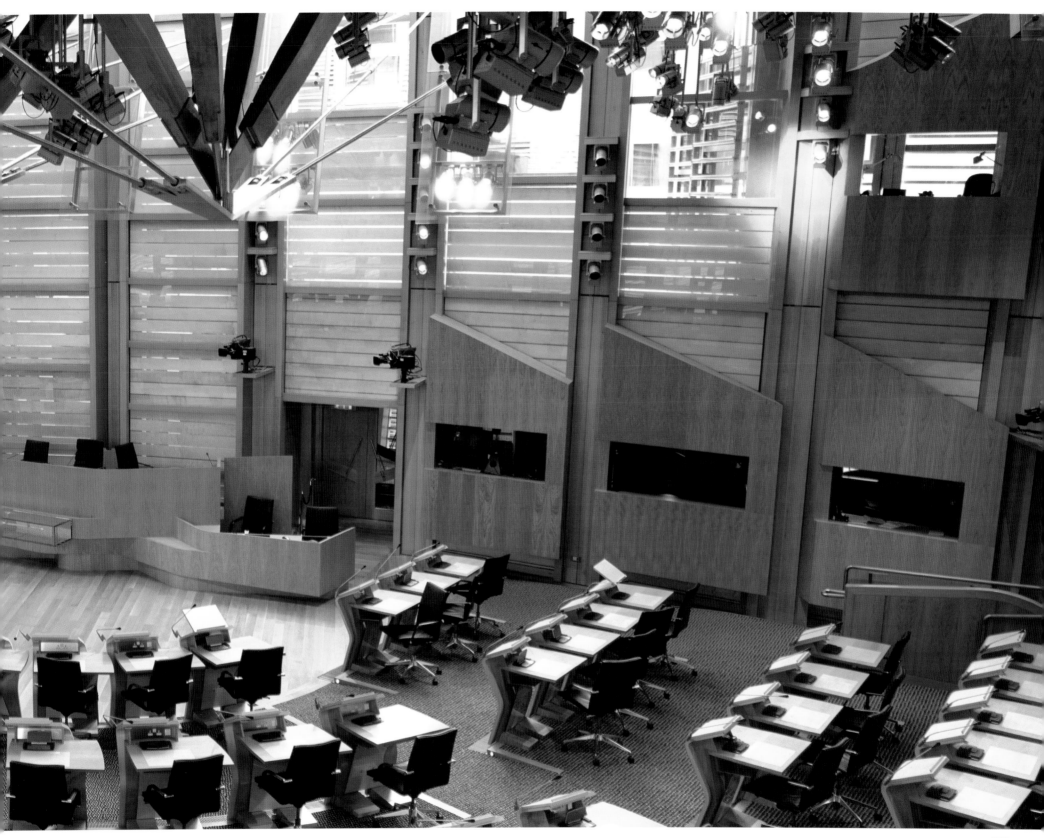

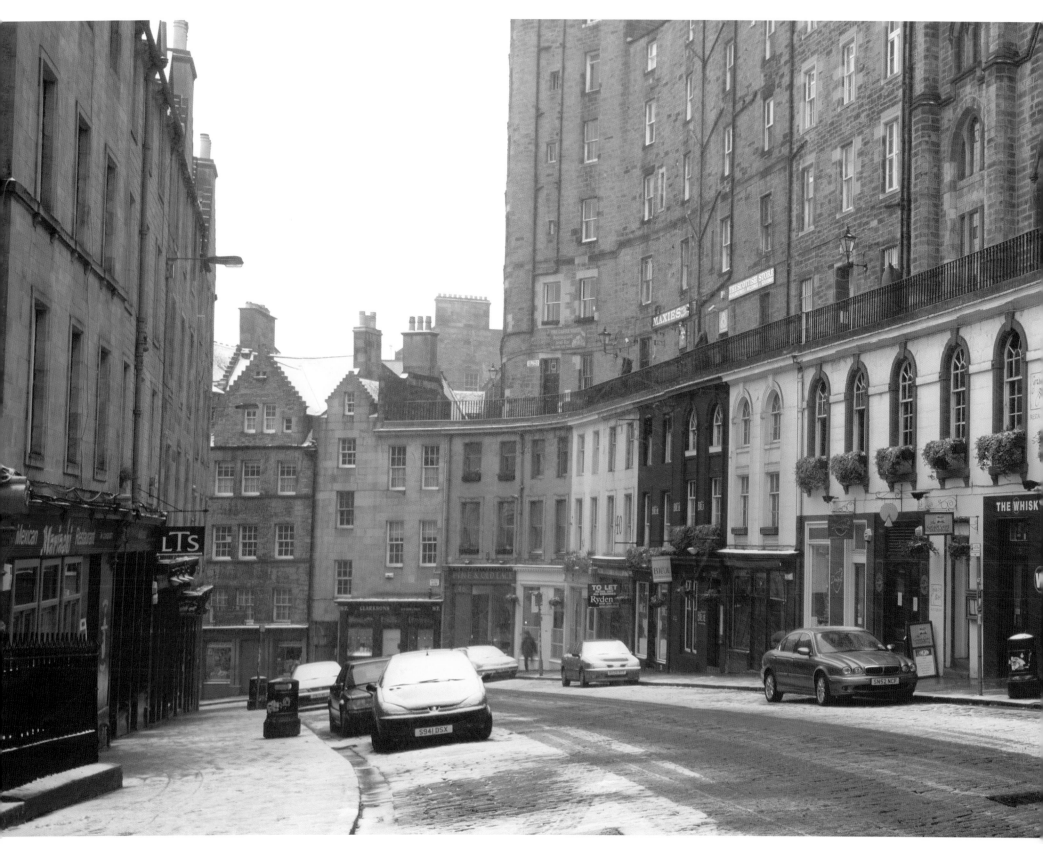

VICTORIA STREET

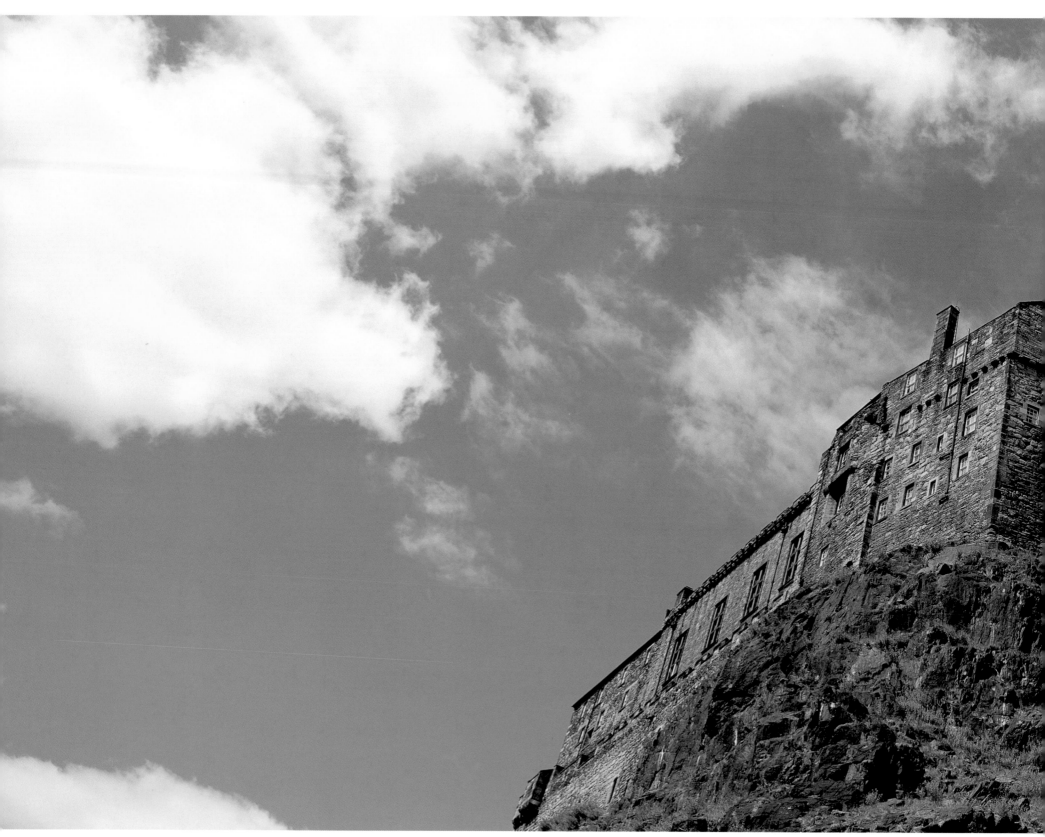

EDINBURGH CASTLE

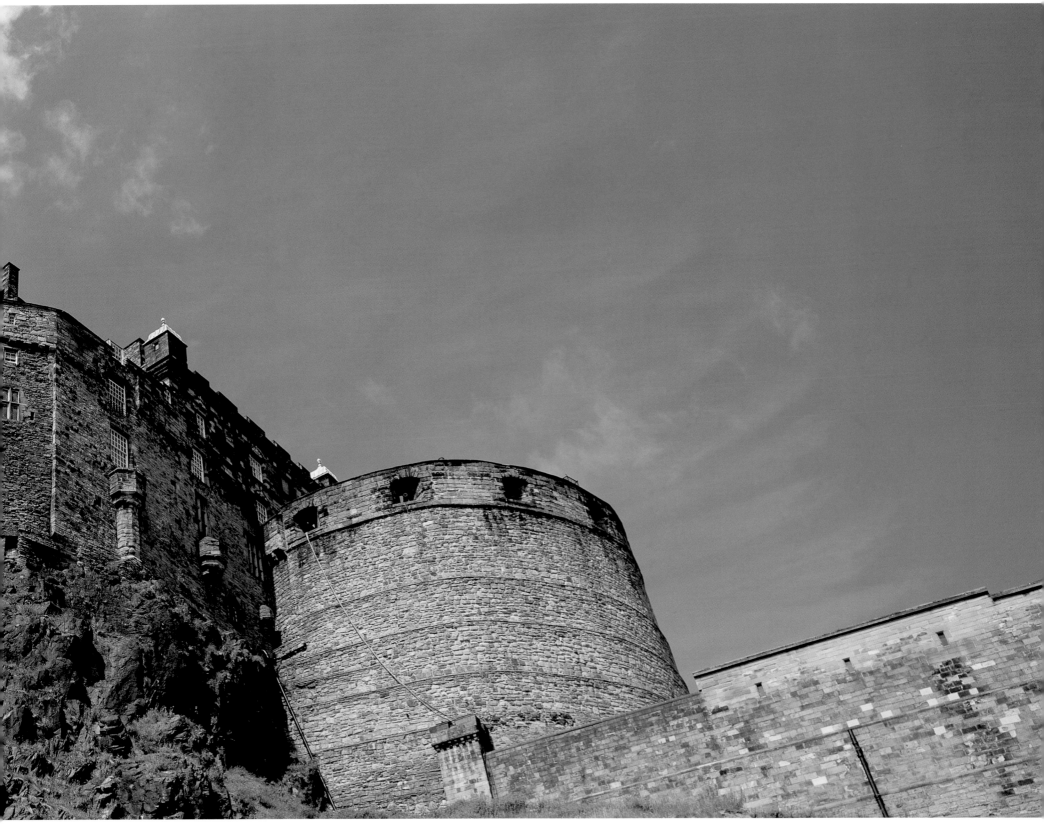

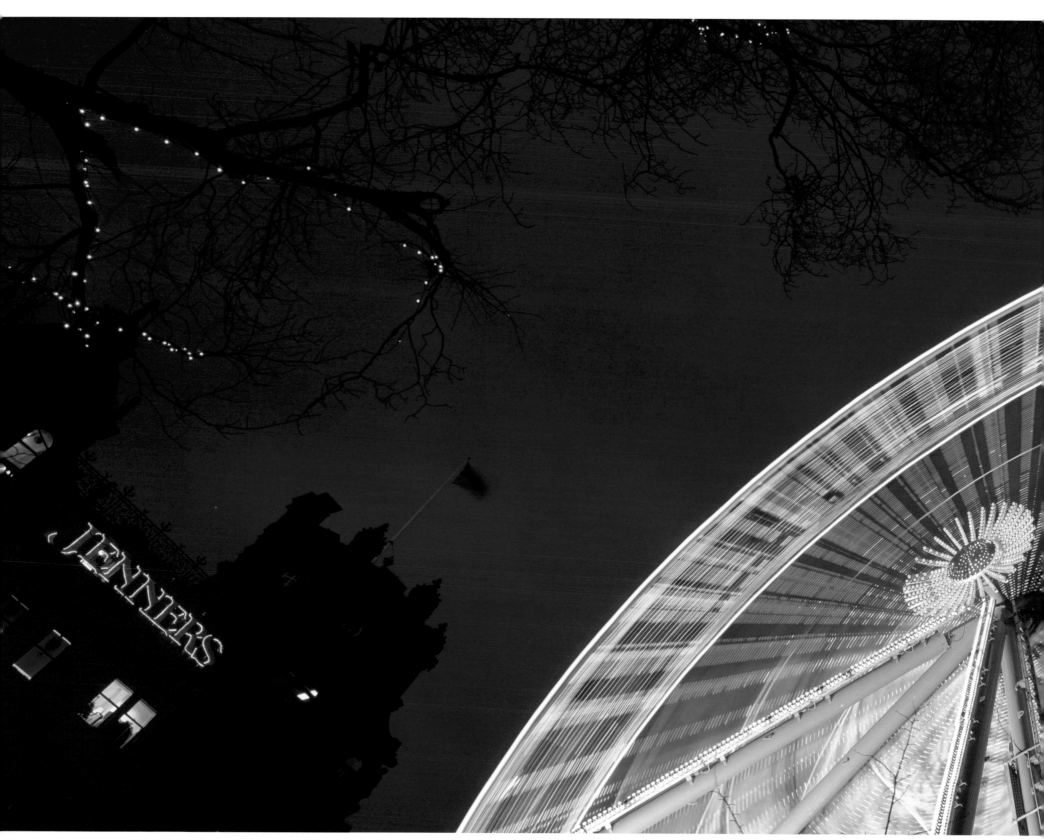

CHRISTMAS FERRIS WHEEL, PRINCES STREET GARDENS

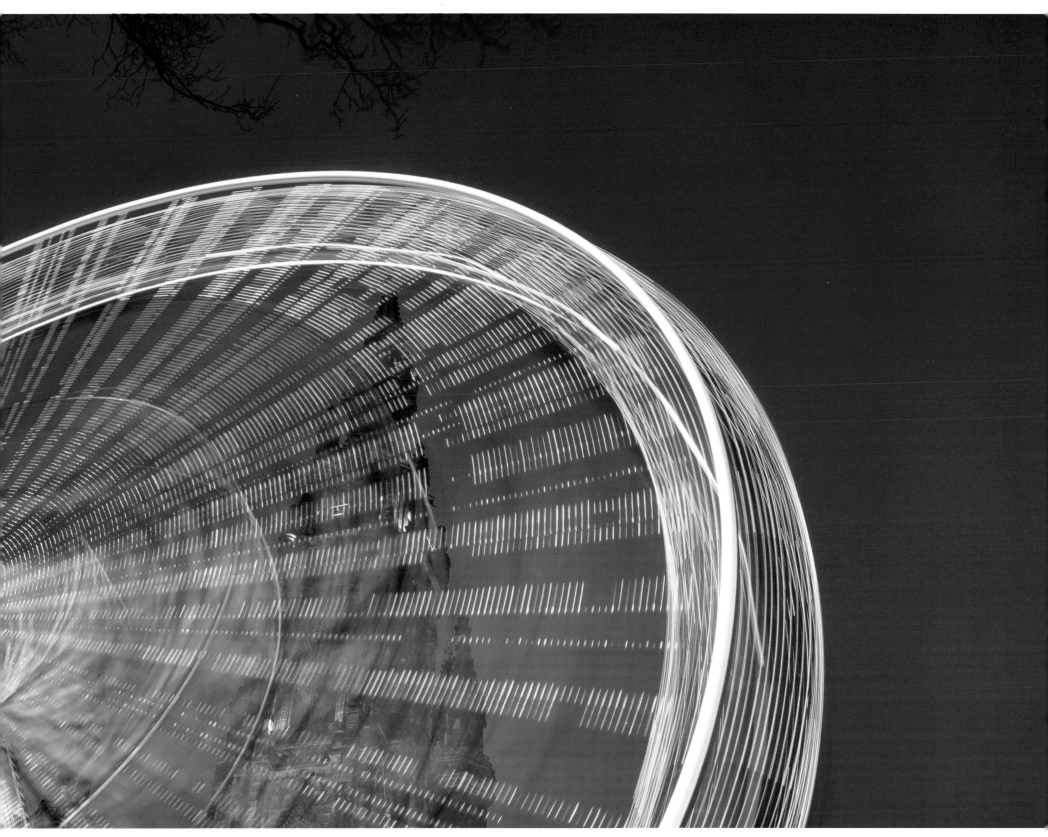

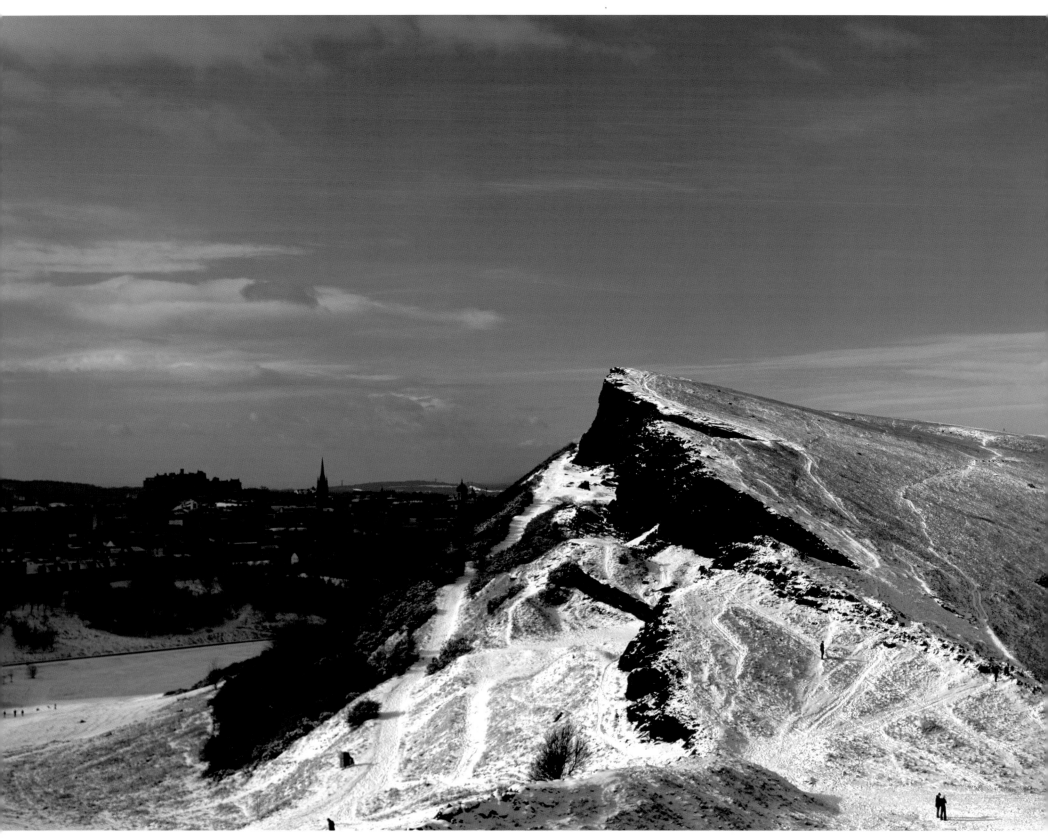

SNOW ON SALISBURY CRAGS

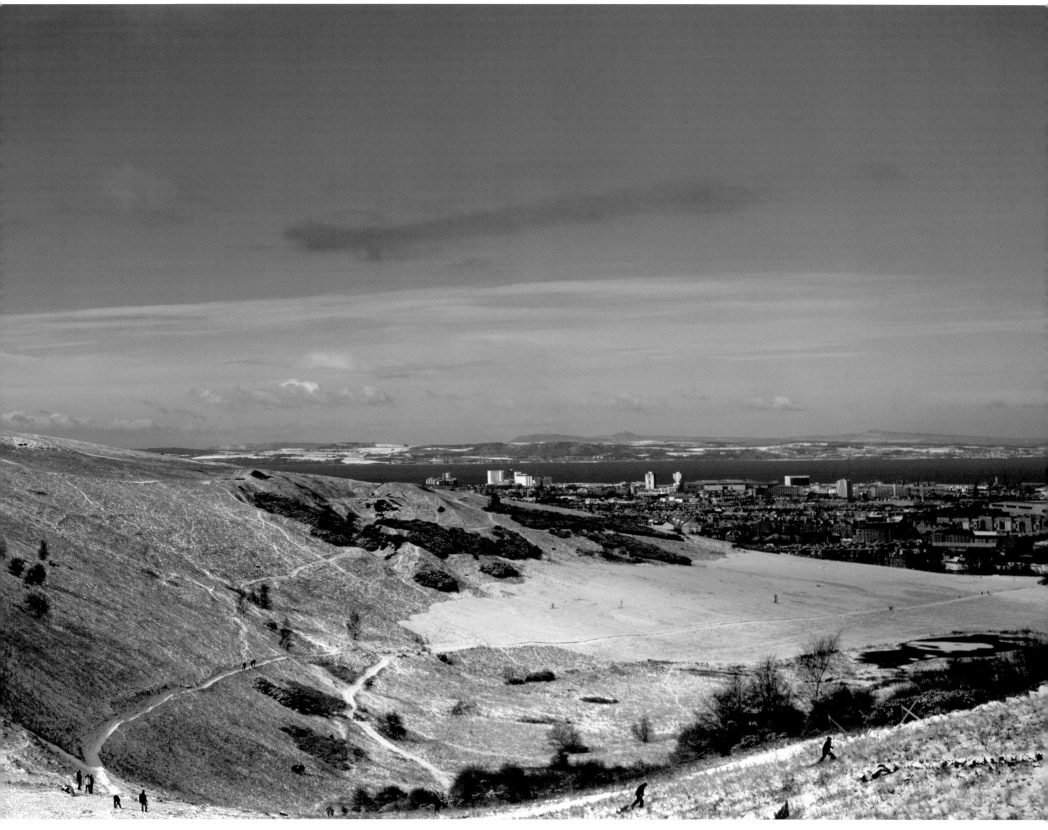

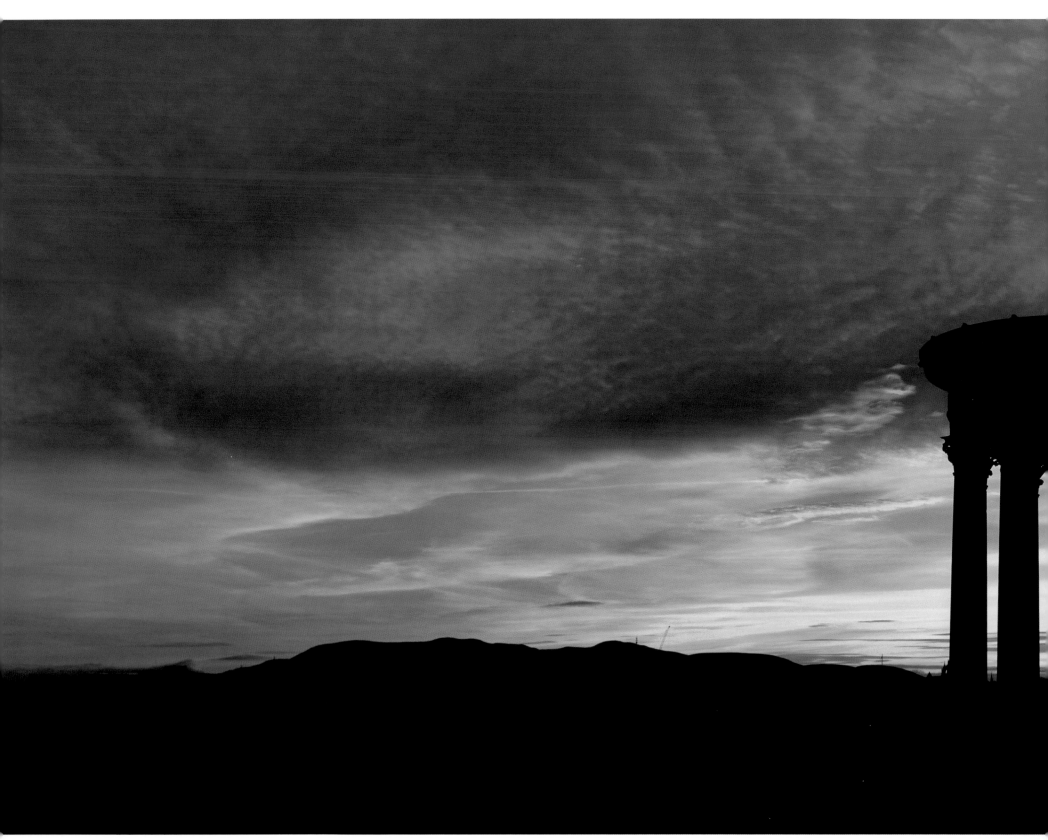

DUGALD STEWART MONUMENT, CALTON HILL

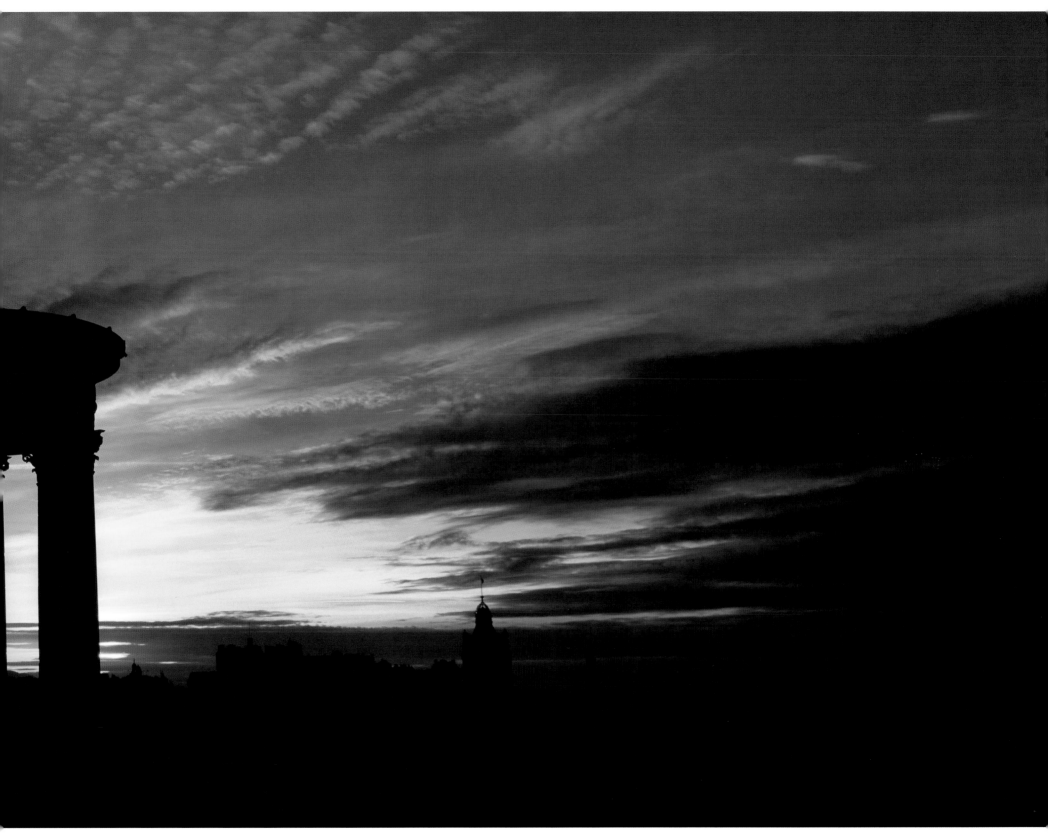

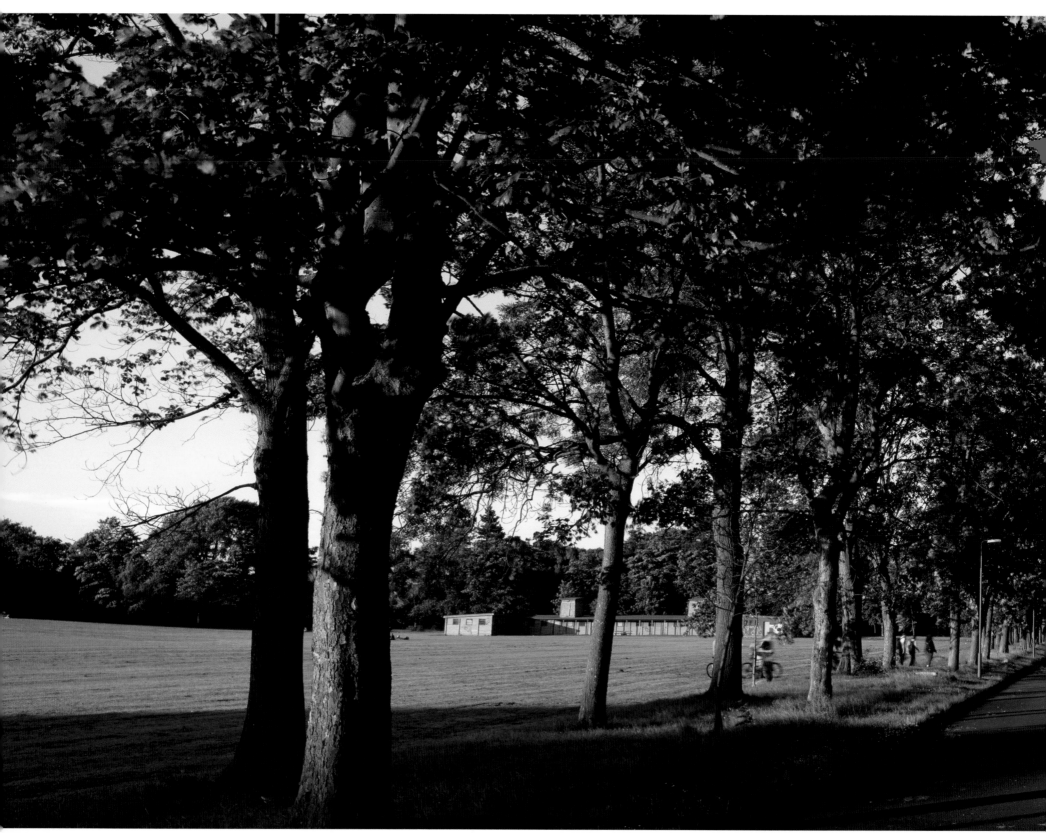

MIDSUMMER IN INVERLEITH PARK

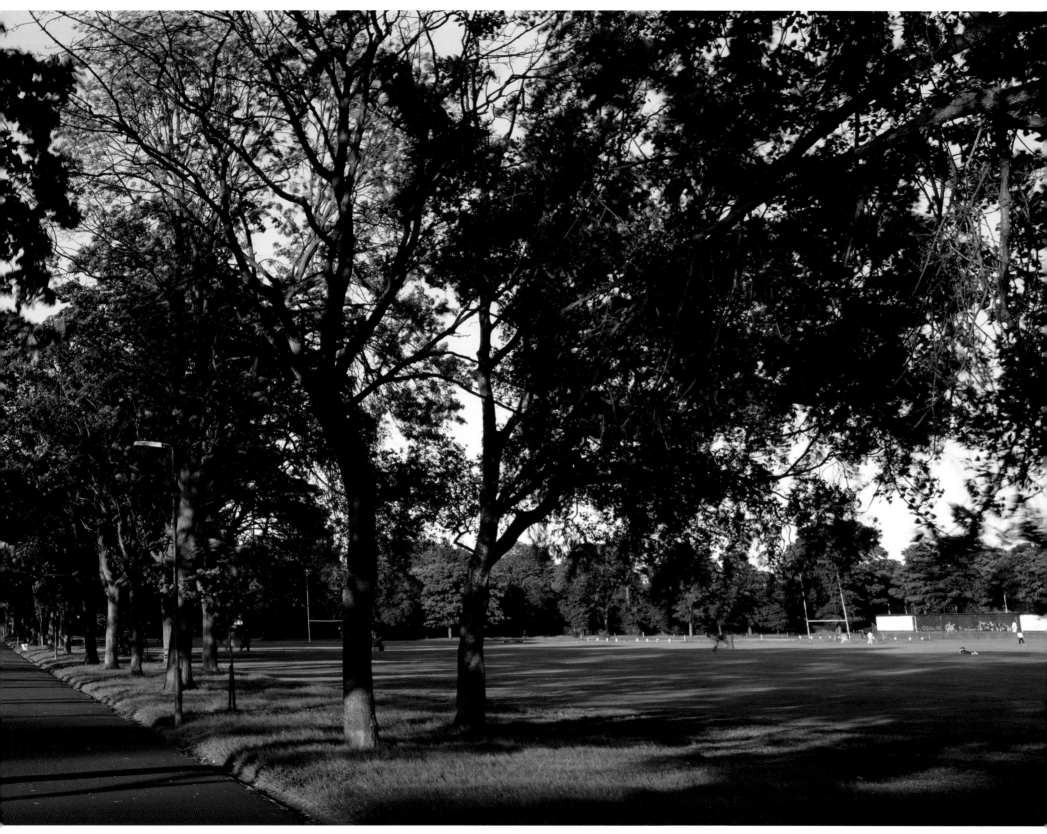

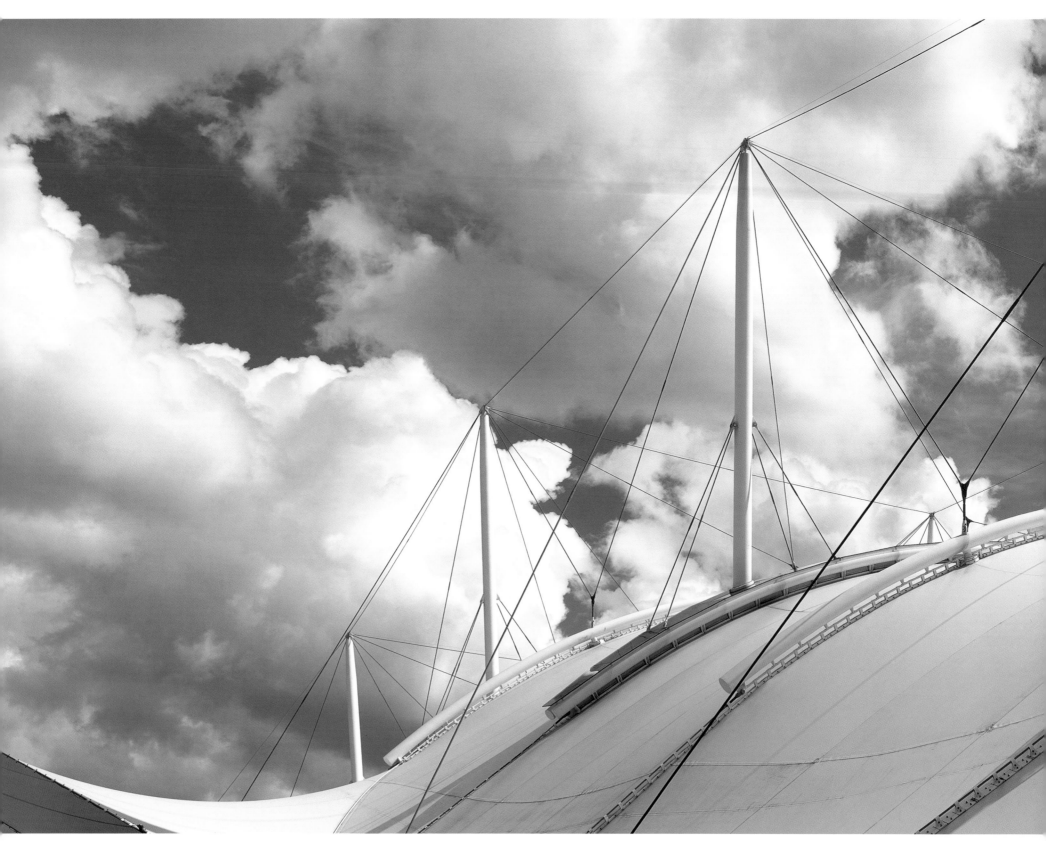

OUR DYNAMIC EARTH, HOLYROOD

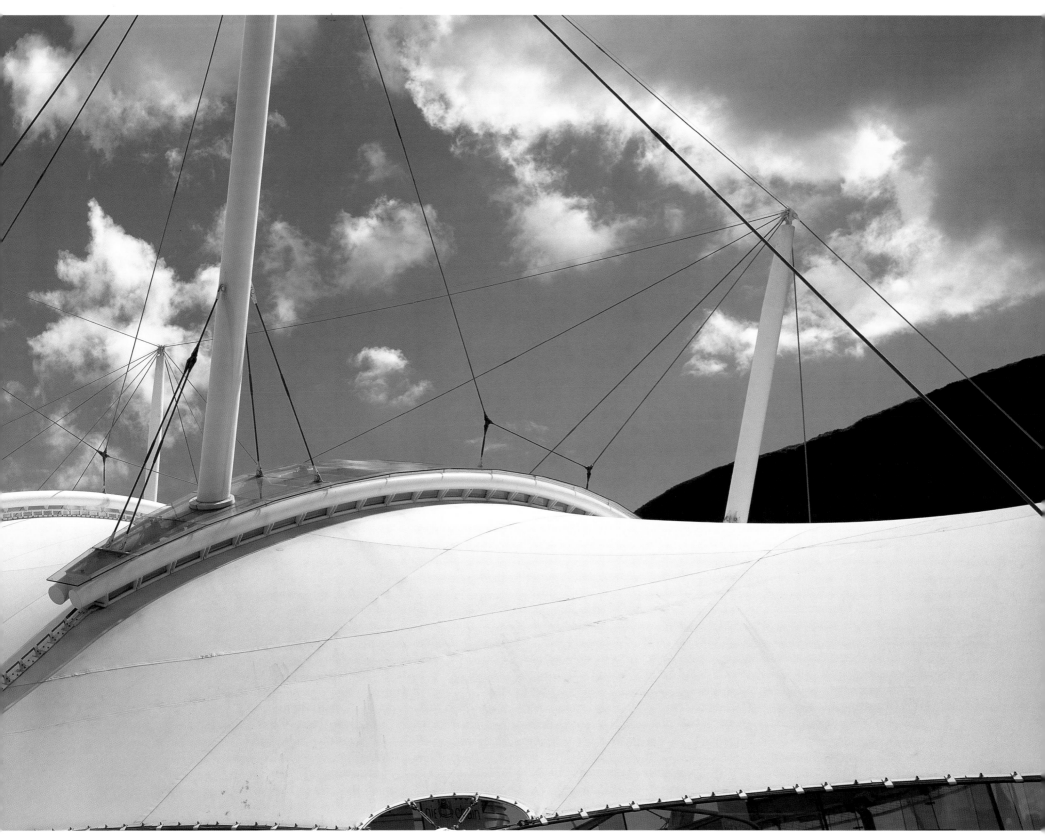

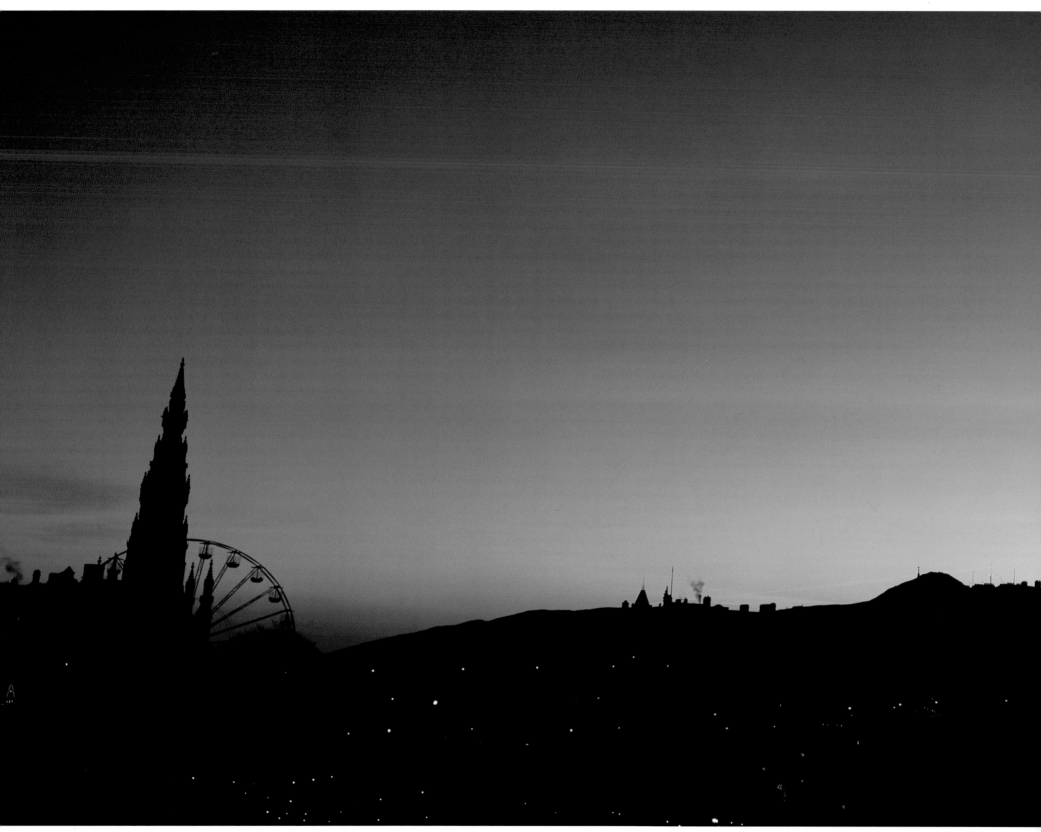

WINTER DAWN SKYLINE

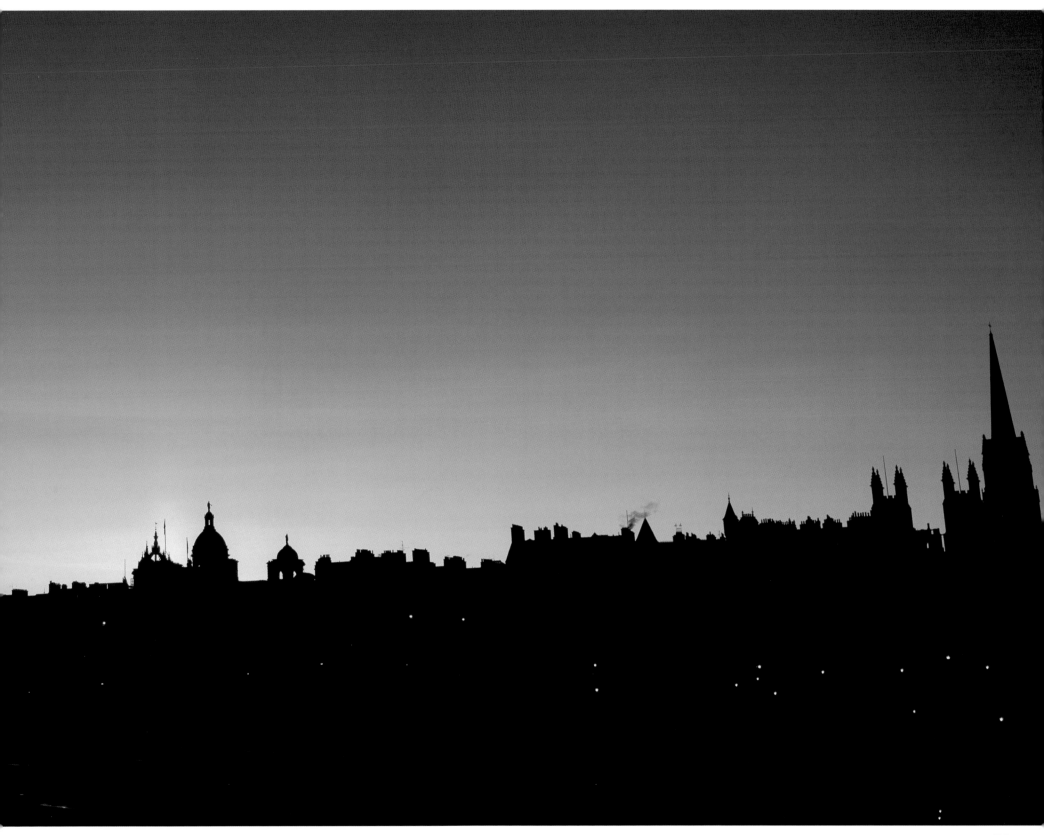

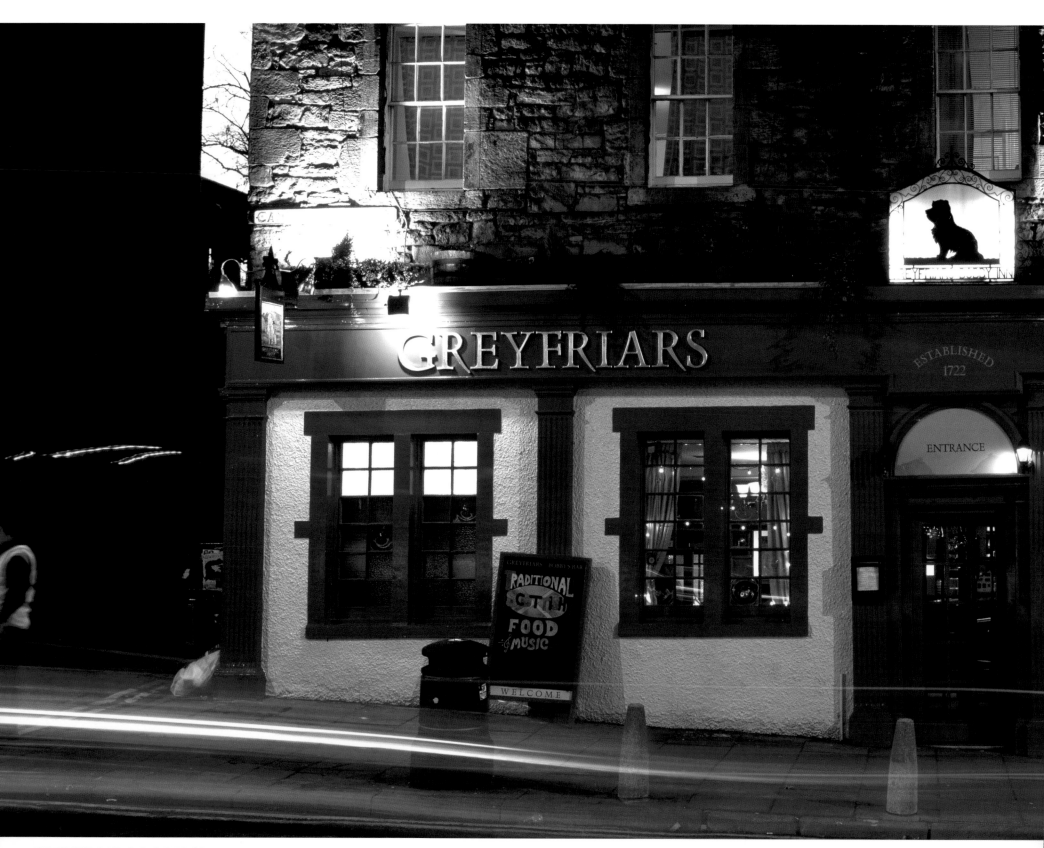

GREYFRIARS BOBBY'S BAR

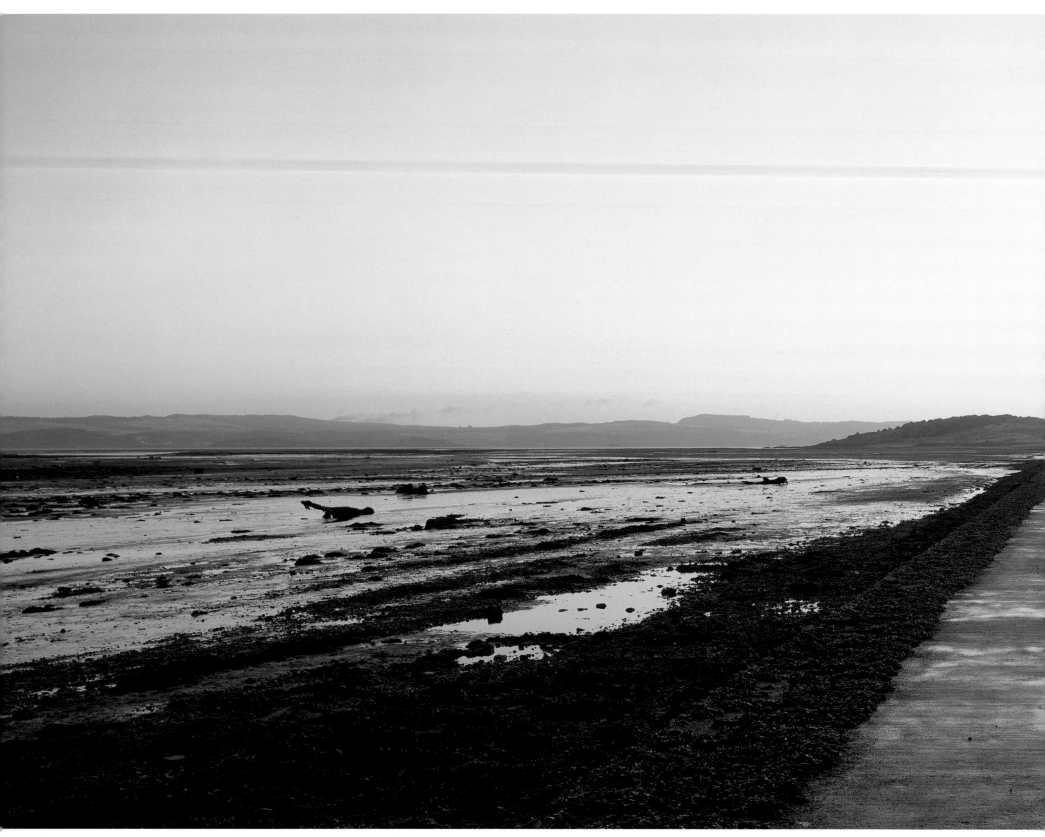

CRAMOND CAUSEWAY, DAWN

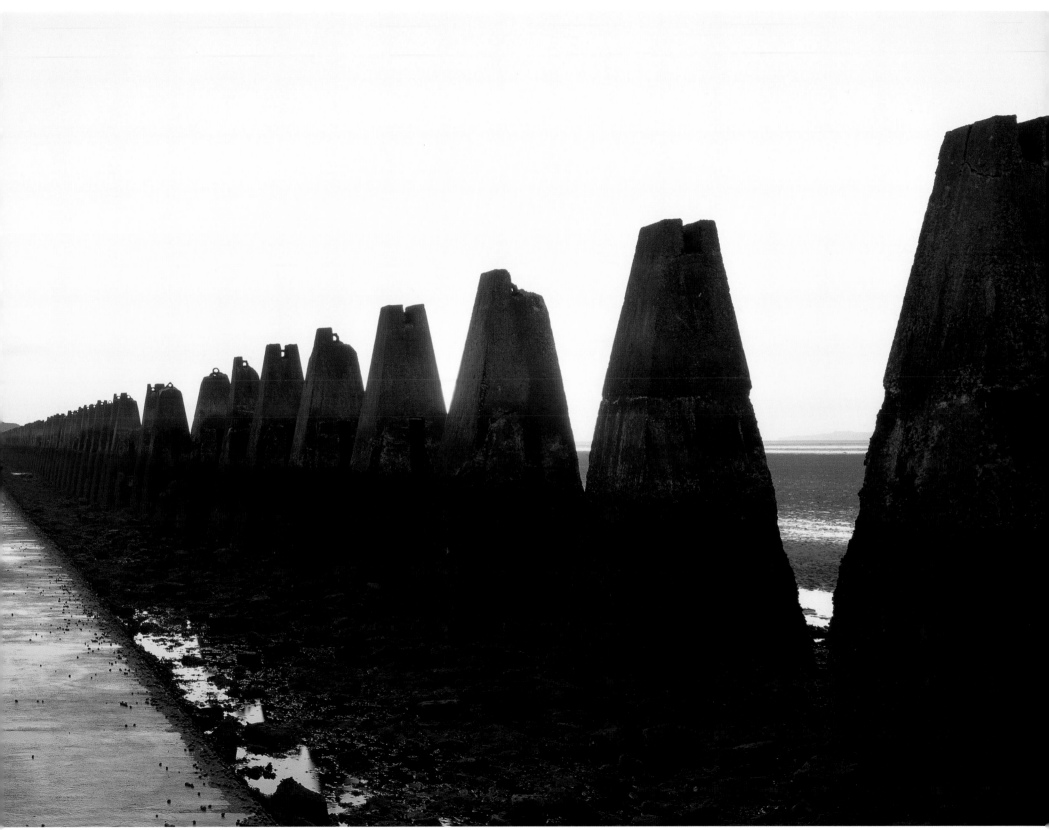

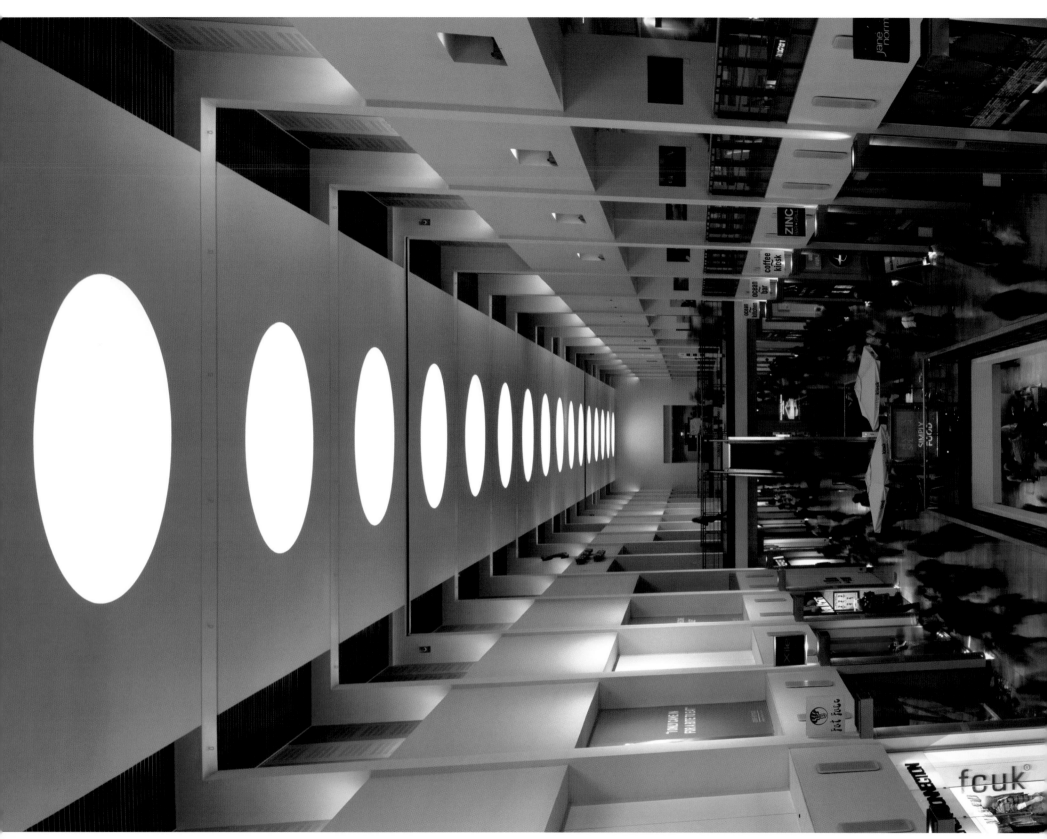

OCEAN TERMINAL SHOPPING CENTRE, LEITH

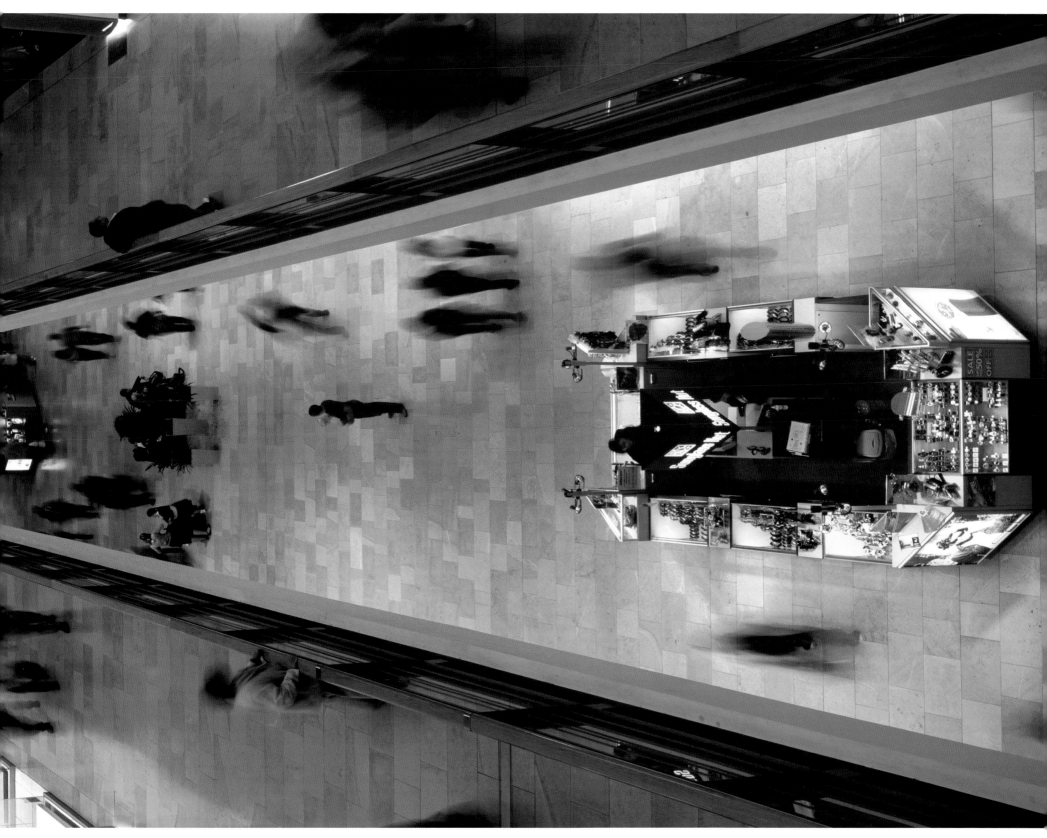

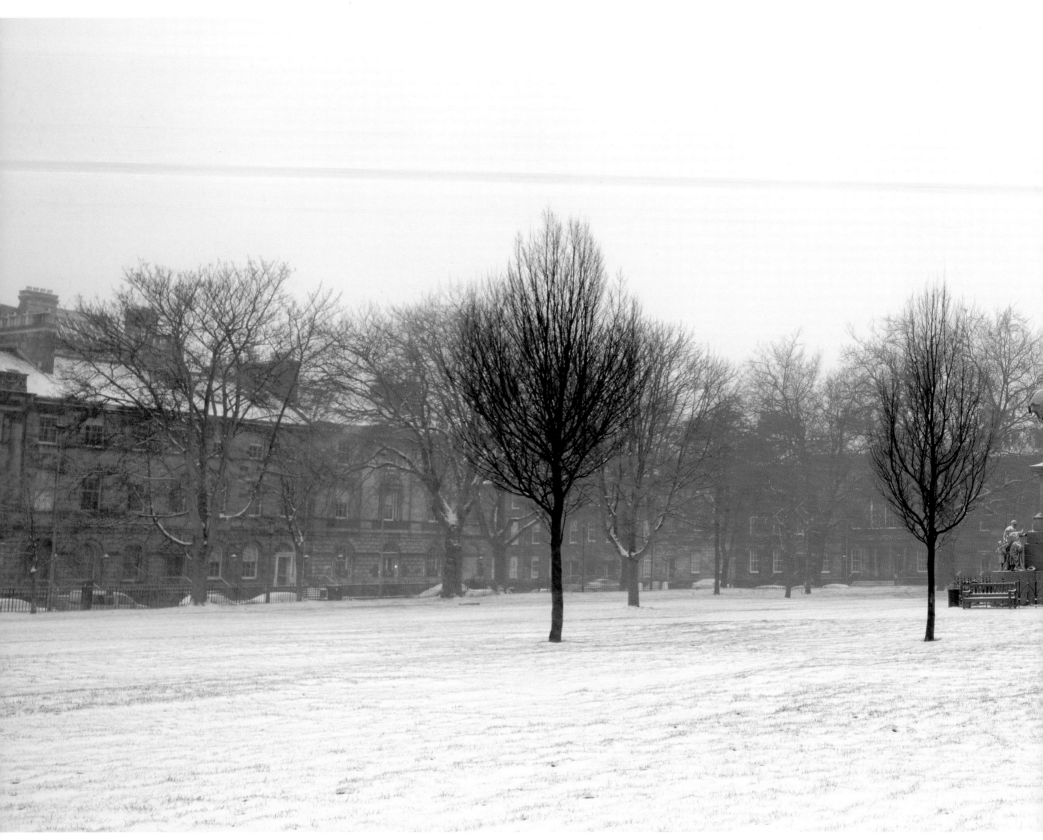

CHARLOTTE SQUARE

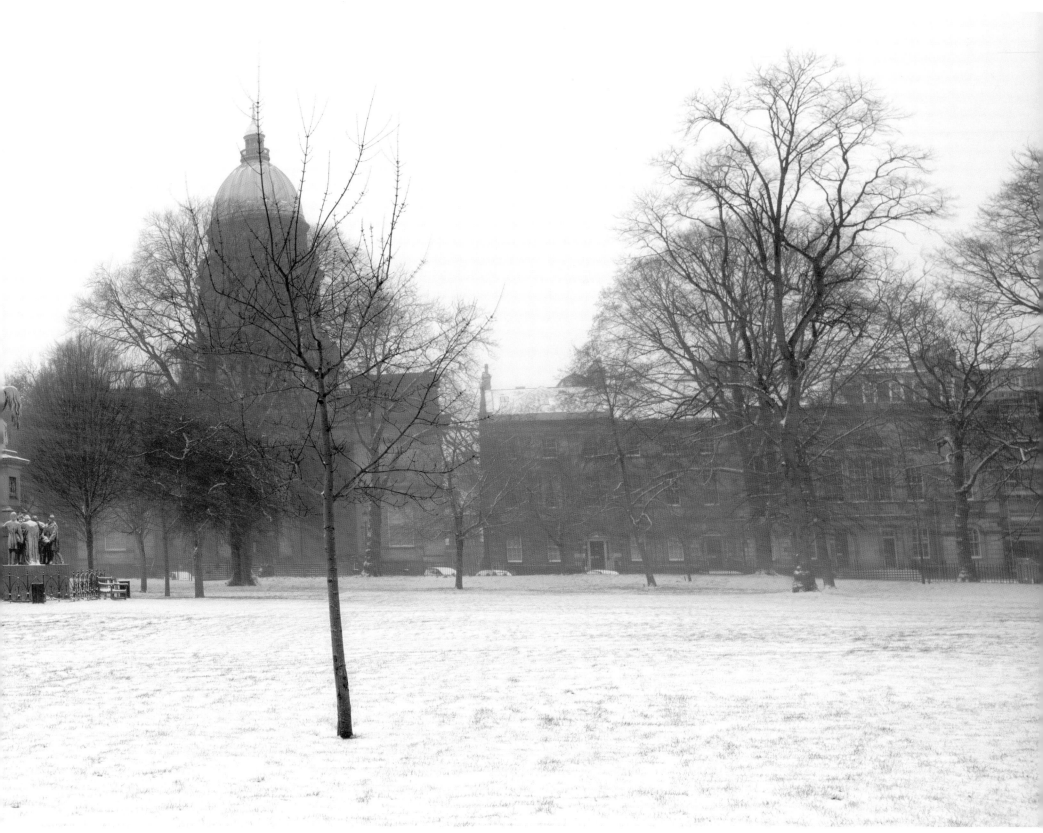

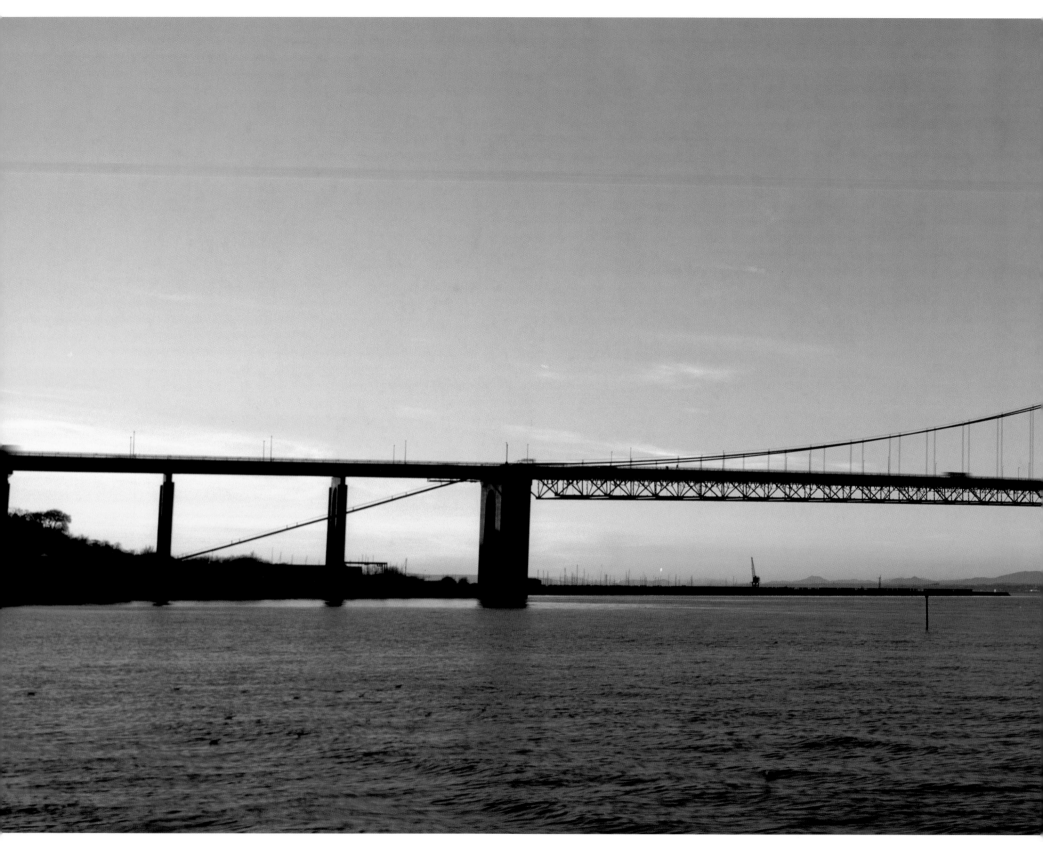

FORTH ROAD BRIDGE

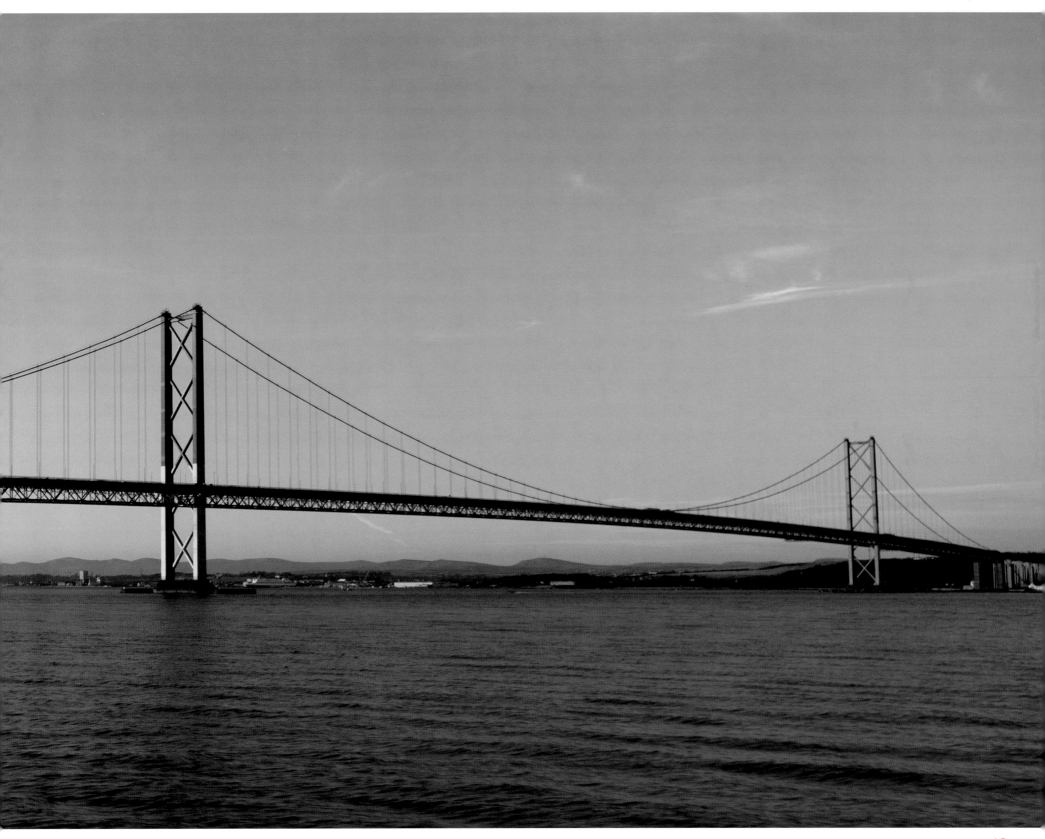

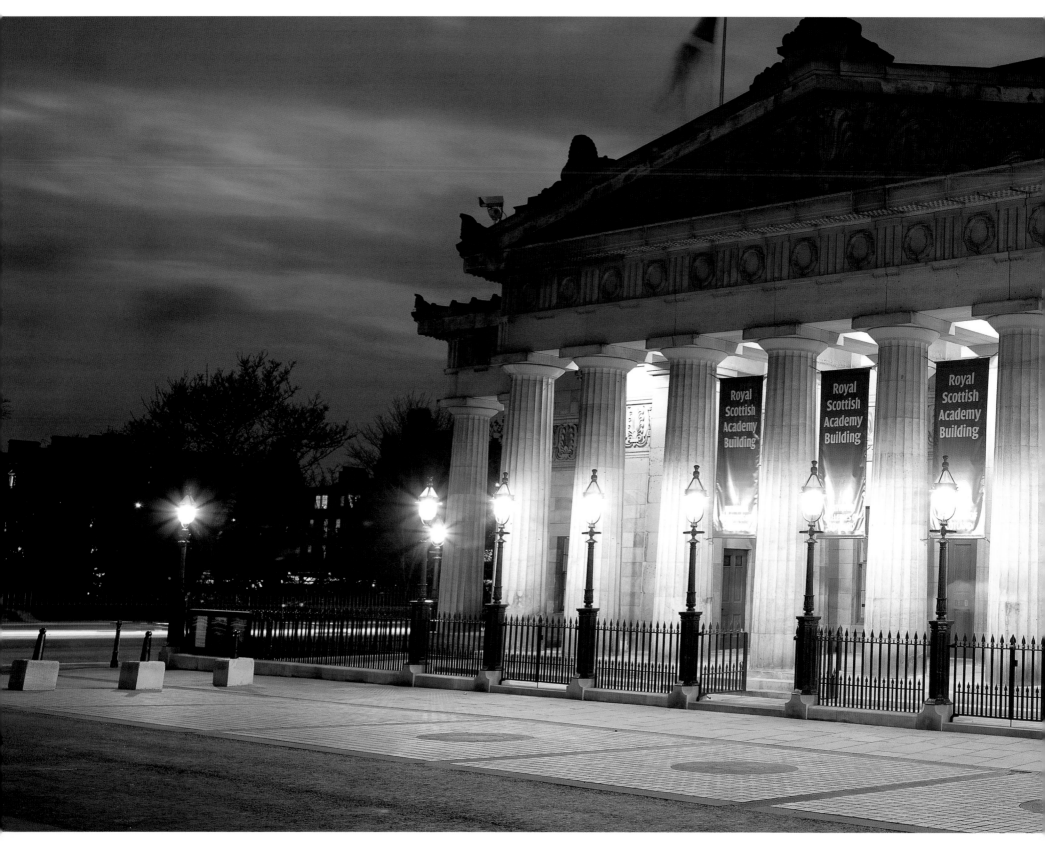

ROYAL SCOTTISH ACADEMY, PRINCES STREET

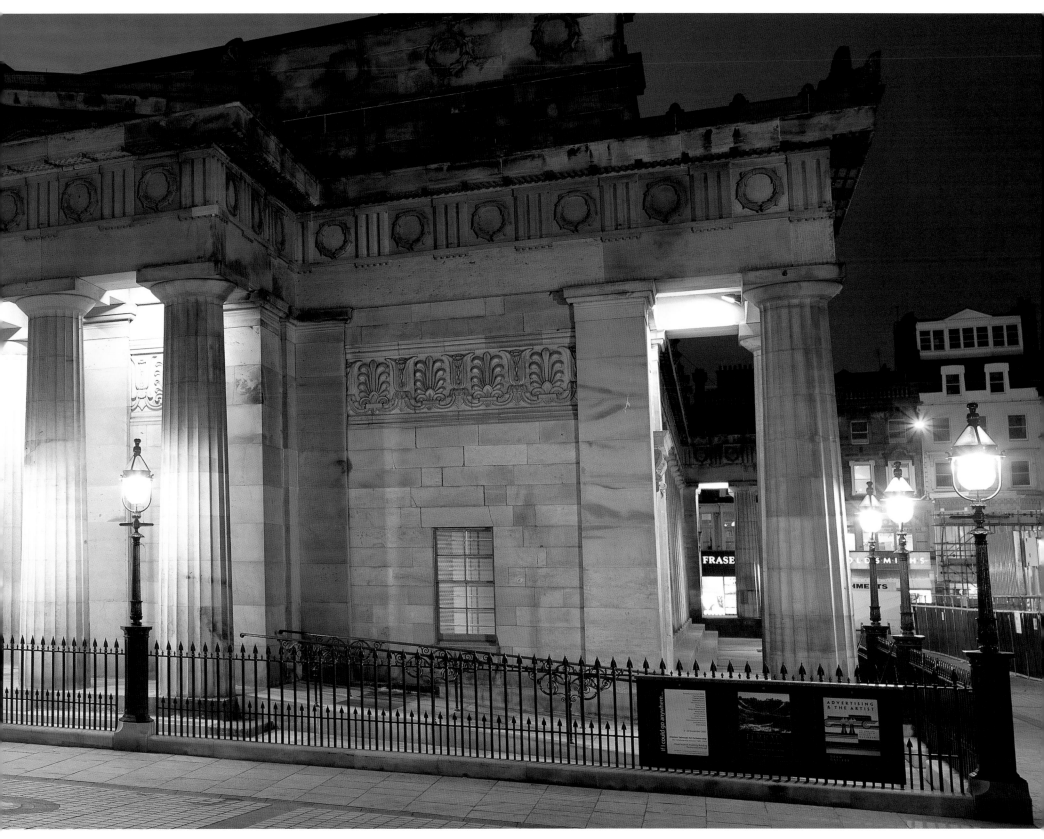

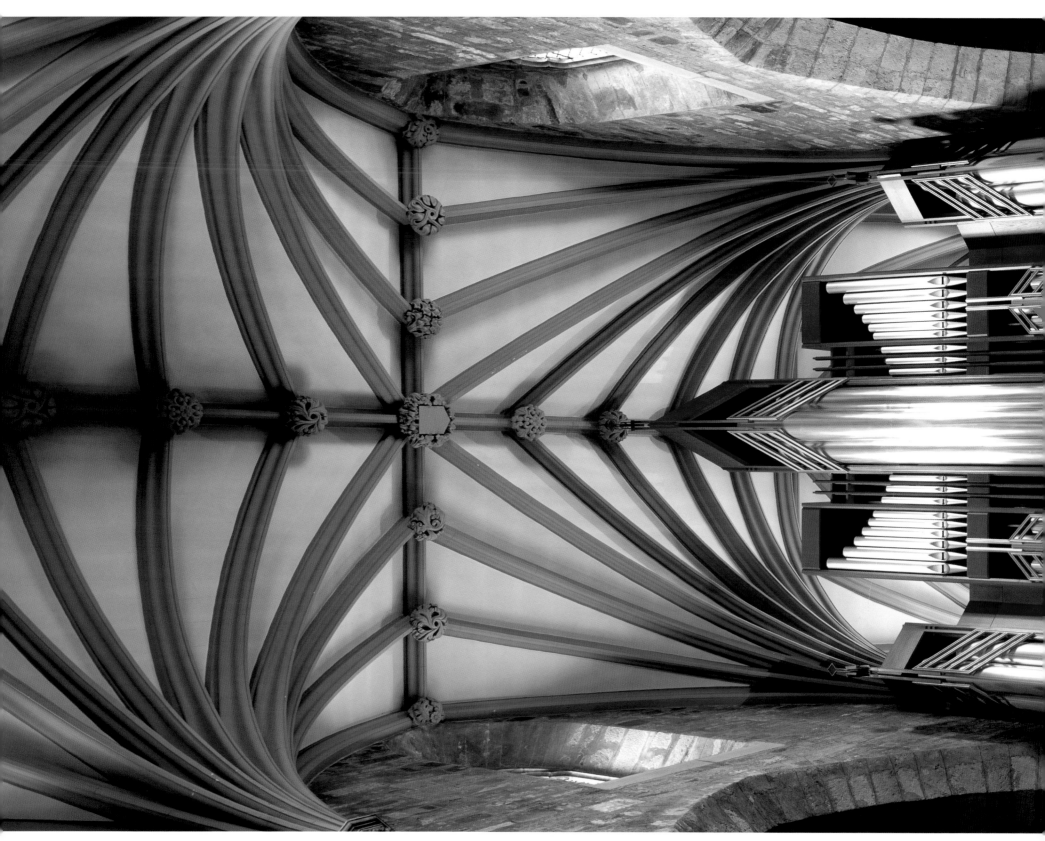

ORGAN, ST GILES CATHEDRAL

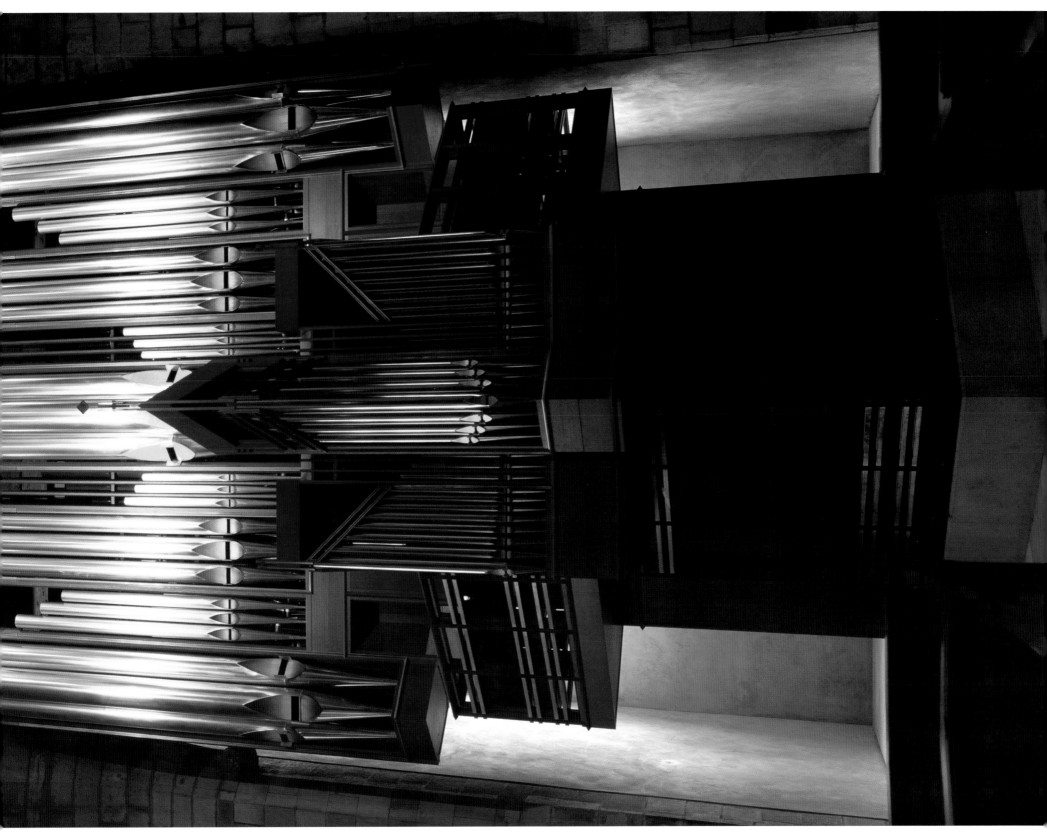

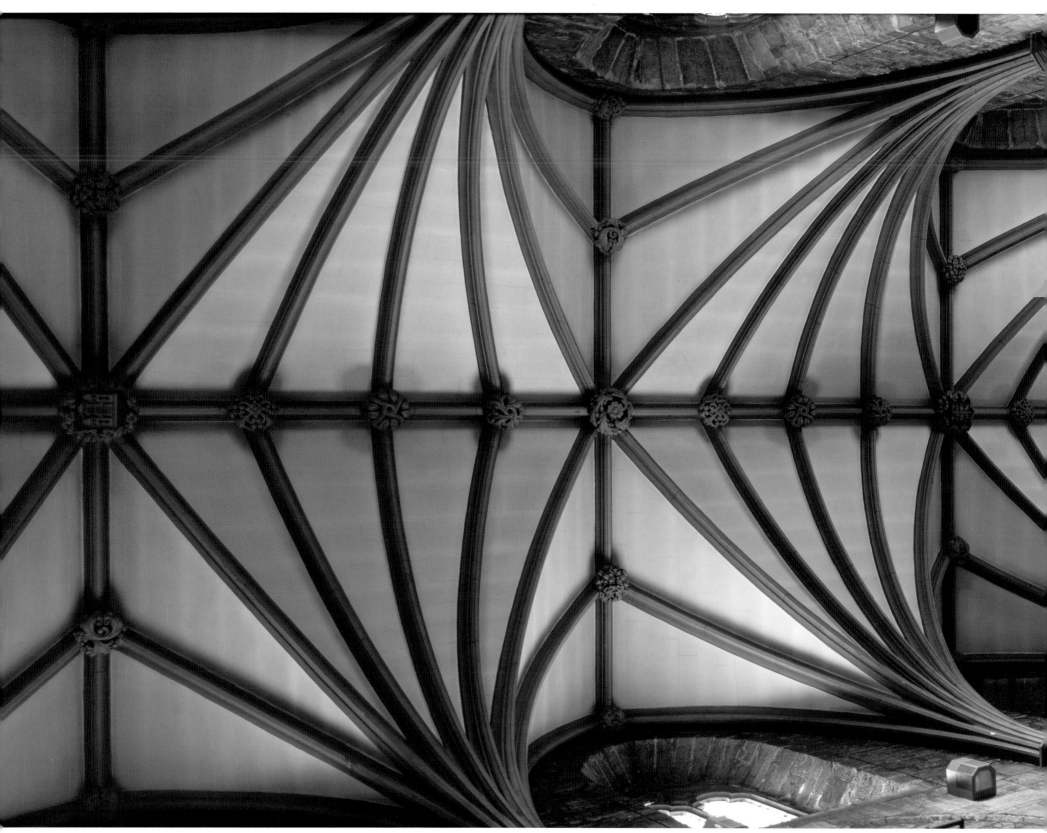

VERTICAL VIEW, ST GILES CATHEDRAL

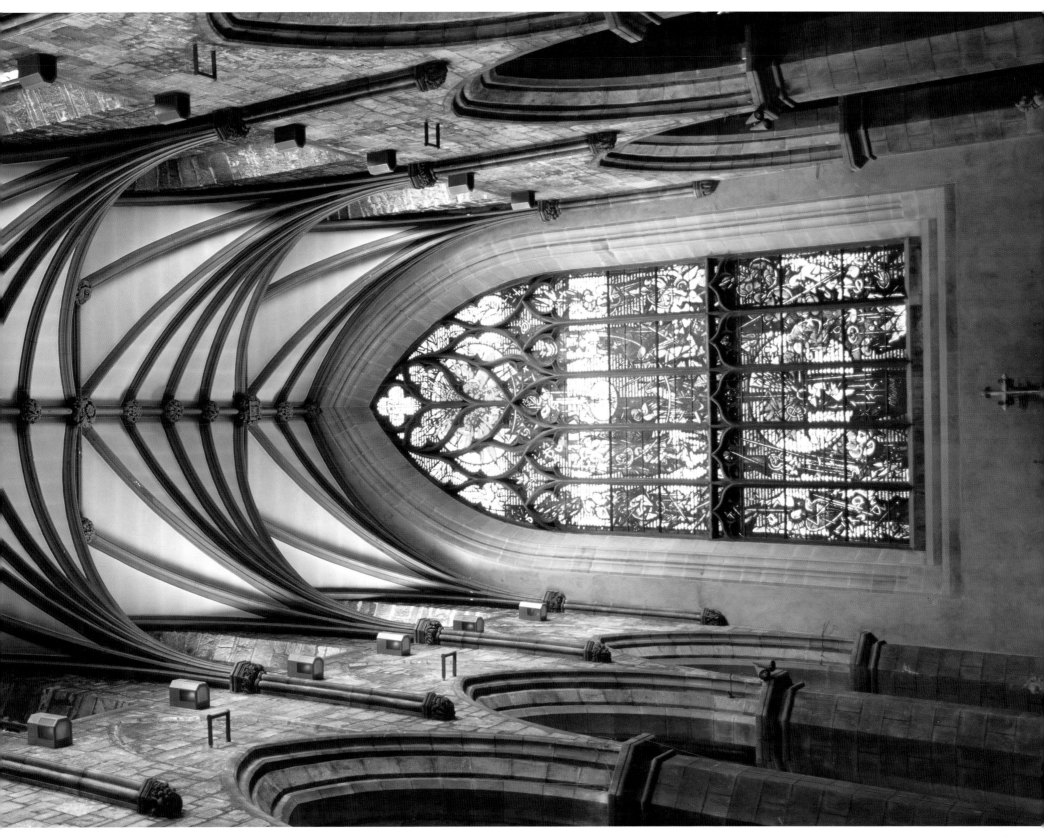

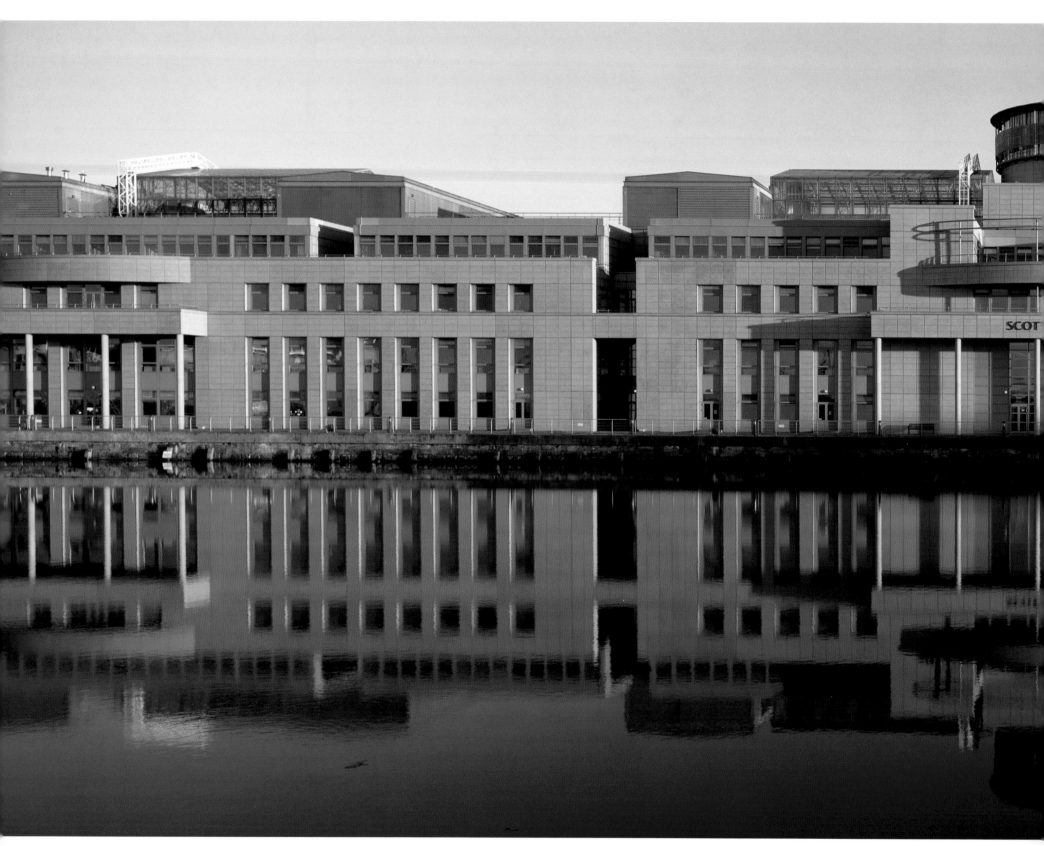

SCOTTISH EXECUTIVE, LEITH

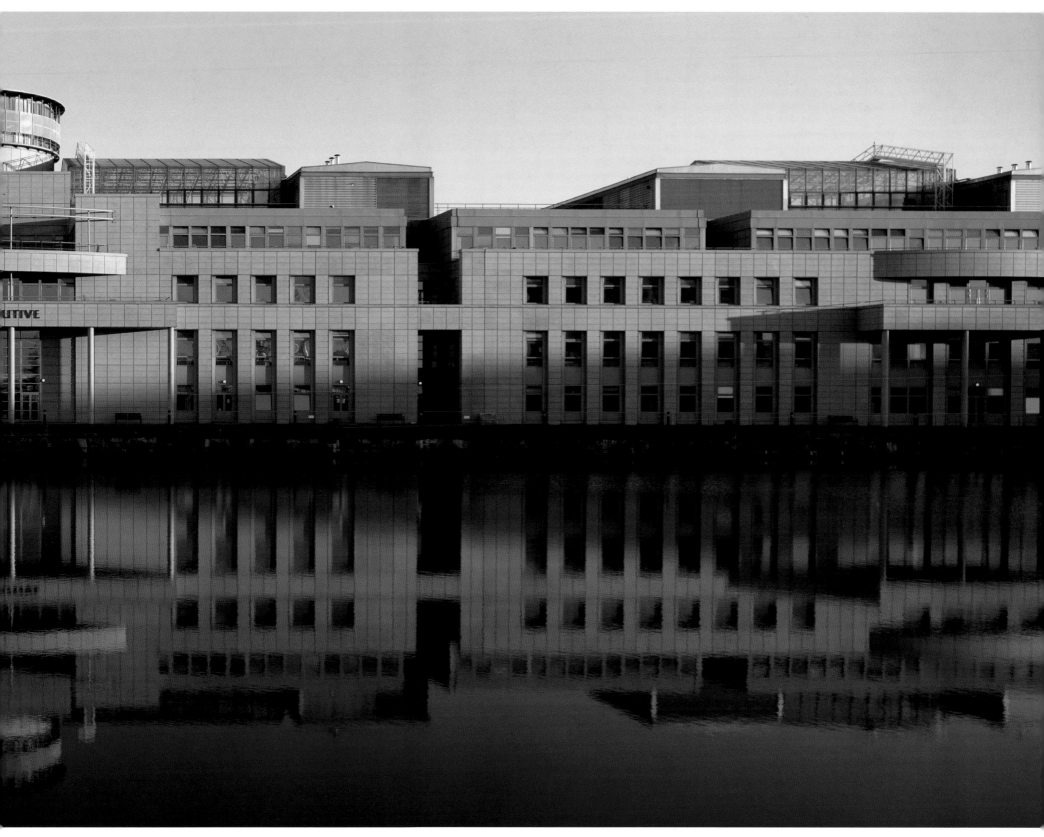

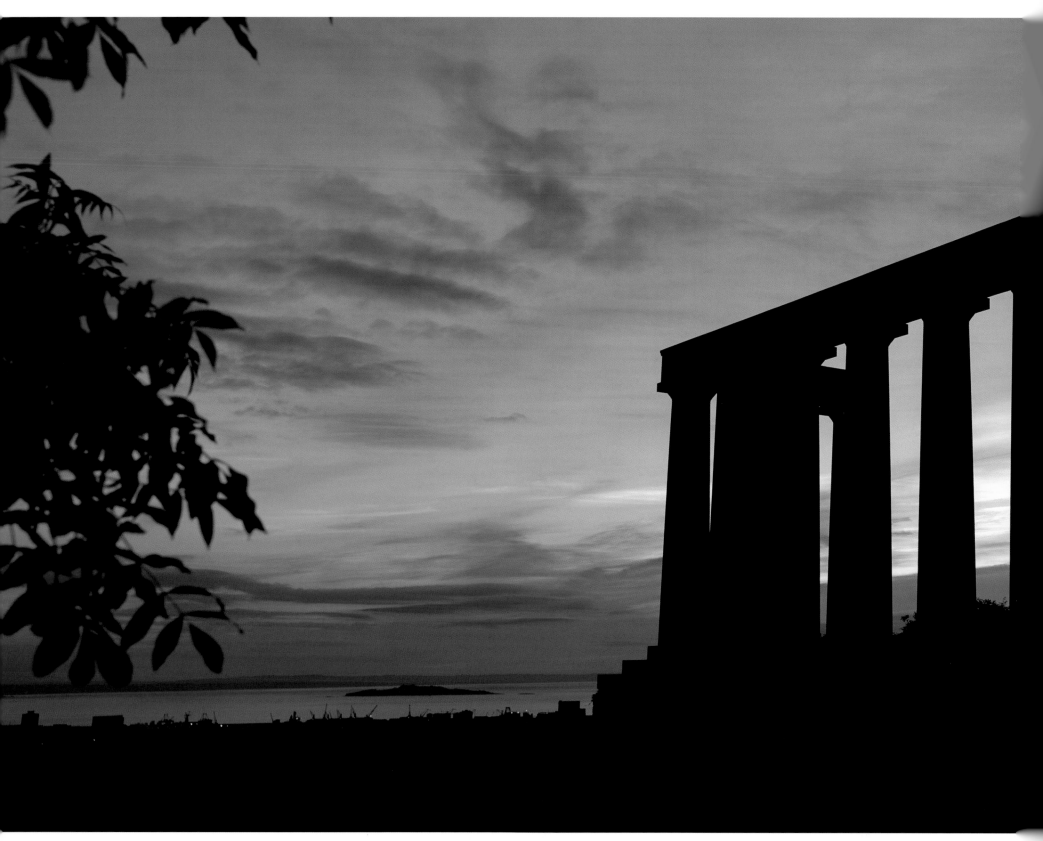

THE NATIONAL MONUMENT (OR EDINBURGH'S DISGRACE), SUNRISE

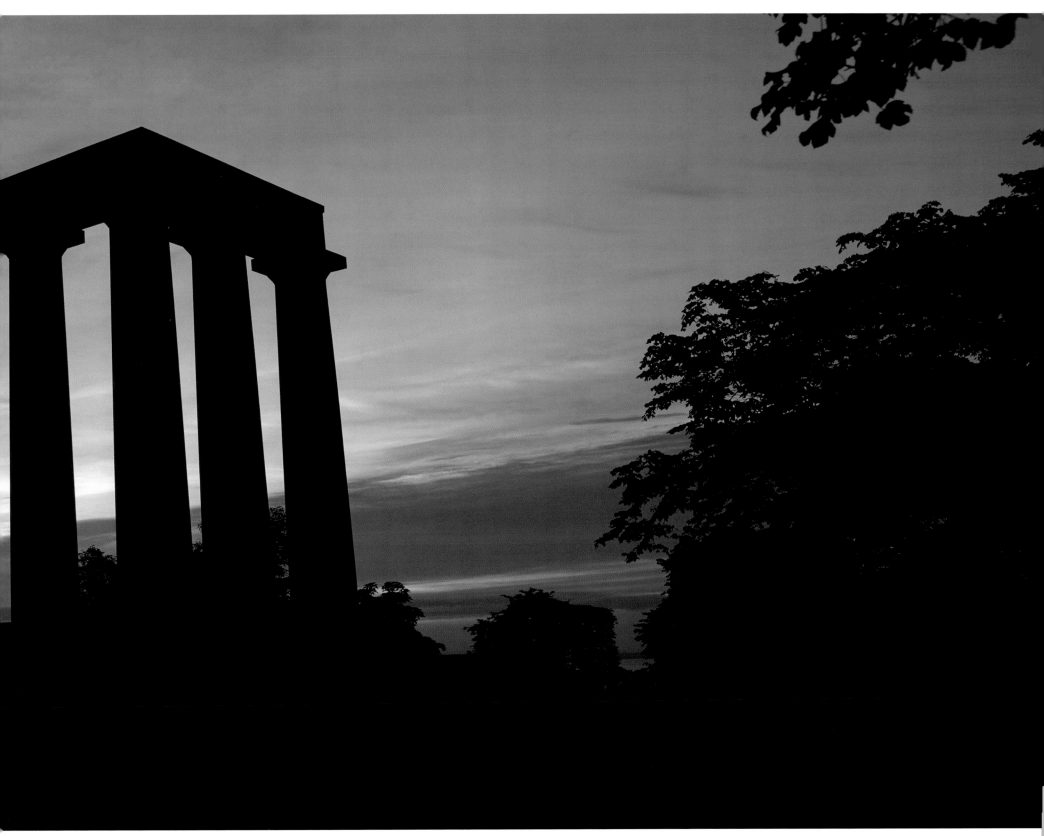

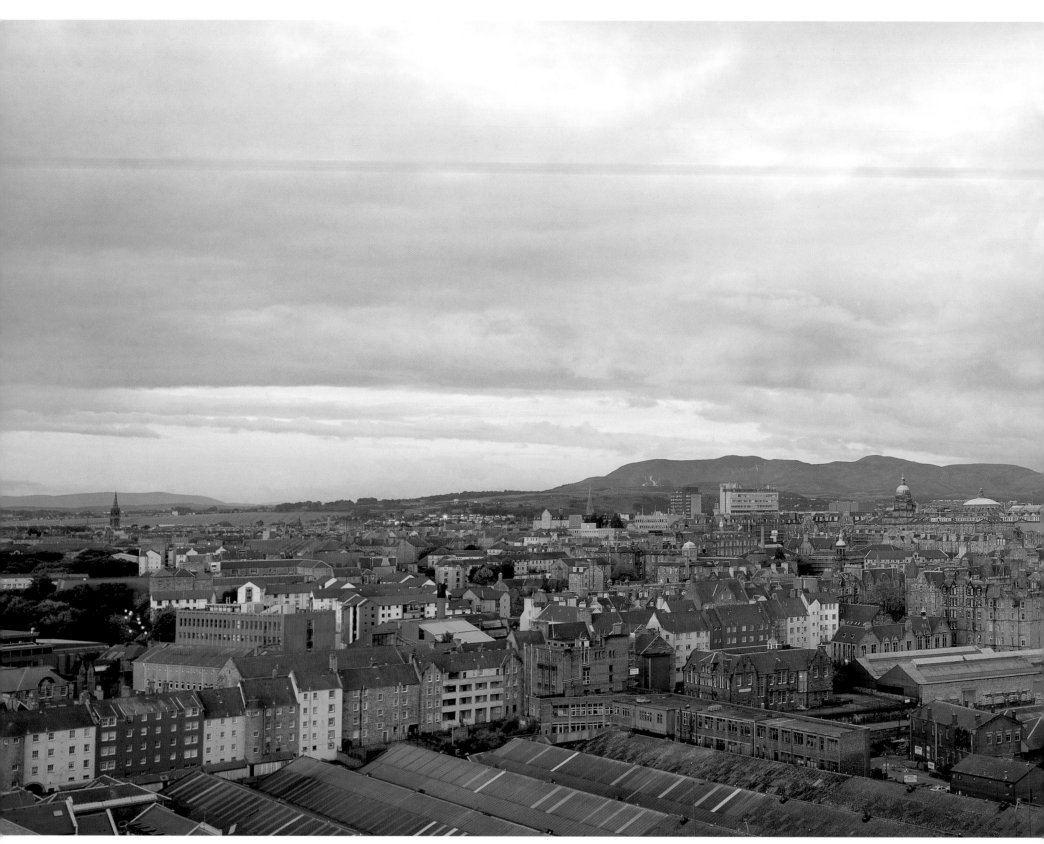

ROYAL MILE FROM CALTON HILL

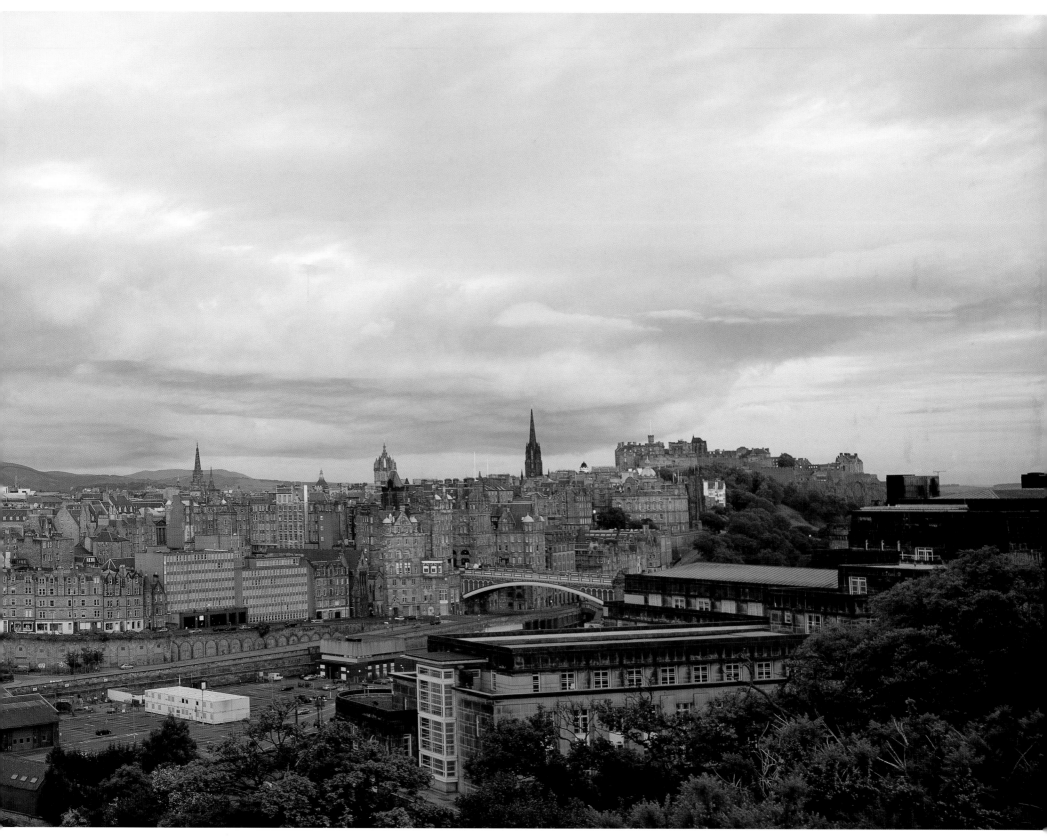

COWGATE, OLD TOWN

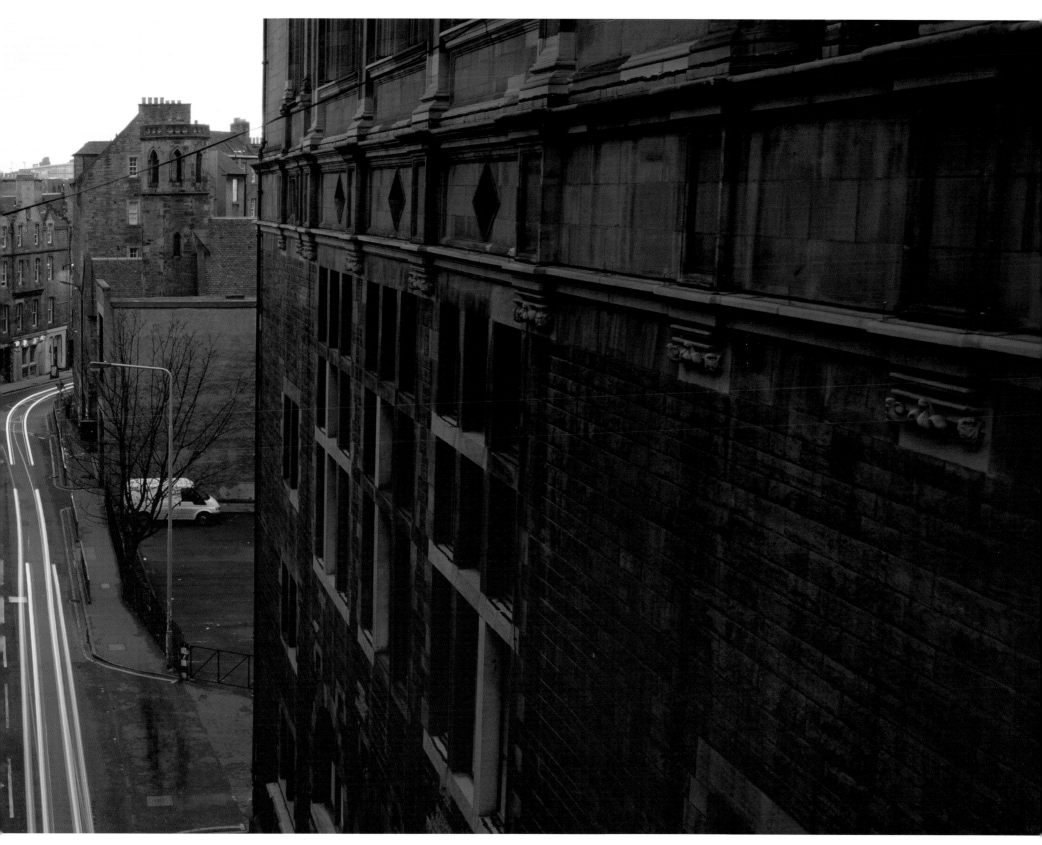

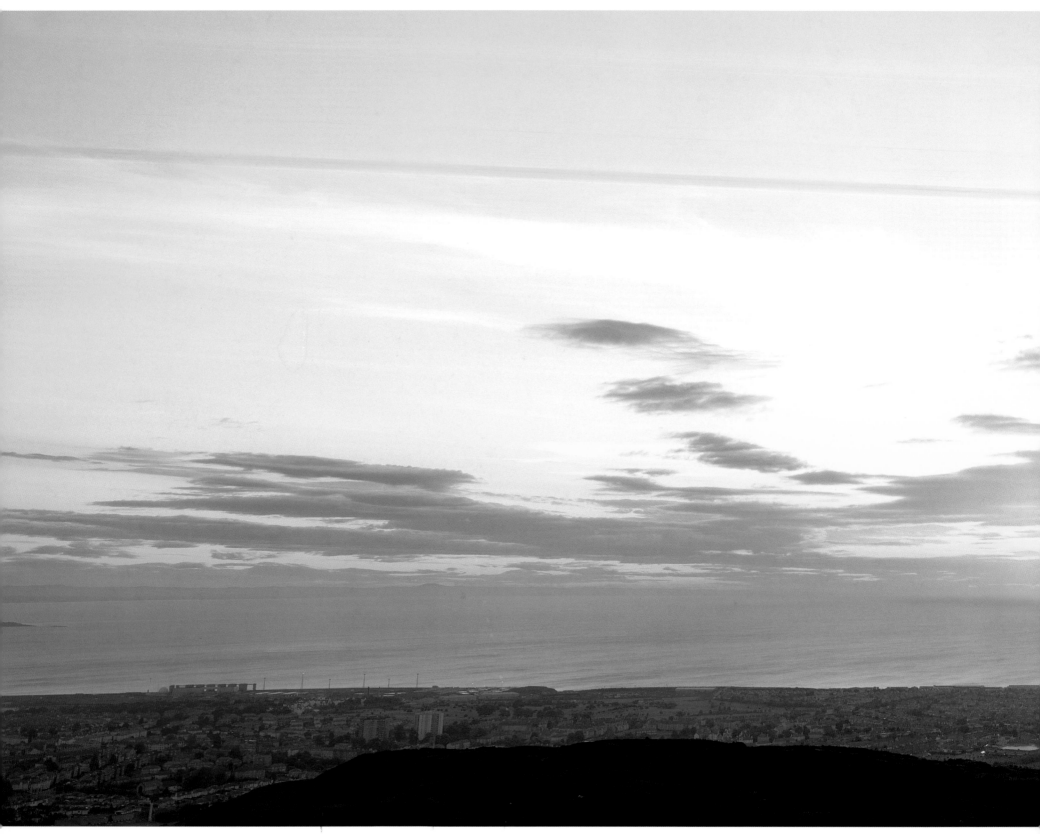

DAWN OVER PORTOBELLO

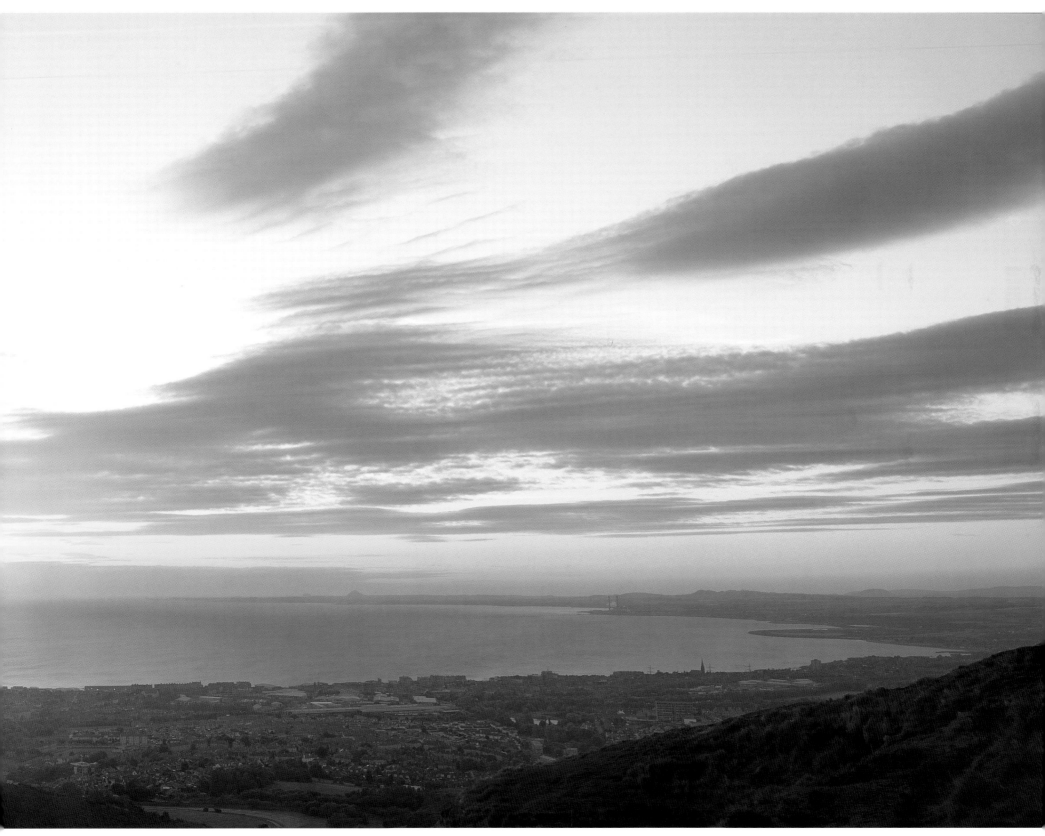

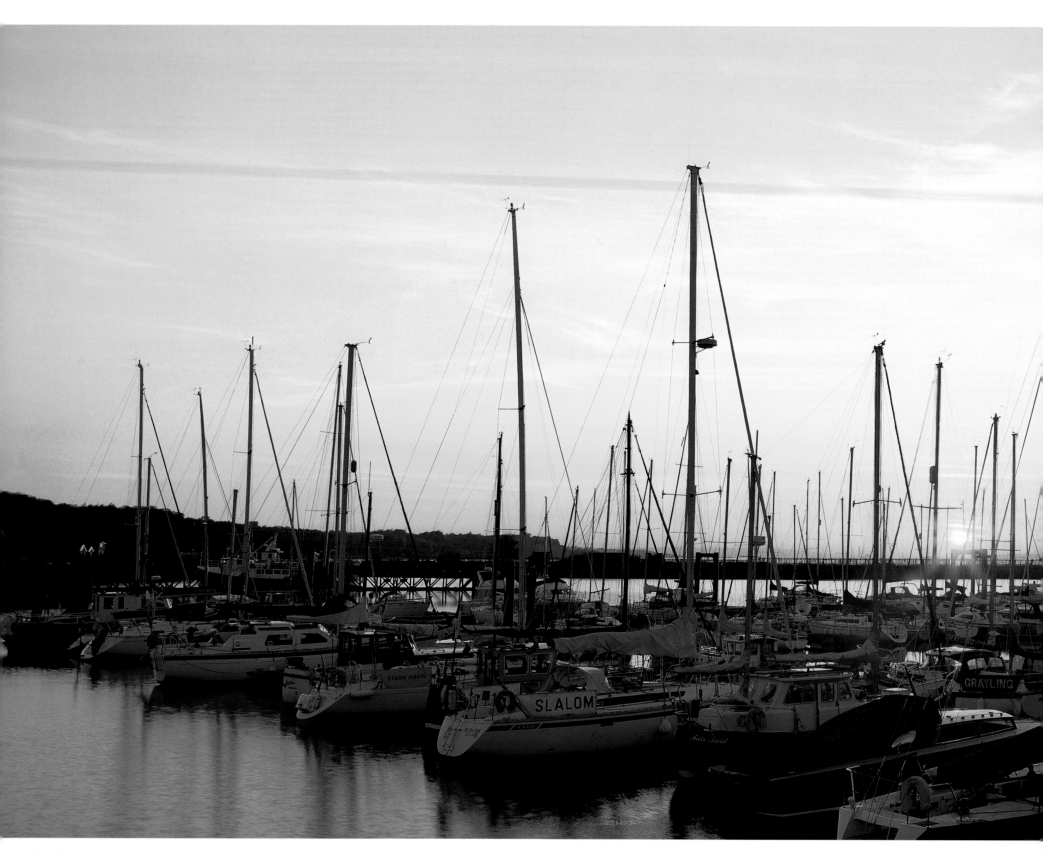

PORT EDGAR, SOUTH QUEENSFERRY

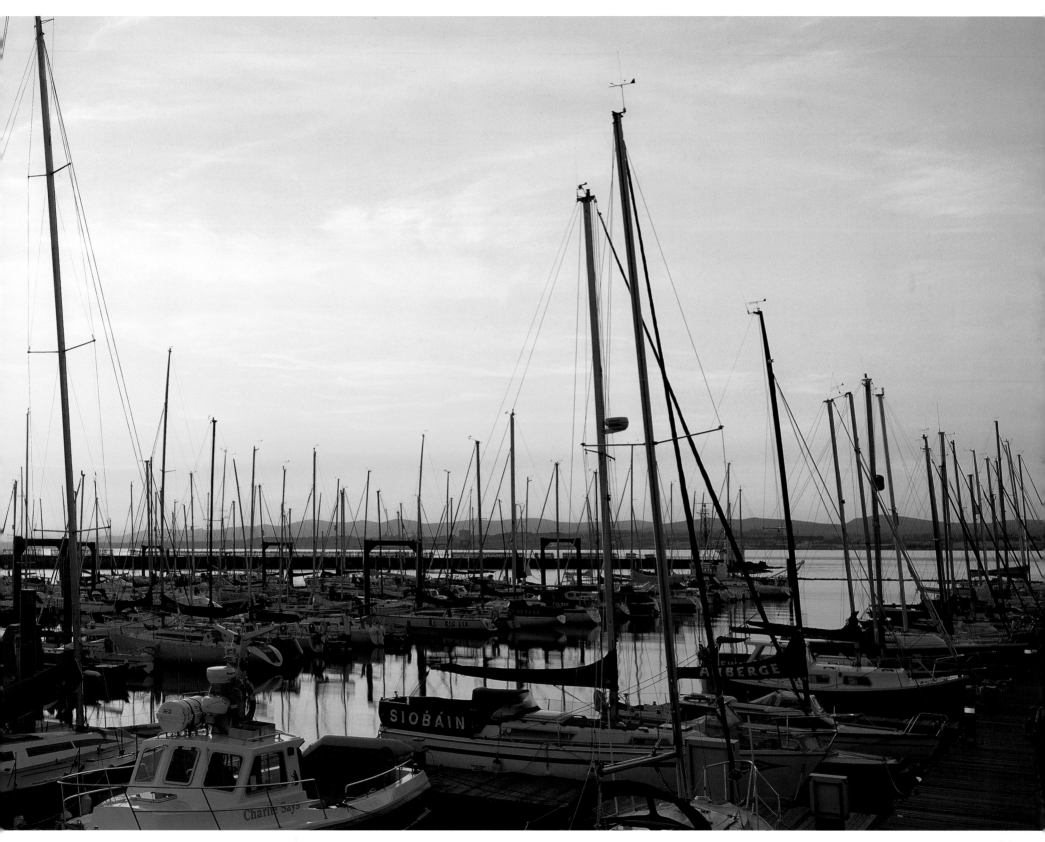

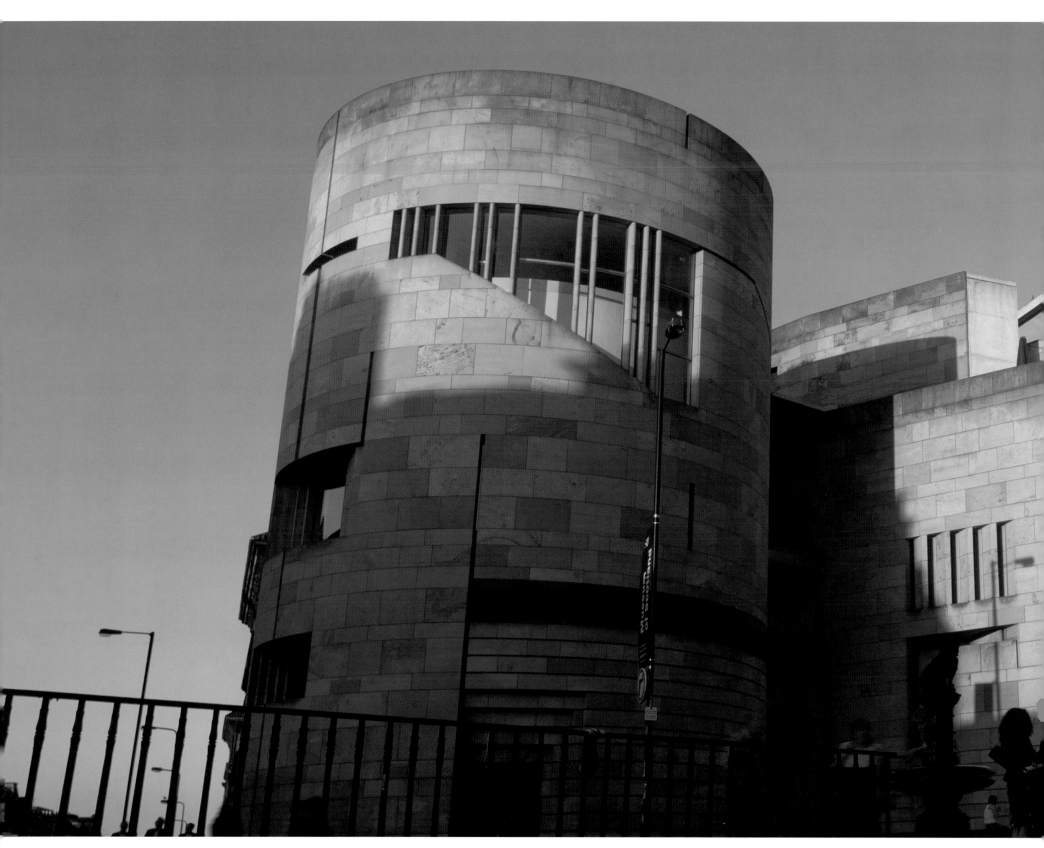

NATIONAL MUSEUM OF SCOTLAND

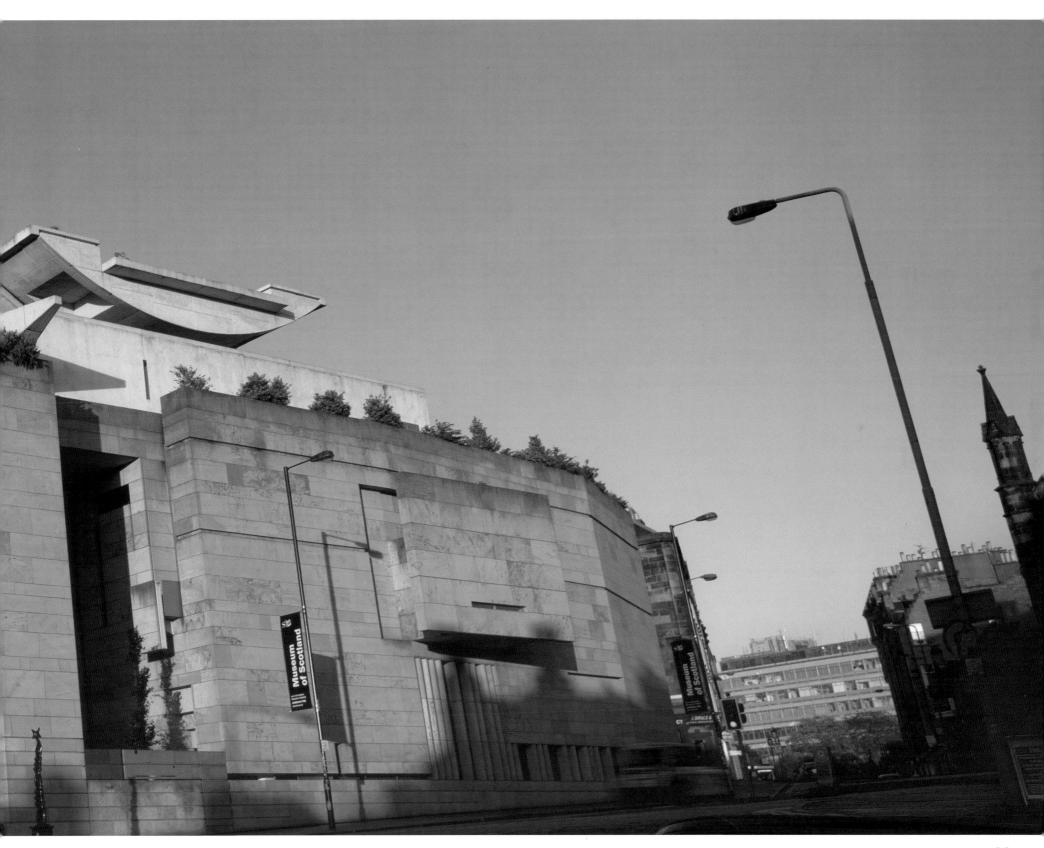

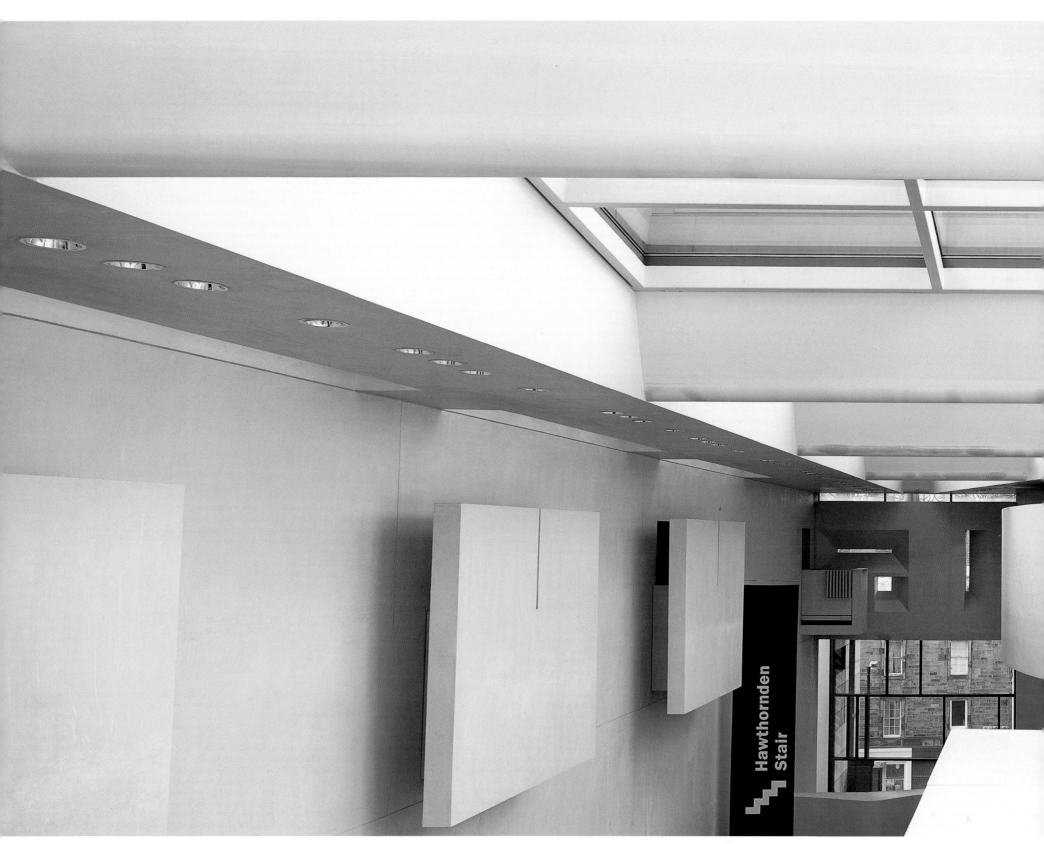

NATIONAL MUSEUM OF SCOTLAND, INTERIOR

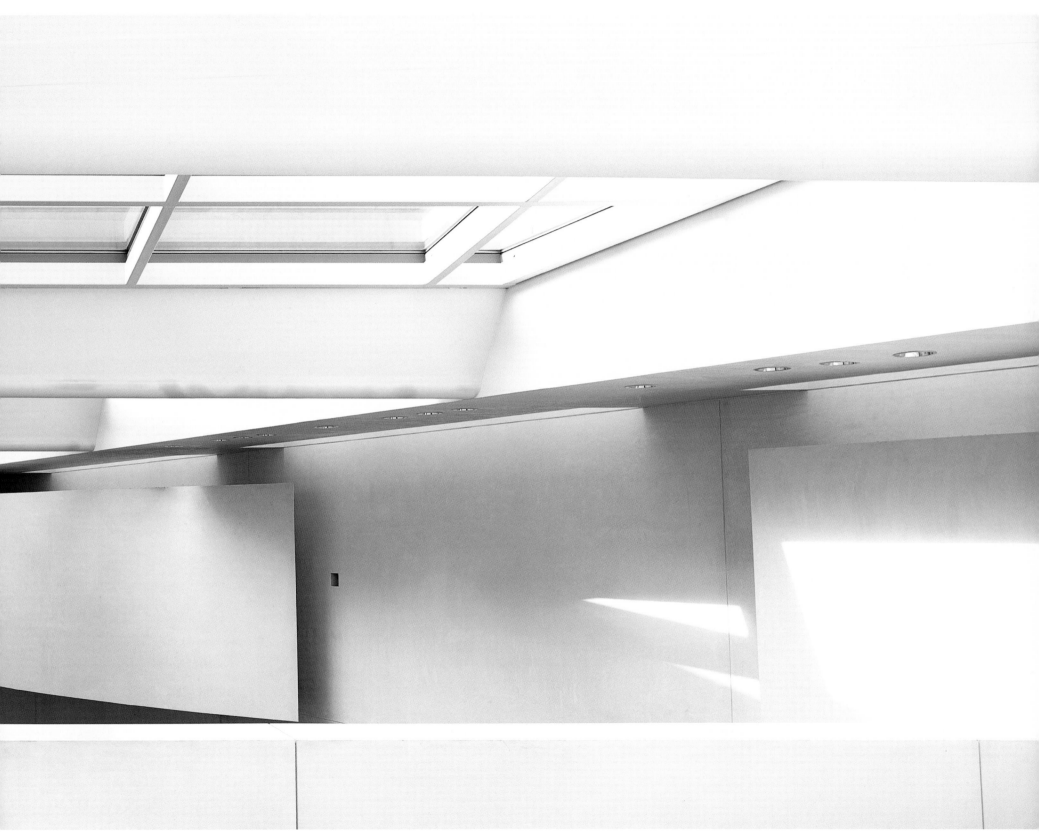

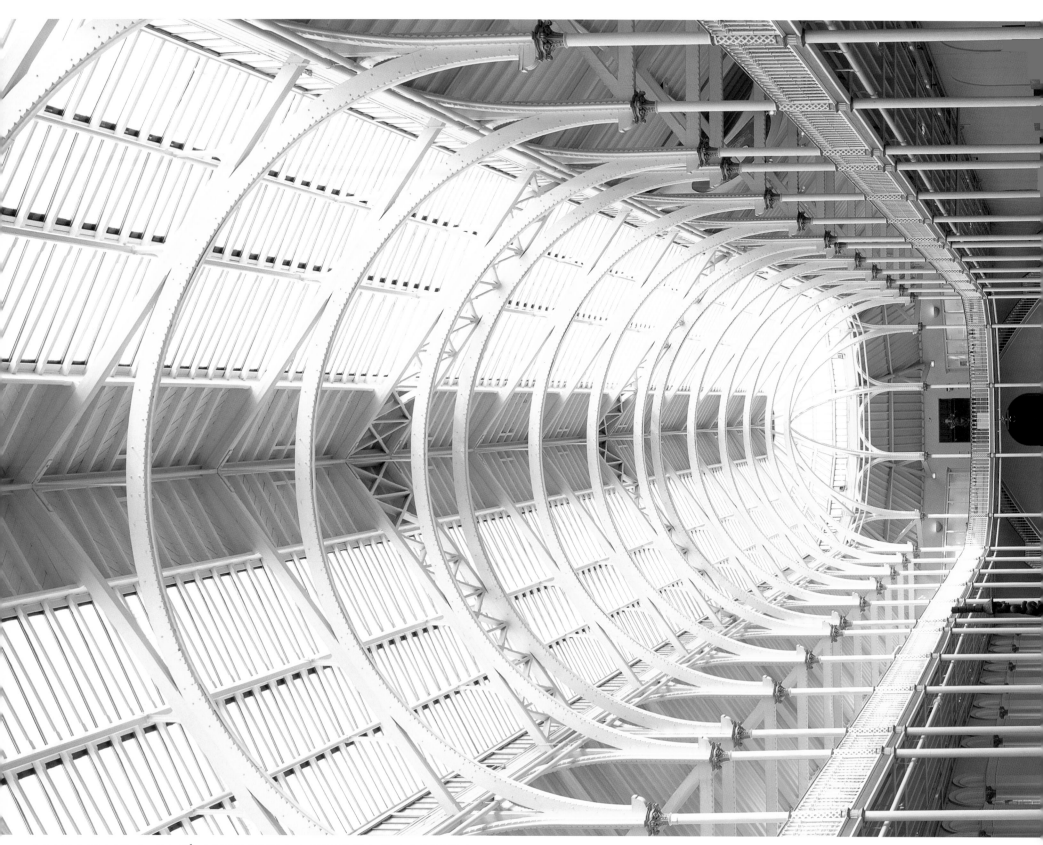

MAIN HALL & CAFÉ, NATIONAL MUSEUM OF SCOTLAND

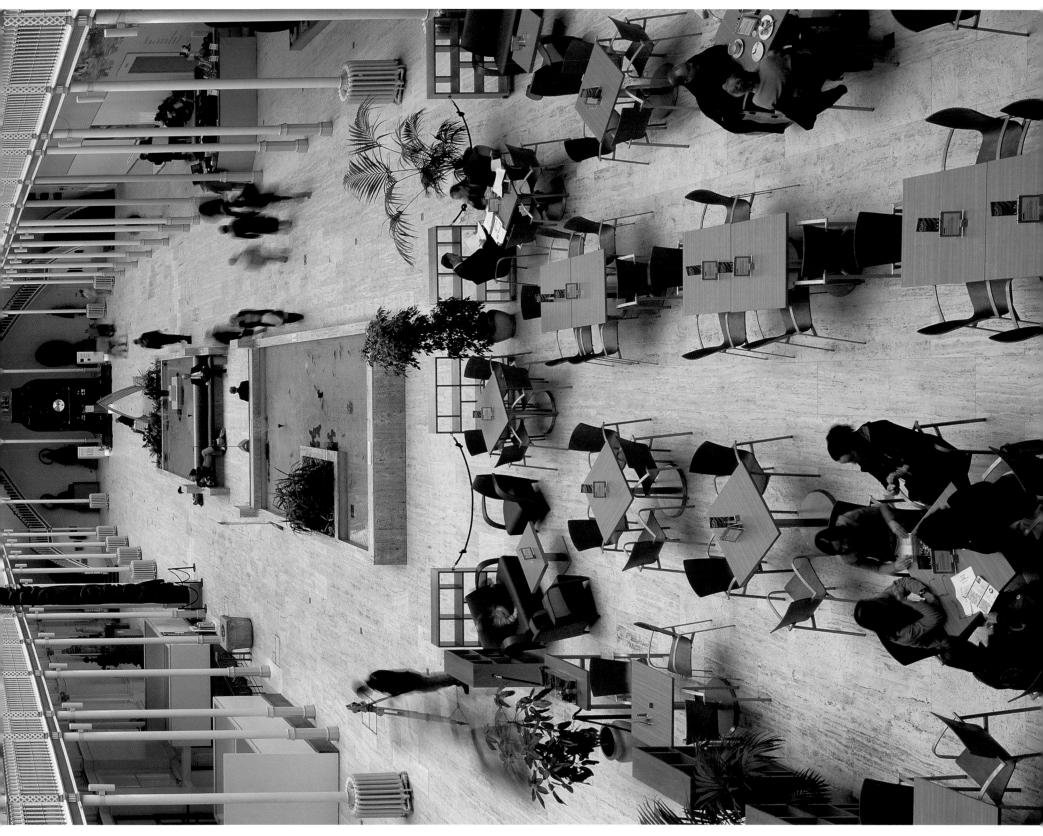

LIGHTHOUSE, GRANTON HARBOUR

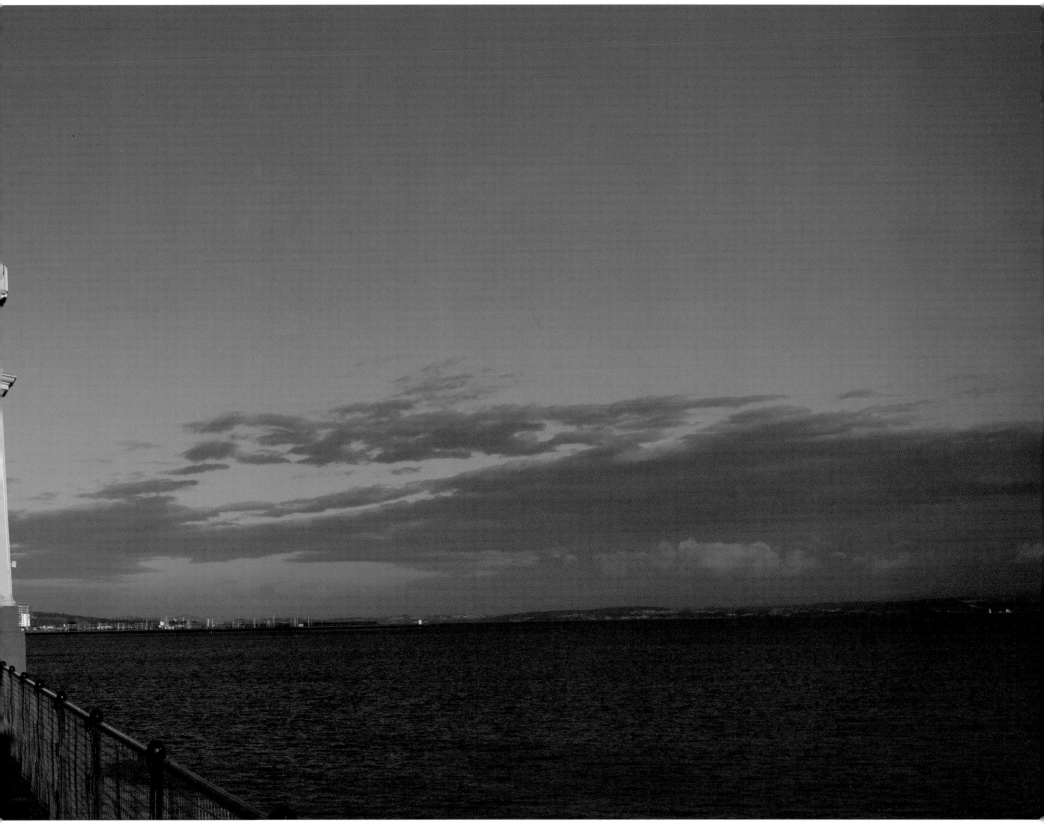

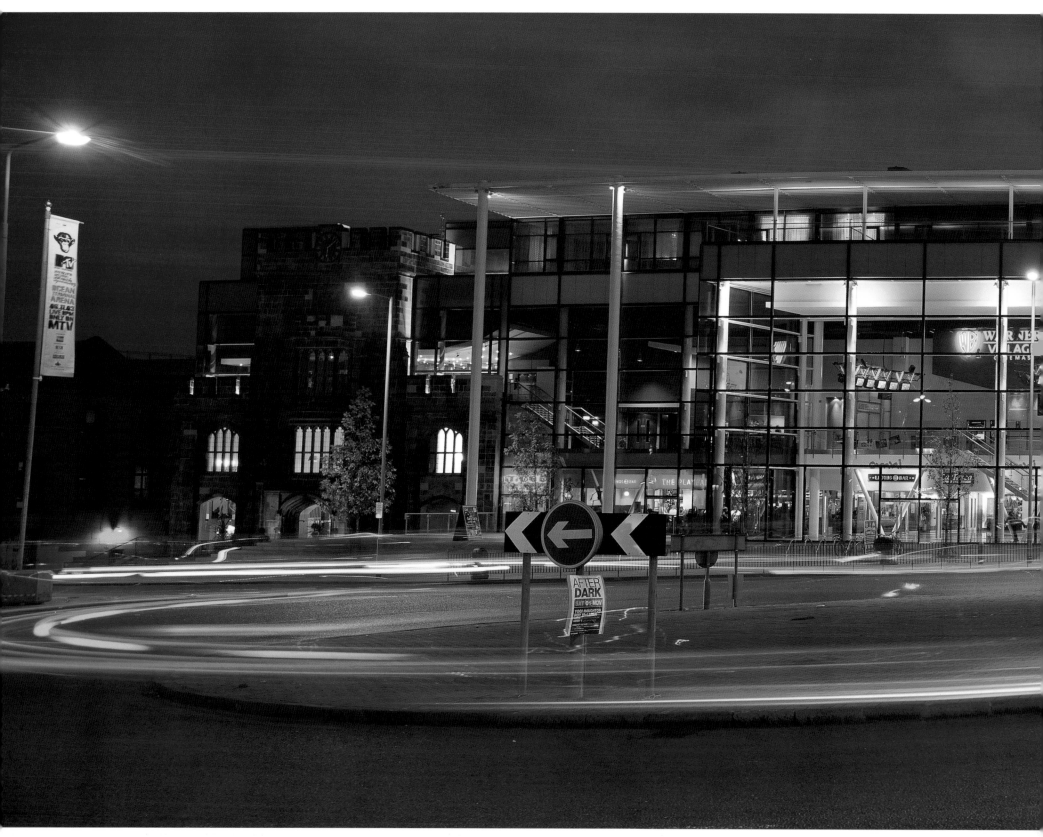

OMNI CENTRE

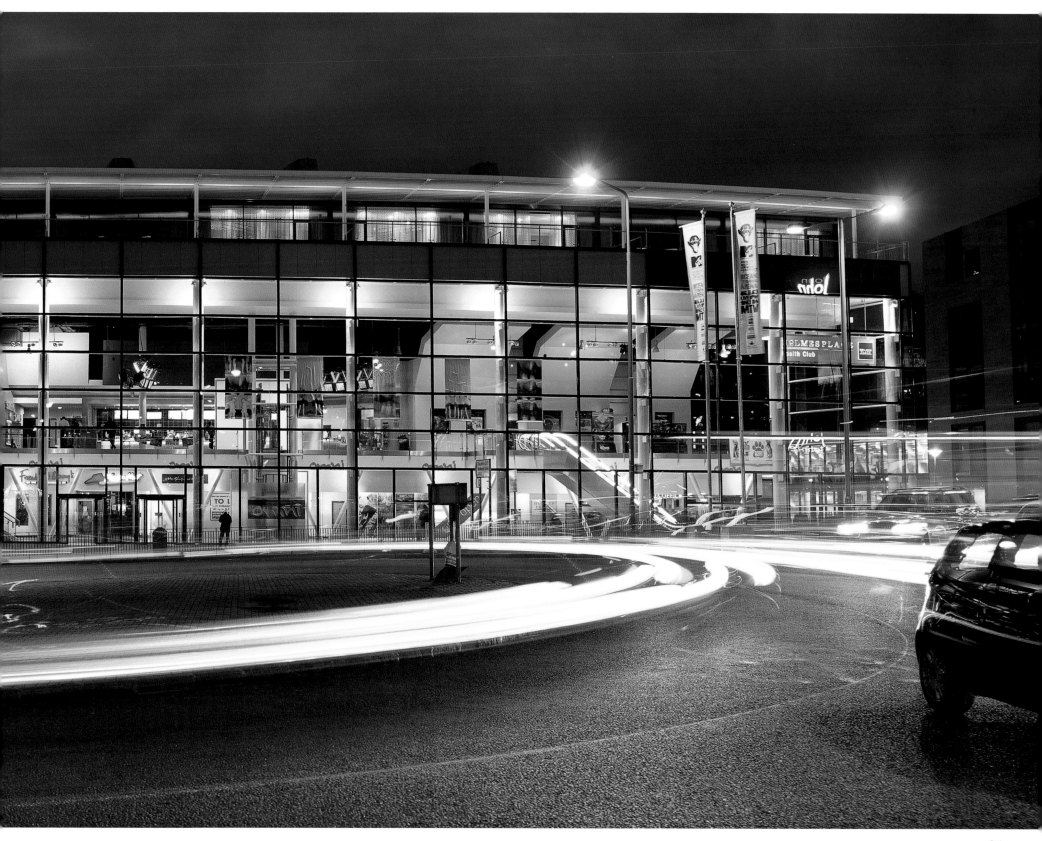

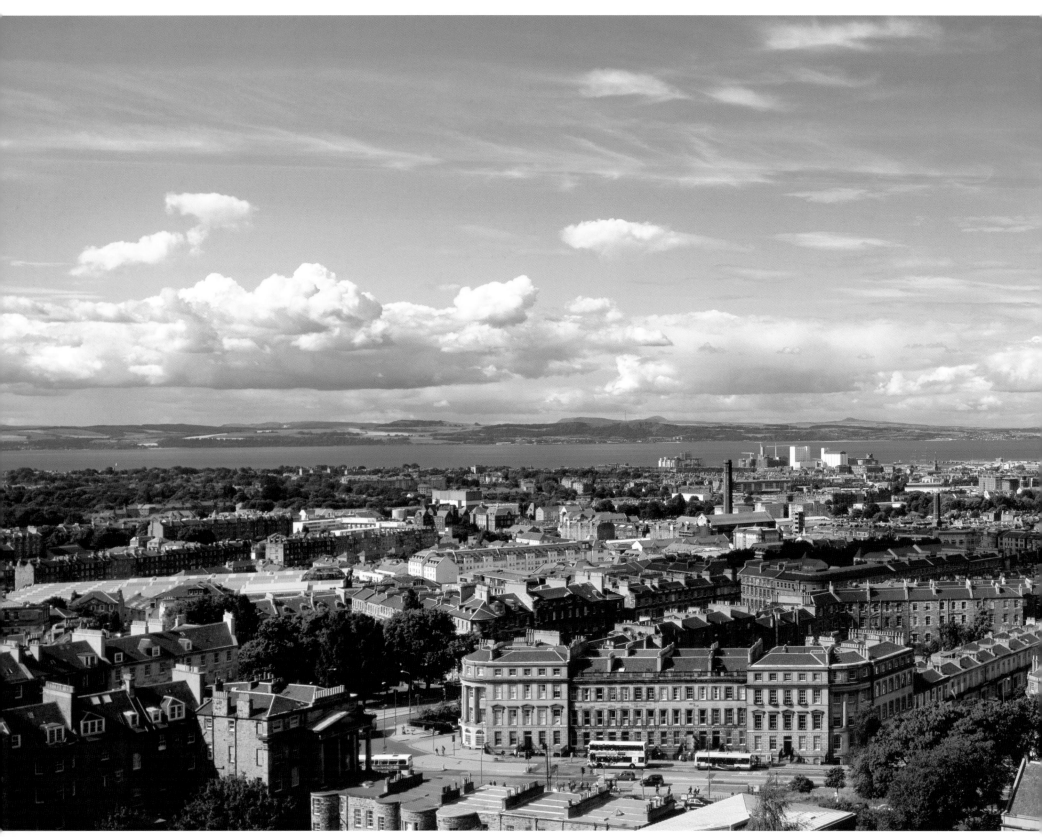

OVERLOOKING LEITH FROM CALTON HILL

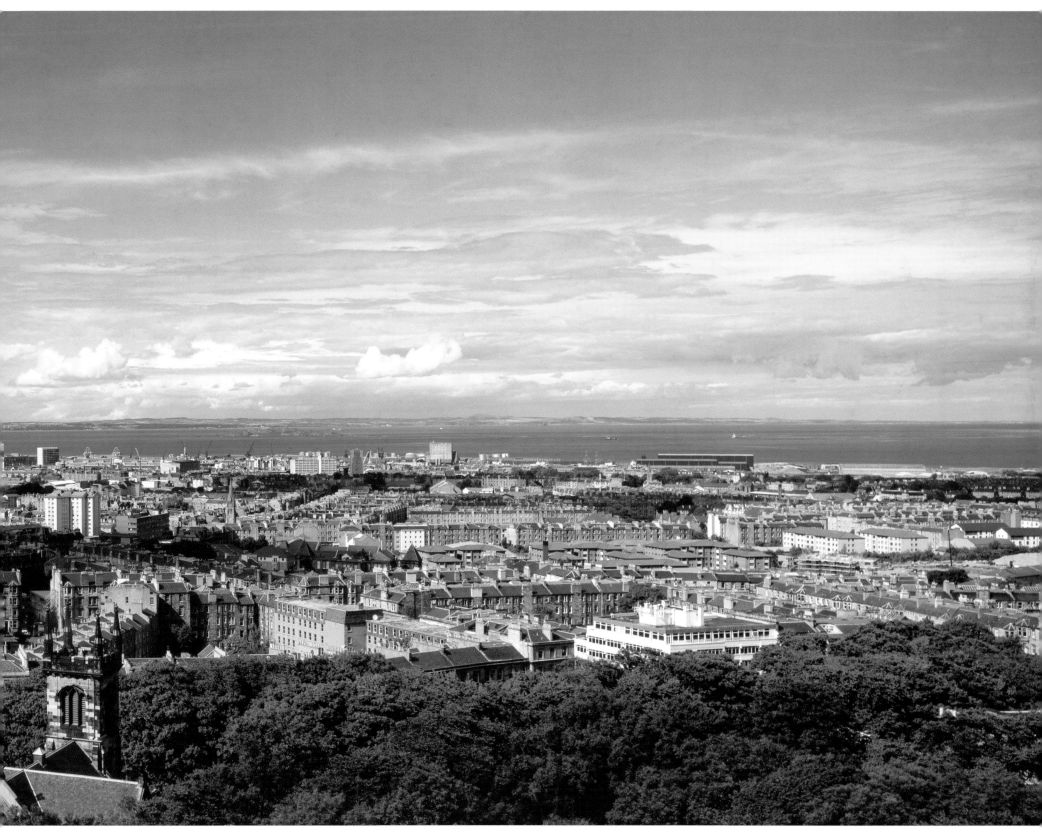

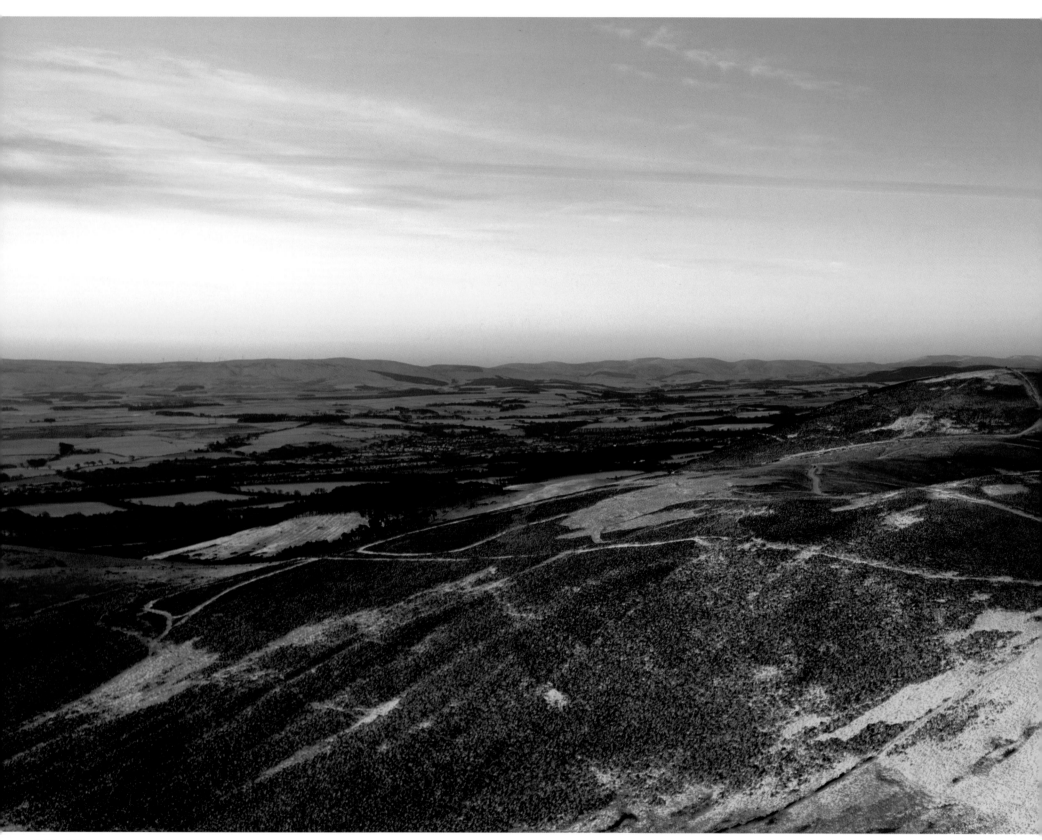

PENTLAND HILLS

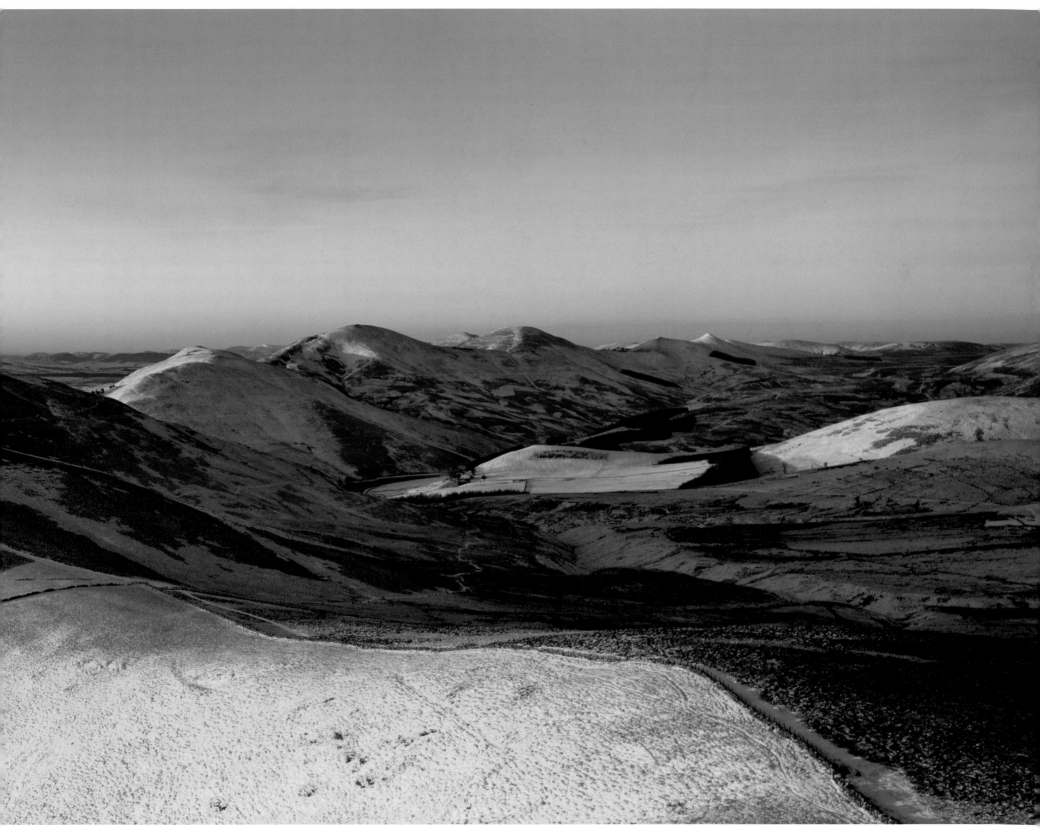

GROSVENOR CRESCENT, WEST END

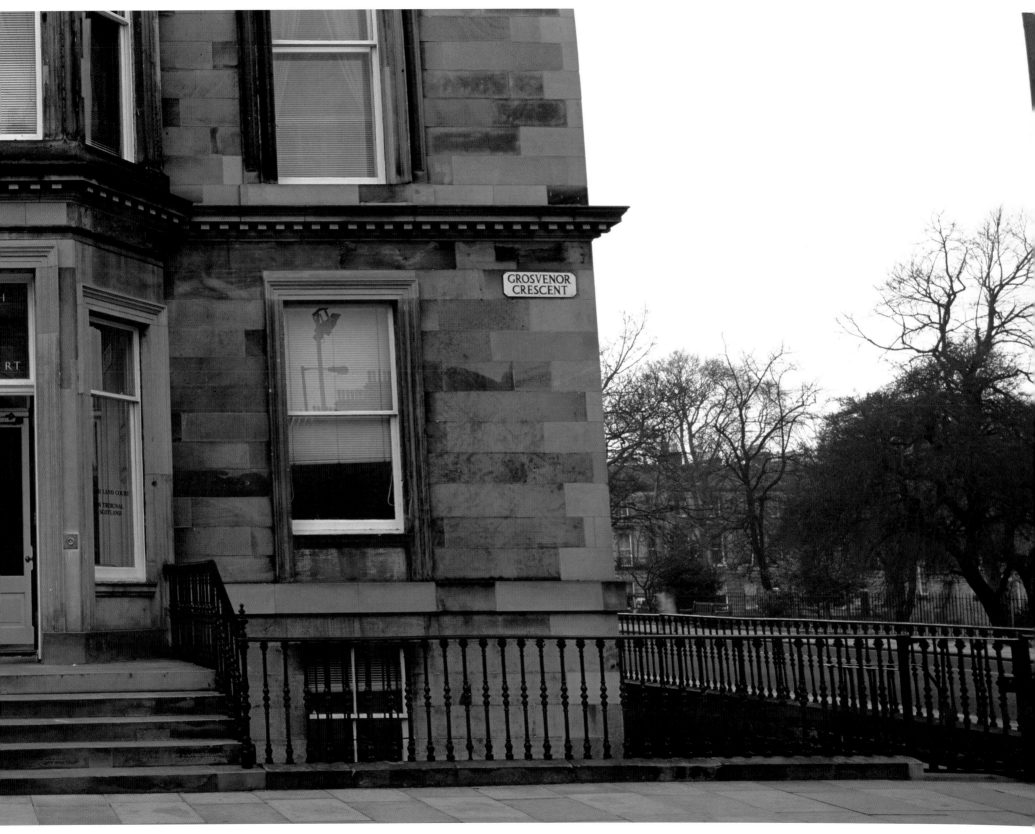

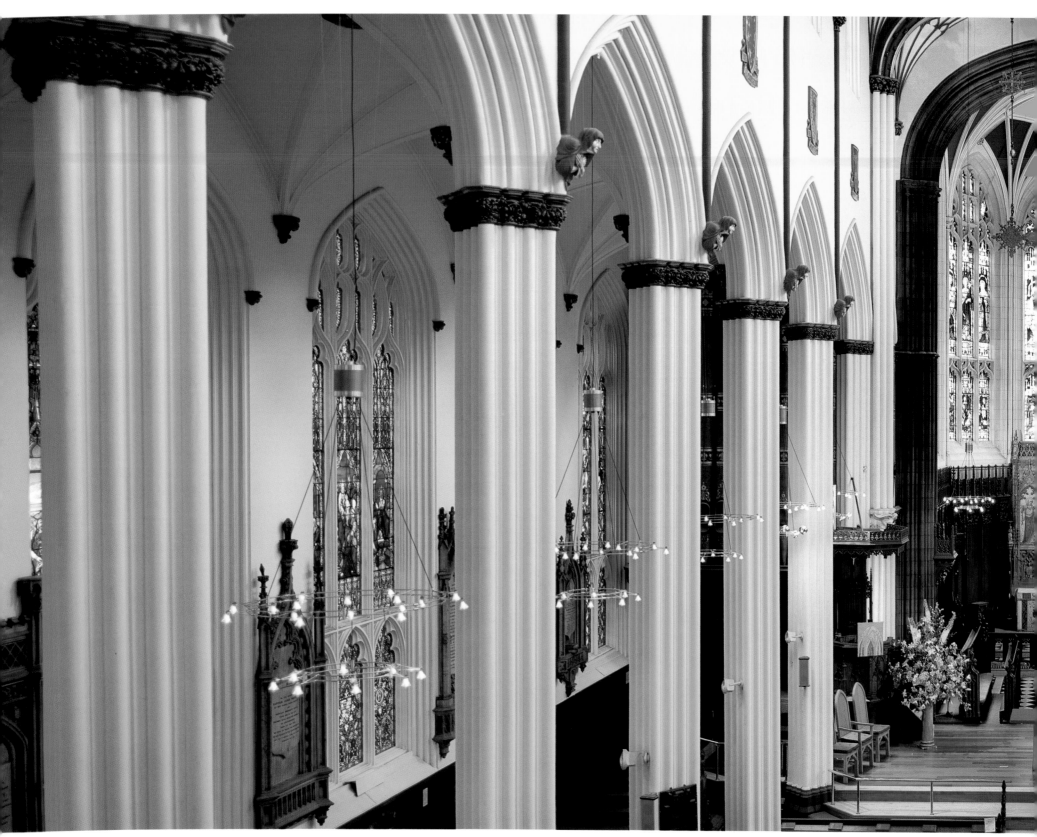

ST JOHN'S CHURCH, PRINCES STREET

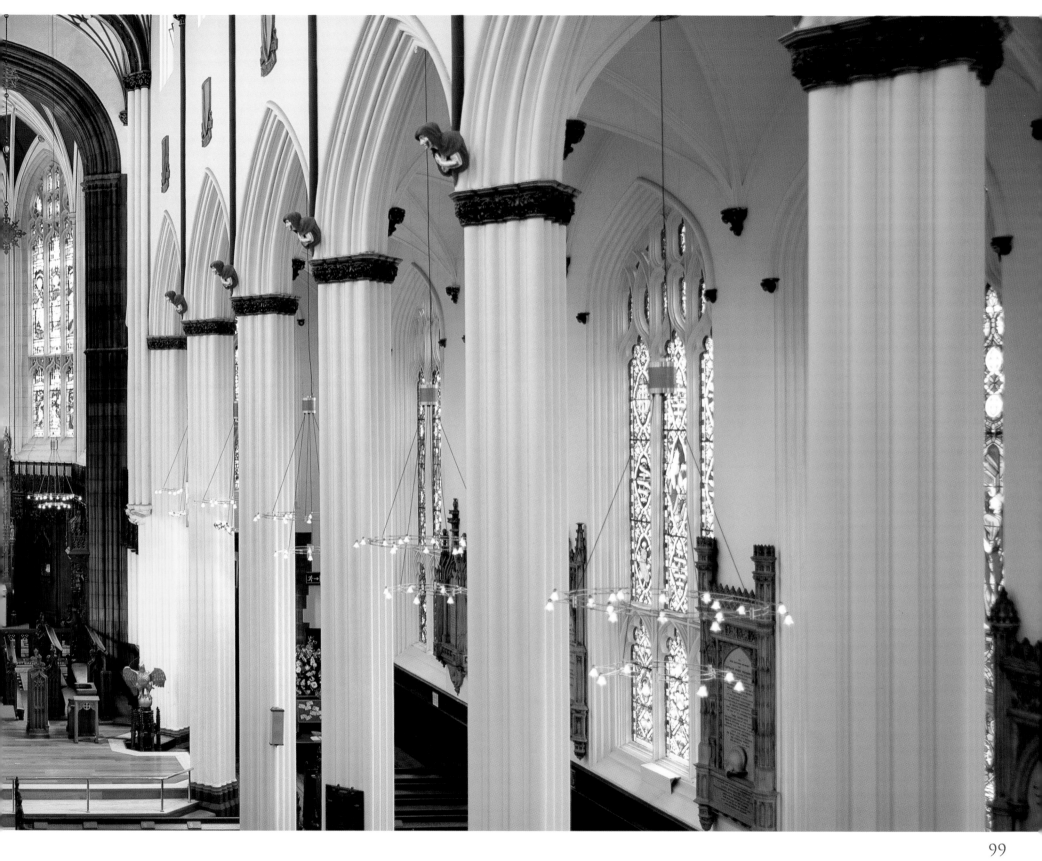

PRINCES STREET

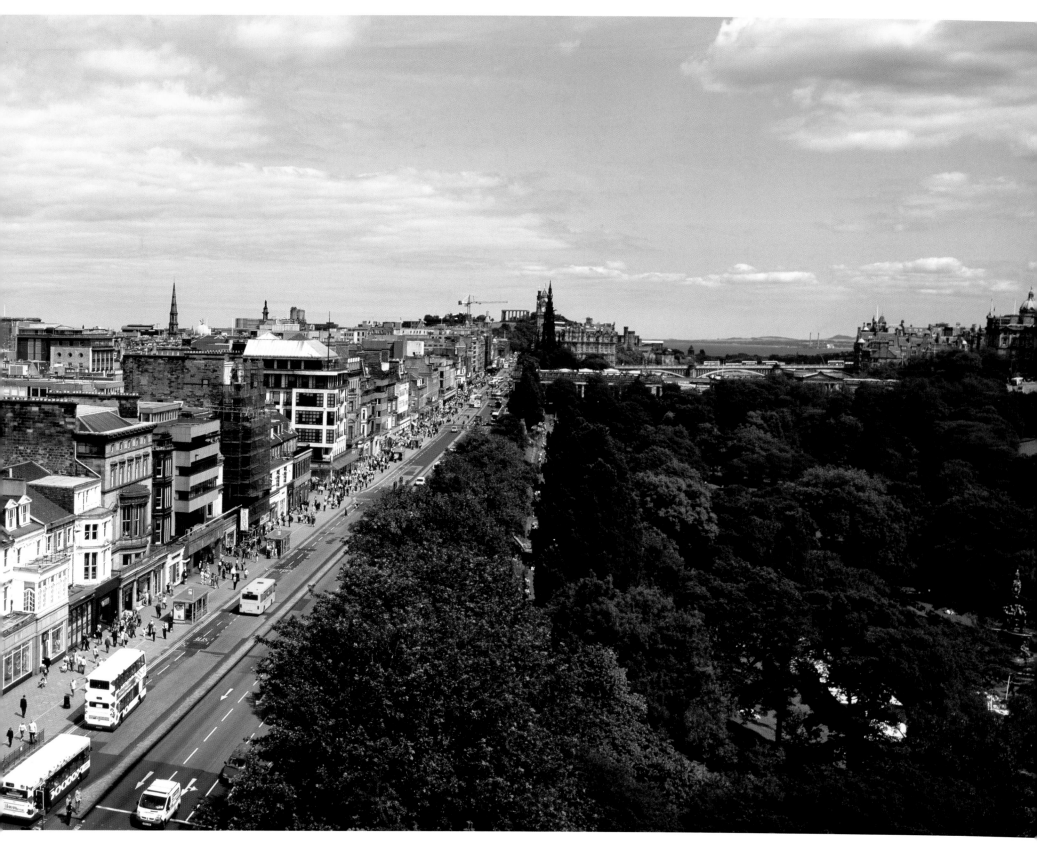

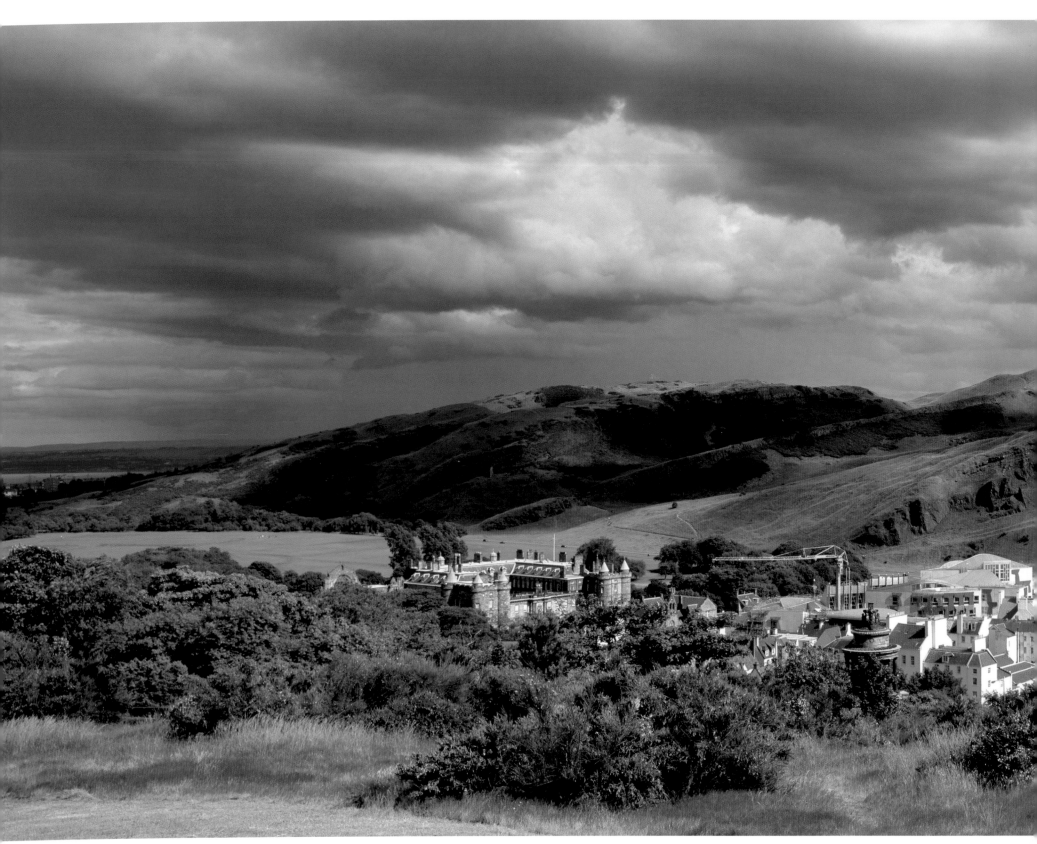

BROODING CLOUDS OVER ARTHUR'S SEAT

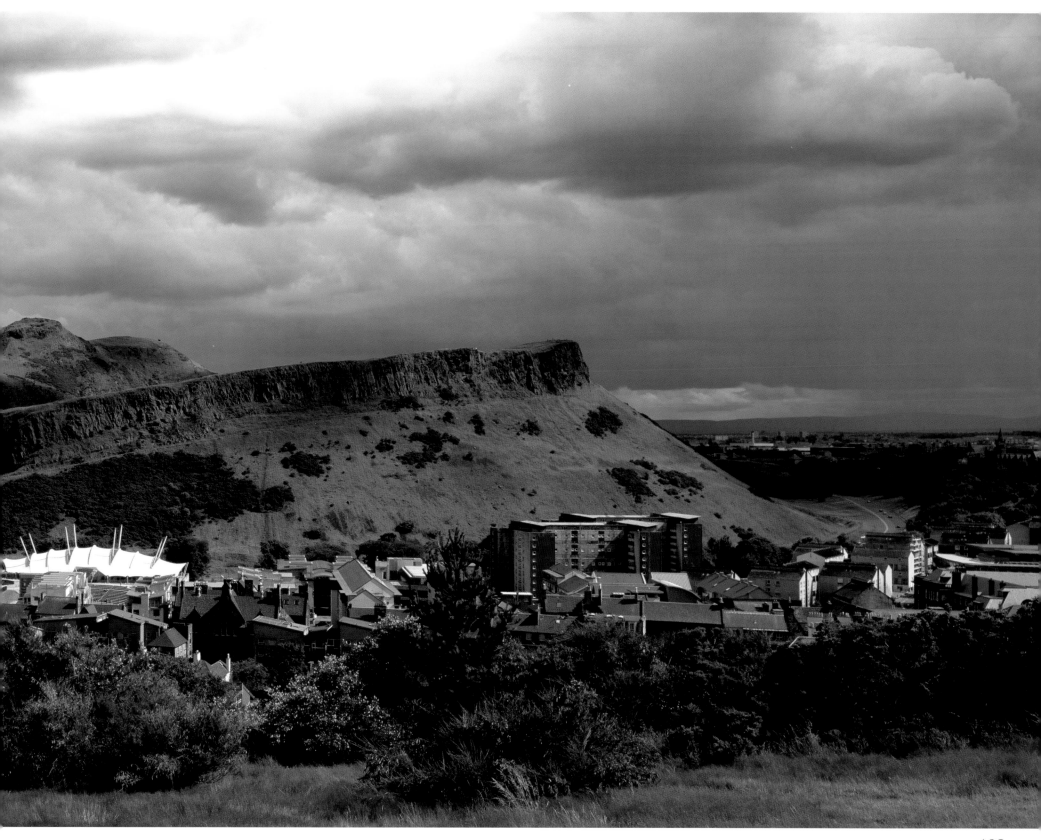

ROYAL BOTANICAL GARDENS

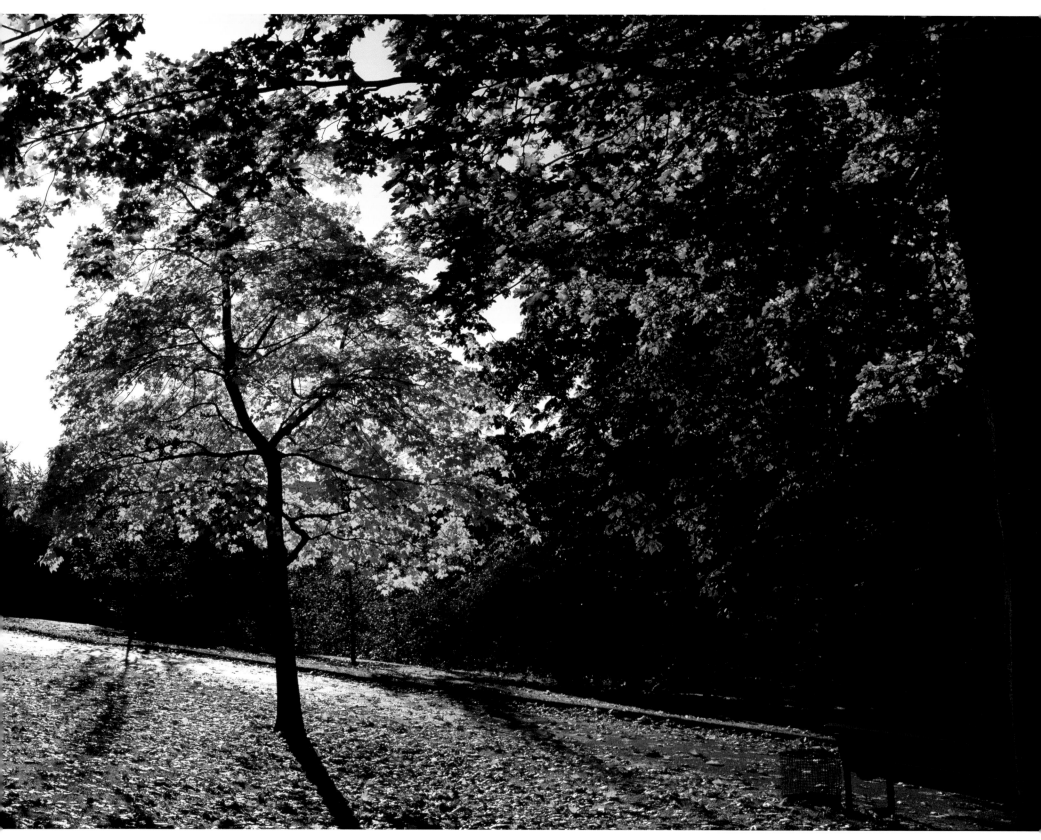

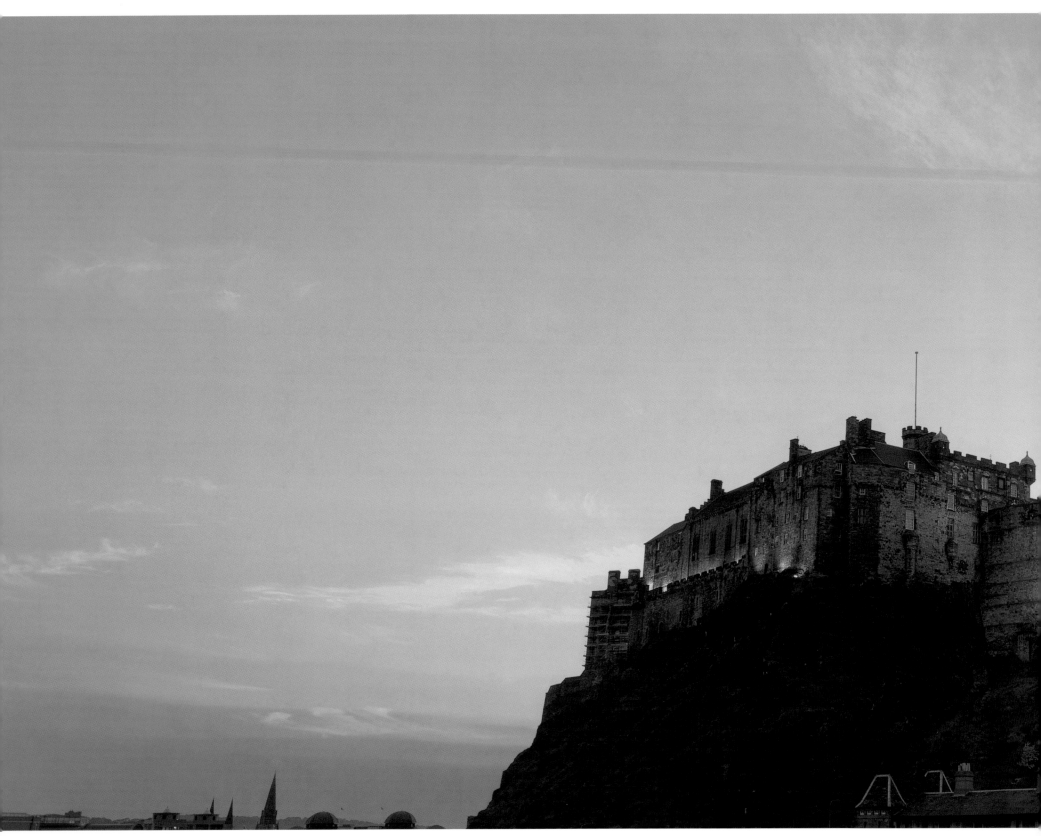

SUNSET COLOURS ON EDINBURGH CASTLE

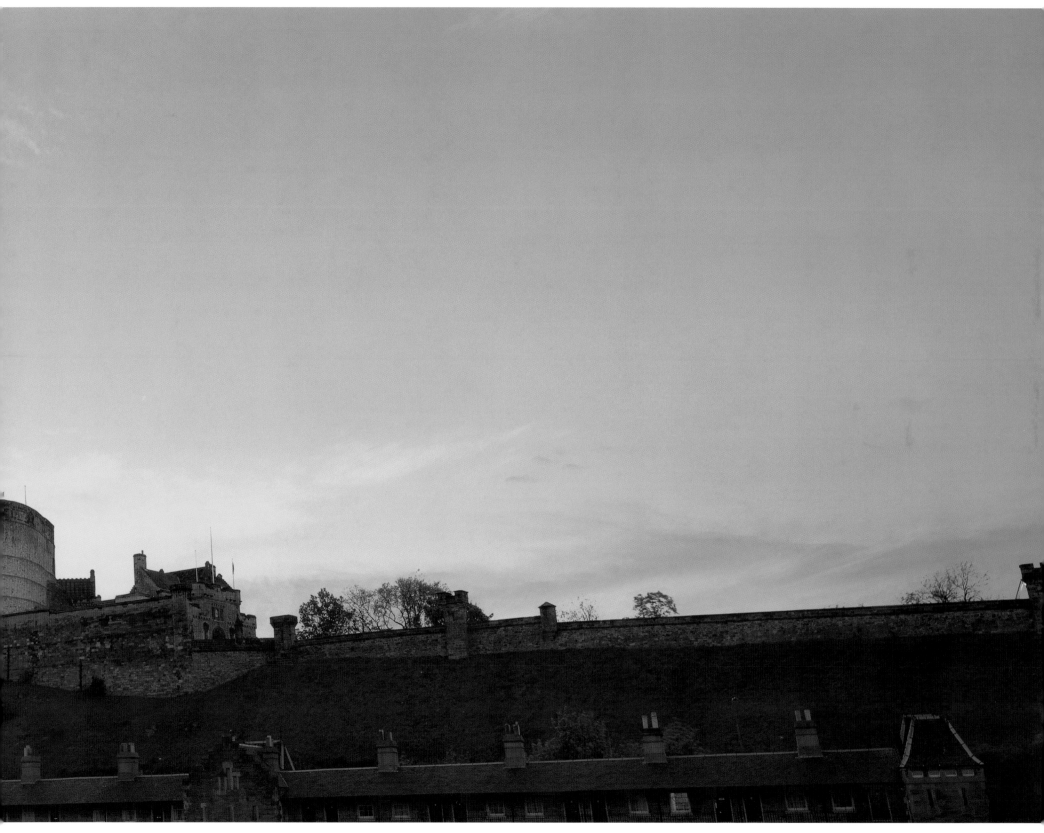

Page 3, Sunset colours on Edinburgh Castle

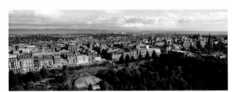

Page 5, Princes Street Gardens looking east to Fife

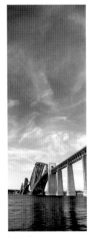

Page 7, Forth Rail Bridge

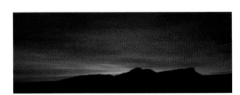

Page 9, Arthur's Seat and Salisbury Crags

It can be easy to think of the Castle as just part of Edinburgh's scenery, the backdrop of the Tattoo and countless holiday snaps, but I like to remember that the site has been in tactical use by various military forces since 900 BC. In taking this photograph, I wanted to reflect that for the majority of its history, the function of this hilltop fortress has been to keep people out rather than inviting them in! The unromantic setting of the car park at Castle Terrace provided the vantage point for this shot, taken as the last of the daylight disappeared over the horizon.

This picture illustrates what a lovely green city Edinburgh is. The foreground is dominated by Princes Street Gardens, which provides a welcome resting place for weary shoppers on a sunny day like this. In the gardens is the Ross Bandstand, scene of the famous Fireworks Concert that signals the end of Edinburgh's world famous International Festival. As the eye travels back through the photograph, more greenery intersperses the buildings before finally giving way to the misty blues of the Forth and onwards towards Fife.

Since opening in 1890, the Forth Rail Bridge, which connects the Lothians and Fife, has been photographed from land, sea and air, from every angle, in every season. It's a challenge, but I think that this unusual shot justifies the title *A New Perspective*. The focus of the picture isn't just a head-on shot of the famous span of girders that are a life's work to paint. The vertical composition, combines with the angle, to set the bridge in its seascape context. I struck extremely lucky with the clouds, which give the image a real depth.

I caught this autumnal sunrise over Arthur's Seat and Salisbury Crags from Calton Hill at around 7.30 in the morning, capturing the most exciting picture I took that autumn. Some ideal weather conditions combined with the right film has resulted in this stunning combination of deep saturated reds on the cloud base as the sun is rising.

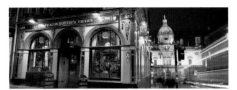

Page 11, Deacon Brodie's Tavern, Royal Mile

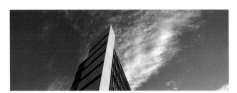

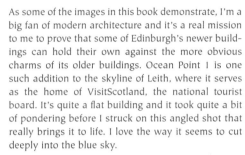

Page 13, Ocean Point 1, Leith

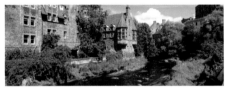

Page 15, Dean Village, Water Of Leith

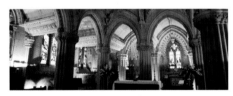

Page 17, Rosslyn Chapel, Roslin

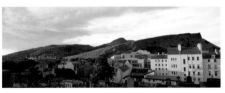

Page 19, Scottish Parliament, Palace of Holyrood-house

I've read that there are more pubs per resident in Edinburgh than anywhere else in Britain—this is one of the most well-known and striking. Using a time exposure I waited until a double-decker bus was about to pass and kept the shutter open for around 10 seconds. The resulting combination of light and colour made an unusual and beautiful image of the Royal Mile.

As some of the images in this book demonstrate, I'm a big fan of modern architecture and it's a real mission to me to prove that some of Edinburgh's newer buildings can hold their own against the more obvious charms of its older buildings. Ocean Point 1 is one such addition to the skyline of Leith, where it serves as the home of VisitScotland, the national tourist board. It's quite a flat building and it took quite a bit of pondering before I struck on this angled shot that really brings it to life. I love the way it seems to cut deeply into the blue sky.

This photograph was taken at the height of summer down at the Dean Village, one of the most scenic parts of the Water of Leith. It's amazing to think that the busy streets of the New Town are only a few hundred metres from this tranquil scene. It is normal to try and avoid taking pictures during the early afternoon due to the harsh light of the midday sun, but this particular scene actually benefits from this —the luscious greens make for a wonderful summer picture.

It's been around since the fifteenth century, but Rosslyn Chapel has seen a remarkable rise in profile in recent years. The subject of a number of provocative and speculative theories regarding the Knights Templar, the Freemasons and the Holy Grail, regardless of what you believe, it is a fascinating and compelling building. I was quite lucky to be able to get this image, as when I turned up at the agreed time to take the shots, the whole site had been taken over ahead of schedule by the crew filming *The Da Vinci Code*. Luckily, we managed to work around each other, but I am disappointed to report that I do not make an appearance in the film!

This image turned out rather well for an accident! I had been taking pictures up Calton Hill and was driving home when this lovely scene caught my eye. The rising sun was just starting to cover the buildings with light, creeping up the valley from Holyrood Park. This, combined with the approaching clouds just touched with pink, makes a really nice image.

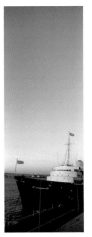

Page 21, Royal Yacht *Britannia*

No book of Edinburgh's scenery would be complete without a shot of one of its biggest tourist attractions: the Royal Yacht *Britannia*. The berth of the yacht is not kind to photographers as it suffers from what I would call "noise": background distractions that clutter the shot and spoil the atmosphere. One summer's evening, just as the sun set and the lights on *Britannia* came on, I took this unusual vertical panoramic shot, which makes me think of the speed of the yacht in its sailing days.

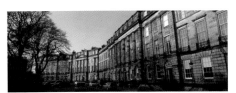

Page 23, Moray Place, New Town

Edinburgh is a town of contrasts, none more obvious than those between the Old and New Towns. The New Town, with its graceful Georgian layout, substantial townhouses and broad streets is one of the finest examples of its kind in the country. This picture was taken early on a March evening, the light giving strong saturated colours.

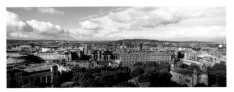

Page 25, Overlooking Edinburgh's financial district

This picture is taken from the back of Edinburgh Castle, which is an ideal vantage point to juxtapose old and new Edinburgh. Old Edinburgh is represented by the venerable Caledonian Hotel and St Cuthbert's church, while the new buildings to the left of the shot are the homes of the prosperous financial sector companies which form the backbone of Edinburgh's economy.

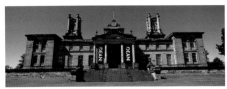

Page 27, Dean Gallery

Like most photographers, I am never far from a camera. One bright and sunny day, I visited the Dean Gallery on a scouting trip, with no real intentions of taking serious photos. However, as I looked at the exterior, I decided to throw out the rule book (rule number 1: don't take pictures with the sun high overhead) and take the shot right then. By the time I set up, it was late afternoon, and the light had softened somewhat, ensuring that the picture had a good contrast. I think it works well. Some buildings in Edinburgh look better in the "dreich"—I think this one looks great basking in the sunshine.

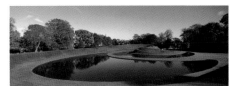

Page 29, Landform, Scottish National Gallery of Modern Art

Opened in 2002 in front of the Scottish National Gallery of Modern Art, I've been intrigued by this landform since I first saw it taking shape. I was desperately impatient for it to be completed so that I could photograph it. The key here was to pick a clear day with not a breath of wind so that the water was mirror-smooth and gave maximum impact. It was autumn, so the leaves had just started to turn, giving wonderful depth to the colours.

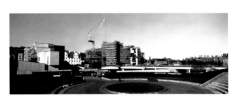

Page 31, Under construction, Scottish Parliament

It was impossible to be in Edinburgh (or Scotland, for that matter) and not be aware of the drawn-out saga that was the construction of the Parliament. I popped round on a few occasions to capture the work in progress, and this is the result. It's not something that I do very often, but in this image, I have added a duotone blue, which has increased the contrast, bringing the picture to life.

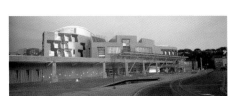

Page 33, Early morning, Scottish Parliament

This shot is filed away under "lucky accidents". Having been up at the crack of dawn to take my then-fiancée (now wife) to the station for an early train, I was driving home when I noticed this fabulous pink hue developing in the sky. I rushed to my office to pick up my gear and was just in time to capture this lovely light on the Scottish Parliament. I've added interest by using a longer exposure than necessary to give the streaking effect on the car lights.

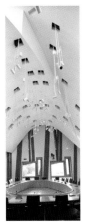

Page 35, Large committee room inside the Scottish Parliament

Walking into this room I was instantly struck by the amount of natural light pouring in and, unlike the very vocal critics, I think I understand the architect's vision. The tall whitewashed ceilings and the hanging lights put me instantly in mind of Charles Rennie Mackintosh. Further research told me that his flower paintings were used as inspiration for the building. The vertical shot gives a good impression of the soaring lines of this room. I'd definitely recommend exploring the Parliament as it is a very rewarding experience, but you have to go inside to really understand the architecture as a whole.

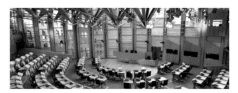

Page 37, Debating chamber, Scottish Parliament

With the weight of three hundred years of expectation, this room has a lot to live up to as the seat of the long-awaited Scottish Parliament. I think it is a hugely impressive space, with clever use of light and colour. It's not been without its problems, but I do believe that in time it will take its place as a national treasure. The lovely warm tones of the wood are what make this picture so inviting.

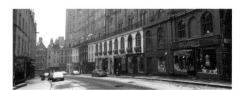

Page 39, Victoria Street

Victoria Street and West Bow, lying beneath the Castle in the Old Town, present a charming little scene with plenty to see on various levels. A snow flurry in early March put an interesting twist on the scene and ensured that the picture was not too busy with people. However I wasn't alone in wanting to photograph this. Moments after I had taken the shot an open-top tourist bus roared up the hill full of passengers armed with cameras, frantically snapping away!

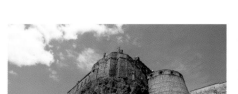

Page 41, Edinburgh Castle

Edinburgh Castle. It looms above the town, planted four-square and dominant on its rocky outcrop, the target of thousands of photographs each year. Locals and tourists alike are captivated by its presence, looking benign on a sunny day, or wrapped in the mists of a dreich Edinburgh afternoon. The challenge with this subject is to try to capture a little-seen view, and as soon as I looked through the viewfinder I knew I'd found the spot. I think it really accentuates the impenetrability which was the castle's original purpose.

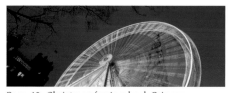

Page 43, Christmas ferris wheel, Princes Street Gardens

Edinburgh transforms itself for the festive season, sprouting ice rinks, fairgrounds and fairy lights in every tree. I was fascinated by the huge ferris wheel and the potential for a great image. I set up below the steps at an extreme angle using a time exposure of around 10 seconds, in order to make the lights on the wheel streak and blur, a nice contrast to the genteel and staid old-Edinburgh Jenners sign behind!

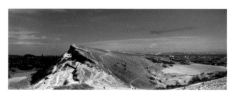

Page 45, Snow on Salisbury Crags

A childhood encounter with Ansel Adams' *The Negative* has given me a love of black and white photography that has lasted for many years, combined with (I hope) a keen understanding of its challenges and rewards. While out on a combined dog-walking/scouting expedition, I discovered a really exciting aspect and had an inkling that black and white would give a very "Adams-ish" effect. When it started to snow a few weeks later, I headed immediately to Holyrood Park with this shot in mind and it was every bit as good as I'd hoped, if rather cold at the time!

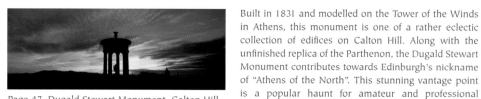

Page 47, Dugald Stewart Monument, Calton Hill

Built in 1831 and modelled on the Tower of the Winds in Athens, this monument is one of a rather eclectic collection of edifices on Calton Hill. Along with the unfinished replica of the Parthenon, the Dugald Stewart Monument contributes towards Edinburgh's nickname of "Athens of the North". This stunning vantage point is a popular haunt for amateur and professional photographer alike. Darkly brooding skies and clouds streaked with the setting sun as it disappeared behind the Pentland Hills make this photograph memorable.

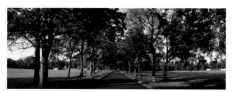

Page 49, Midsummer in Inverleith Park

Inverleith Park in summer is a hive of activity with runners, dog walkers, softball and cricket teams all competing for space. I decided that the best picture of this would be a long central perspective that highlights the long straight paths framed by trees. With the late summer sunshine filtering through, there is the sense of a lazy warm evening in the local park with all that it entails.

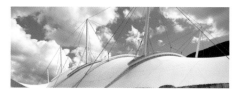

Page 51, Our Dynamic Earth, Holyrood

It was a bold move to site this modern piece of architecture between the ancient volcano of Arthur's Seat and the venerable Palace of Holyroodhouse, but it somehow fits in rather well with its environment. The picture was taken on a summer's afternoon, which meant that the sun was still relatively high, but some cloud cover makes this picture brightly coloured without being garish.

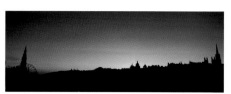

Page 53, Winter dawn skyline

The risks that I take as a photographer often involve climbing hills in the dark and the cold, but the city shots are usually more sedate affairs. This shot was an exception, and not one that I would recommend. The kind people at the Abbey Business Centre on Princes Street gave me access to their roof, which was great as it has some stunning views of the Royal Mile. However, balancing on a flat roof covered in ice while three storeys above Princes Street, all in the dark and in the name of art does not go down as one of my finer moments! Just as well that the shot turned out to be something special.

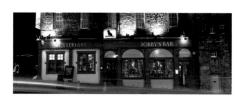

Page 55, Greyfriars Bobby's Bar

This image of Greyfriars Bobby's Bar, which is situated next to Greyfriars Kirkyard, haunt of the renowned faithful dog Bobby, involved an extended period of standing outside in the cold waiting for the right light and conditions. Luckily the owner spotted my lonely vigil and invited me in for a very welcome cup of coffee. He also very helpfully switched on all of the lights to help me achieve the picture that I was looking for.

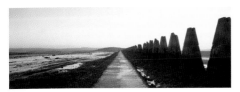

Page 57, Dawn, Cramond Causeway

Cramond Island causeway is only accessible at low tide—many an unwary hiker has lingered too long on the Island and returned to find the causeway has disappeared under the rising tide! A combination of several natural elements had to be in place for this picture to work. The tide had to be out, the skies had to be clear and I had to be poised to capture it as the sun rose across the scene. In all it took three months to capture this image, with lots of close observations of weather and tide and several unsuccessful outings.

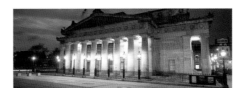

Page 65, Royal Scottish Academy, Princes Street

Half way down Princes Street, where the Mound meets Frederick Street, two large buildings with columns catch your eye. This building, the Royal Scottish Academy, houses exhibitions of old masters as well as contemporary art. It is often mistaken for the National Gallery of Scotland which sits to the rear. No project to document Edinburgh would be complete without its dominating presence, and I've chosen an early evening shot for maximum contrast between the dark blue sky and the floodlit building.

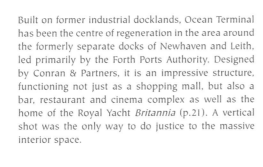

Page 59, Ocean Terminal shopping centre, Leith

Built on former industrial docklands, Ocean Terminal has been the centre of regeneration in the area around the formerly separate docks of Newhaven and Leith, led primarily by the Forth Ports Authority. Designed by Conran & Partners, it is an impressive structure, functioning not just as a shopping mall, but also a bar, restaurant and cinema complex as well as the home of the Royal Yacht *Britannia* (p.21). A vertical shot was the only way to do justice to the massive interior space.

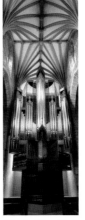

Page 67, Organ inside St Giles Cathedral

It's hard not to be impressed by a 4,000 piece organ, but given the scale and proportions, it can be harder still to take a fresh and original photograph of it. In this shot, I have gone for the vertical panoramic angle, which gives a sense of the looming majesty of the instrument. I think the image conveys how well the organ fits into its surroundings and echoes the architecture of the cathedral.

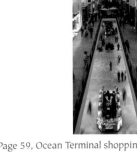

Page 61, Charlotte Square

Every photographer is on a quest for their ultimate shot, and, at the moment, I think that this is mine. The simplicity is what makes it so special—the three bare trees and the statue make a striking composition with the backdrop of the snow giving an unusual texture and tone. There was nothing terribly fulfilling about stumbling through a blizzard first thing on a Sunday morning, fighting a howling gale to keep the tripod upright while trying to keep the snow off my camera, but every time I look at this picture I think that it was worth every second.

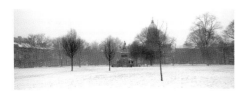

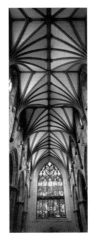

Page 69, Vertical view inside St Giles Cathedral

Named after the patron saint of cripples and lepers, this cathedral has been a focal point for religious Edinburgh for over 900 years. Strictly speaking, it is no longer a cathedral, but the Church of Scotland Parish Church for the Old Town; however it colloquially retains the title. Given how integral it has been to the history of the city, I wanted to do justice to it, and I think that this vertical shot really illustrates the soaring ceilings and the grandeur of the stained glass.

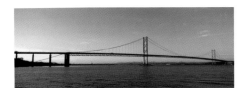

Page 63, Forth Road Bridge

The Forth Road Bridge is often overlooked by photographers in favour of its larger, majestic brother, the Forth Rail Bridge (p.7). As the Rail Bridge is usually covered in scaffolding, I decided the Road Bridge would be a better subject matter. As you can see the span on the bridge is accentuated in this scene—the combination of the angle and the wispy cirrus clouds brings your eye from the left side along the bridge and up into the sky. The panoramic format is really the only way to capture the true extent of this bridge.

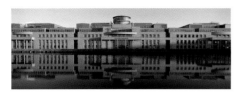

Page 71, Scottish Executive, Leith

The Scottish Executive is set at an angle, which means that it very rarely gets any morning or evening light on the front of the building, except in high summer. As this building was on my list of "must have" shots, it was a race against time one summer's evening to capture this image before the shadows enveloped the building. The soft light makes a calm and tranquil scene, with barely a ripple to be seen in the dock.

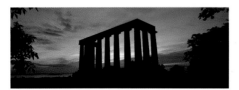

Page 73, The National Monument (or Edinburgh's Disgrace), sunrise

Started in 1822 as a memorial to those who died in the Napoleonic Wars, this is an iconic part of Edinburgh's skyline and one which has a particular place in the hearts of locals. Conceived as a replica of the Parthenon, construction stopped when funding ran out and it has remained unfinished. Nonetheless it is striking and unusual in its partial state. I like this silhouetted shot as it underlines just how imposing a structure it is and suggests how overwhelming, or perhaps even vulgar, it would have been if completed.

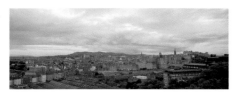

Page 75, Royal Mile from Calton Hill

The Royal Mile can be rather higgledy-piggledy, making it difficult to convey, in a photograph, its context within the city. I decided to draw the focus back and look at it from quite far away, in this case from Calton Hill which lies to the east. This is an early morning shot and the colours of the buildings have turned out amazingly warm. One often thinks of the buildings of Edinburgh as being predominantly grey, but this picture shows a far greater variety of tones.

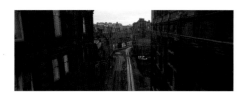

Page 77, Cowgate

A map of this area of Edinburgh can't really convey the complexity of the Old Town and the Cowgate which carves its way through looming buildings with various bridges spanning it. Threatened and partially destroyed by a large fire in 2003, it remains a most fascinating street. This picture, taken from George IV Bridge as the sun set and the colour leached from the scene, conveys the impression of the solid, imposing nature of the buildings over the narrow street.

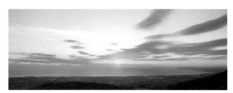

Page 79, Dawn over Portobello

In the summer, the sun rises early and so does the photographer. This sunrise was taken at around 4.50am, from the top of Arthur's Seat, which involved a very early start climbing the hill in the dark—not recommended unless you know the immediate area very well! What makes this picture for me is the way the clouds fan out in such dramatic style, sculpted by the high winds and making lovely shapes across the sky.

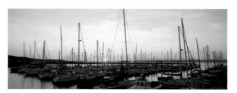

Page 81, Port Edgar, South Queensferry

Looking at this picture, it seems that the only place to be on this glorious summer's evening would be sitting on the deck of one of these yachts sipping Pimms and feeling very Mediterranean. However, appearances can be deceptive, as this was actually taken on a very cold March day with a northerly wind whipping across the water! Not very Mediterranean at all, unfortunately. I've always been fascinated by marinas and this one has quite an interesting history, should you ever find yourself in the area.

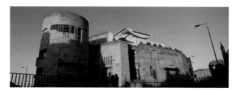

Page 83, National Museum Of Scotland

It's not easy to do full justice to the NMS with a photograph. It's a very interesting and complex building with some unexpected angles. Its greatest blessing to the photographer is that its roof provides an excellent spot from which to capture stunning images of other parts of the city! With this photograph, I wanted to bring out the soft colours of the building as it was bathed in early evening summer light. It took a number of visits with the viewfinder to establish the optimum time, with the ideal proportions of the building in light and shade combined with an interesting angle.

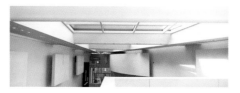

Page 85, Interior, National Museum of Scotland

Many of the images in this book are the exteriors of Edinburgh's architecture, but an equally exciting prospect is capturing some of the interiors. Considering modern architecture, I immediately thought of the National Museum. The focus of this picture is the "high key" nature of the picture, with the white walls and the flood of natural light from the skylights. I think it really demonstrates the exciting modernity of the interior.

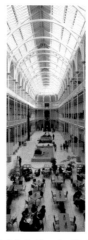

Page 87, Main Hall & Café at the National Museum of Scotland

Sitting having a cup of tea one day in the café in the National Museum of Scotland I gazed up at the ceiling high above, and the problem of how to photograph this wonderful interior suddenly resolved itself. The obvious choice was to showcase the wonderful airy galleries and vaulted ceiling in a vertical panorama. I was really pleased to be able to do justice to a building that I admire so much.

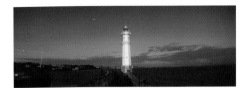

Page 89, Lighthouse, Granton Harbour

A lot of my photography tends to be quite literally about the "big picture": the sweeping land, city and skyscapes that are my trademark, but this shot is somewhat different as it is the small details which make it unique. A closer look reveals that the moon is lingering on in the morning sky, and a seagull has swooped through the shot, appearing as a blur due to the long exposure. The quality of light makes the lighthouse glow brightly against the intense blue of the sky, making this picture vibrant and alive.

Page 91, Omni Centre

This is another one of the shots where the real skill lies in not getting run over while taking it! I wanted the traffic to form the point of interest for this shot, as I felt that a static image of the Omni Centre might not turn out to be terribly exciting. The shape of the building actually proved to be very suitable for the panoramic format, and the streaking lights make a really vibrant modern city scene.

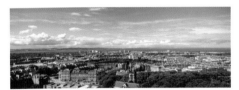

Page 93, Overlooking Leith from Calton Hill

Like Rome, Edinburgh is built on seven hills. At an early stage in the project, I realised the benefit that this provides to the photographer in terms of vantage points. Looking to show the port of Leith to its advantage, I climbed Calton Hill one morning to capture this simple shot from the top of Leith Walk leading down to the port.

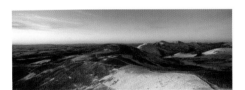

Page 95, Pentland Hills

Being a keen hill walker, I am endlessly impressed by how easy and quick it is to access the countryside from Edinburgh. The Pentland Hills lie a short distance from the city boundaries and are a popular haunt for residents looking for a wee bit more than a stroll in the park. The morning of this shot was absolutely freezing, and I was very glad of my photographic assistant—my dog, Ruby. Not only did she perform sterling work keeping my hands warm, but playing with her in the snow while I waited for the light kept the rest of me warm, too!

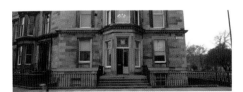

Page 97, Grosvenor Crescent, West End

Number One, Grosvenor Crescent is the home of the Scottish Land Court. The Land Court's remit is to resolve disputes which arise in agriculture and crofting throughout Scotland. Situated opposite St Mary's Cathedral and not far from the west end of Princes Street, it is a solidly Georgian and somehow a very "Edinburgh" building. On the day of this shot, a drifting haar from the Forth cast a soft glow over the brickwork which brings out its lovely colouring.

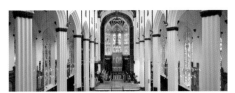

Page 99, St John's Church interior, Princes Street

Edinburgh is not short of churches gracing its cityscape and I have really enjoyed getting to know some of the spectacular interiors that easily win a photographer's heart. This is St John's church at the west end of Princes Street. It certainly is well worth a visit, with its bright, airy and colourful interior.

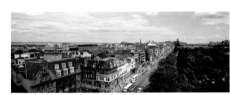

Page 101, Princes Street

This picture is another that fits into the "more adventurous than it seems" category. This isn't a view that people get to see very often as I suspect not many people would be prepared to climb the series of steep ladders high above the ground up the spire of St John's Church. It was so far up that the only way I could get my equipment to the top was by winching it up on a rope. Luckily, I managed not to drop anything: I can't quite imagine how that conversation with the insurance company would have gone.

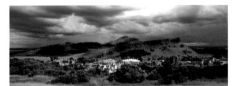

Page 103, Brooding clouds over Arthur's Seat

I really love how this picture manages to frame Arthur's Seat and Salisbury Crags, with parts of the city peeking up in between. There is quite a sense of menace in the threatening clouds that are forming across the sky. Rain is definitely on the way to spoil this lovely sunny day.

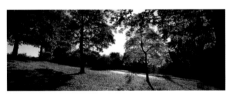

Page 105, Royal Botanical Gardens

The Royal Botanical Gardens in autumn produces more colours than you would believe exist in nature. From luscious reds to deep yellows and every hue of green, it's like being inside an artist's paint box. I always feel spoiled for choice. I like this composition of trees with the sunlight filtering through—lots of colours and textures, all highlighted with bright autumnal sunshine.

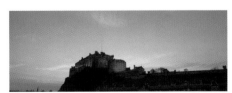

Page 107, Dusk over Edinburgh Castle

This picture was all about timing. I wanted to strike exactly the right balance between the light that was illuminating the castle, and the contrasting dusk. This meant taking the picture within ten minutes of the sunset, as after this the residual light starts to fade and the balance is lost.

# INDEX

# ACKNOWLEDGEMENTS

Many thanks to the following people and organisations for helping to make this book a reality:
Caroline, Tom, Vikki and Seán at Mercat Press; Helen Osmani, the picture library at the National
Museum of Scotland; Adam Elder, Scottish Parliament press office; David Fletcher; Edinburgh Junior
Chamber of Commerce; Ocean Terminal, Leith; Abbey Business Centre, Princes Street; Rosslyn Chapel;
The Church of St John the Evangelist, Princes Street; Peter Marshall, an early inspiration in my career.

Jason Baxter was born in Dover in 1973. His passion for photography began when he was given
a camera on his 14th birthday. Since then he has worked freelance all over the world capturing
everything from panoramic landscapes to cityscapes and even a portrait of His Holiness the Dalai
Lama. He now lives in Edinburgh with his wife where he runs his own company, Baxter Photography.

A selection of the images from the book are available as prints at www.jasonbaxter.net